# WHAT IS PAINTING?

## THE CLASSICAL AMERICA SERIES
## IN ART AND ARCHITECTURE
Henry Hope Reed and H. Stafford Bryant, Jr., General Editors

W. W. NORTON & COMPANY, INC.

*The American Vignola* by William R. Ware

*The Architecture of Humanism* by Geoffrey Scott

*The Classic Point of View* by Kenyon Cox

*The Decoration of Houses* by Edith Wharton
and Ogden Codman, Jr.

*The Golden City* by Henry Hope Reed

*Fragments from Greek and Roman Architecture* The Classical
America Edition of Hector d'Espouy's Plates

*Man as Hero: The Human Figure in Western Art* by Pierce Rice

*The New York Public Library: Its Architecture and
Decoration* by Henry Hope Reed

*Monumental Classic Architecture in Great Britain and Ireland*
by Albert F. Richardson

*The Library of Congress: Its Architecture and Decoration*
by Herbert Small

*The United States Capitol: Its Architecture and Decoration*
by Henry Hope Reed
(in preparation)

WITH THE ARCHITECTURAL BOOK PUBLISHING COMPANY

Student's Edition of the *Monograph of the Work of McKim, Mead
& White, 1879–1915*; Letarouilly on Renaissance Rome: The Stu-
dent's Edition of *Paul Letarouilly's Edifices de Rome Moderne* and *Le
Vatican et la Basilique de Saint-Pierre* by John Barrington Bayley;
*Architectural Rendering in Wash* by H. Van Buren Magonigle (in
preparation)
  *Drawing of the Classical: A Videotape Series Devoted to the Drafting
of the Five Orders* by Alvin Holm, A.I.A. (in preparation)

Classical America is a society that encourages the classical tradition
in the arts of the United States. Inquiries about the society should
be sent to Classical America, in care of W. W. Norton & Company,
Inc., 500 Fifth Avenue, New York, N.Y. 10110.

# WHAT IS PAINTING?

## "Winslow Homer" and Other Essays

## Kenyon Cox

*Preface by Arthur Ross*

*Introduction by Gene Thornton*

Classical America
The Arthur Ross Foundation

W · W · Norton & Company

*New York · London*

First Edition

LIBRARY OF CONGRESS
Library of Congress Cataloging-in-Publication Data
Cox, Kenyon, 1856–1919.
    [Winslow Homer]
    What is painting?: Winslow Homer and other essays/Kenyon Cox;
preface by Arthur Ross; introduction by Gene Thornton.—1st ed.
        p. 338 cm.—(Classical America series in art and architecture)
    Reprint of: Winslow Homer, originally published privately in 1914;
and Concerning painting, published by Scribner in 1917.
    Bibliography: p.
    ISBN 0-393-30545-7
    1. Painting.  I. Cox, Kenyon, 1856–1919. Concerning painting.
1988.  II. Title.  III. Series.
ND1150.C63  1988
750—dc19                                                      88-9686
                                                                  CIP

W. W. Norton & Company, Inc., 500 Fifth Avenue, New York, N.Y. 10110
W. W. Norton & Company Ltd.,
37 Great Russell Street, London WC1B 3NU

1 2 3 4 5 6 7 8 9 10

# CONTENTS

# CONTENTS

## PART III

### SOME PHASES OF NINETEENTH-CENTURY PAINTING

# ACKNOWLEDGMENTS

For research: The New York Public Library; the Joseph Curtis Sloane Art Library of the University of North Carolina, Chapel Hill. For an opportunity to read an earlier version of the Introduction to a group of artists, art historians and patrons: The New York Academy of Art and Grand Central Galleries, New York, New York.

—Gene Thornton

# ILLUSTRATIONS

## ILLUSTRATIONS

# PREFACE

## BY ARTHUR ROSS

A new vitality has been stimulating the fine arts in America. New art museums and additions to old museums are being constructed in towns, cities, colleges, universities, and even summer resorts. Art has gone public, and with it arises a public responsibility. More magazines than ever are given over to the arts. The ferment is matched by a questioning of purpose and style, as Gene Thornton points out in his searching introduction to these essays by Kenyon Cox. Concerned Americans are asking themselves if our contemporary art will, indeed, be a long-lived chapter in history.

It is only natural, therefore, that we look back at the road we have traveled over the past century. We Americans are fortunate to have, as guide, one of our own to throw some light on the changing art scene. The painter, Kenyon Cox, was no ordinary artist; for over twenty years from the 1890s, he was one of our leading muralists, his works

found in such varied buildings as New York's Appellate Court and the Public Library of Winona, Minnesota. In addition to being a painter, he has an unrivaled understanding and knowledge of his art and, more, the ability to convey both with wit.

He did not hesitate to pose the basic question, "What is painting?" and assess such masters among his contemporaries as Winslow Homer. For that reason, what he has to say is a resource that should command our full attention in these changing times.

The Classical America Series in Art and Architecture published Cox's *The Classic Point of View* in 1980. Now it is a privilege to add to the distinguished series this companion volume of his essays.

AR

New York City

# INTRODUCTION: KENYON COX TODAY AND TOMORROW

## BY GENE THORNTON

It is appropriate that Classical America should sponsor the republication of these essays on painting by Kenyon Cox and that they should appear after Pierce Rice's magisterial essay on the central theme of Western art, *Man as Hero: The Human Figure in Western Art*. Cox was, and still is, America's foremost spokesman for the classical idea in art, and the two books that are here combined under the title *What Is Painting?: "Winslow Homer" and Other Essays* go to the heart of the subject.

These two books draw on Cox's lifetime of thought and experience not just as a writer on art, but as a practicing artist. The first and shorter one, a study of Winslow Homer that was privately published in 1914, is a knowledgeable and sympathetic appraisal of the achievements of a fellow painter of radi-

cally different artistic aims and accomplishments. It is today, as it was then, a first-rate introduction not just to Homer's work, but to Cox's critical approach. The other book here represented is Cox's last, *Concerning Painting: Considerations Theoretical and Historical*, a collection of related essays published in 1917 that deals in a broader, more general way with questions of fundamental importance to painters of all eras. The title of its opening section, "What is Painting?," was adopted for the present volume to suggest the scope of the whole.

As additions to Classical America's library of critical writings by Cox, both books have much to say to readers today—to classicists, of course, but also to the many doubtful or disillusioned modernists who have emerged in recent years. Cox's essay on one of America's most radically realist painters treats with great subtlety and distinction Homer's relationship not just to his contemporaries, but to the great painters of the past. The essays collected in *Concerning Painting*, written soon after the Armory Show of 1913 first made what we now call "modern art" well known in America, bring Cox's wide and detailed knowledge of the

art of all the ages to bear on the artistic aims and practices of our own time.

Since Cox grew up in an earlier time than ours, his idea of the classical in art was developed in a different artistic environment. Born in 1856, he lived most of his life in a world where painting was dominated by realists who devoted their often formidable talents to the rendering of minute and transitory aspects of visible nature. Some of these artists—the Impressionists—are more highly thought of today than they once were. Others, more fashionable then, virtuoso brushmen like Giovanni Boldini and meticulous draftsmen like Jules Bastien-Lepage, were equally devoted to a purely ocular approach to nature and equally indebted, in their avoidance of the ideal and the imaginary, to the Realism of Courbet. Cox lumped them all together as nineteenth-century Naturalists, and it was in opposition to them that he formulated his idea of the classical.

By "classical," he did not mean the style of Jacques-Louis David, whose preoccupation with archaeologically correct Antique subjects and trappings seemed to him to be the beginning of nineteenth-century naturalism. Nor did he mean by "classical" an adapta-

tion or imitation of Greco-Roman sculpture or Renaissance painting. Cox also regarded as classical the peasant paintings of Jean-François Millet, which were regarded as triumphs of truth to nature in their time, as well as the American genre paintings of Winslow Homer, which might appear even today to be the opposite of classical.

At times when Cox refers to Millet and Homer as classicists, he seems to mean nothing more than that their peasants and small-town girls have in their faces and figures something of the monumentality of a Michelangelo sibyl. But usually he means that the painter, starting from nature, has eliminated from his subject everything that is not characteristic and essential, and has re-created it on canvas free from all irrelevant details.

To Cox, classicism meant not so much depending on Greek or Renaissance models as achieving the close union of representation and abstraction that the ancient Greeks were the first to achieve and that was achieved again by the great masters of the Italian Renaissance. To him, a classical American art would be an art as clear, orderly and accessible as the art of the Greeks, even when

it dealt realistically with the everyday life of a world that the ancient Greeks never knew of or imagined.

Students of Van Gogh, Gauguin, Cézanne, and Seurat may find something familiar in these ideas. Cox and the Post-Impressionist painters were contemporaries, and he had more in common with them than historians and critics have realized. Like them, he regarded Impressionism as a dead end. Like them, he regarded the recovery of the formal elements of painting as one of the principal tasks of the artists of his time. To this extent, he, too, was a Post-Impressionist.

Where he differed from the artists of the European avant-garde was in his respect for the artistic standards upheld and propagated by the French Academy and the École des Beaux-Arts. To many Europeans, these standards were stifling, a window shut against life, light and truth. In France especially, rebellion against the Academy was itself a tradition that dated back to the 1830s. And though some of Cox's European contemporaries—Cézanne, Seurat—were beginning to realize that something important had been lost in this prolonged rebellion, others were turning even further away from

the high art of the West and seeking new inspiration in the primitive art of peasants and exotic peoples.

To Cox, however, and to many Americans of his generation, the traditional ideas and practices of the Academy were liberating, a window opening onto the great art of the past from which they, as Americans, had been cut off by the wide Atlantic and nearly a century of absorption in purely American tasks. Their rebellion (if such it was) was against the quirky home-grown art of nineteenth-century America in favor of something larger and more universal. They aimed to create a new American art that would express not just their own, but the American people's, deepest dreams and highest aspirations in a language that everyone could understand. To do this, they needed all the help they could get from everything valuable in the European past.

There is no doubt that Americans of Cox's generation were more optimistic than their European counterparts. They hoped to obtain for their work a kind of enlightened public support that the Europeans despaired of. The Europeans, looking back on a long succession of churches and palaces built and

adorned by the greatest artists for the princes and prelates of earlier times, believed that this kind of support for the arts was no longer possible. It seemed to them that the new patrons—the great financiers, merchants and industrialists of the nineteenth and twentieth centuries—lacked both the will and the knowledge to recognize and encourage great art; and without their support, the greatest artists were forced to work in isolation for themselves, while public acclaim, for what it was worth, went to mediocrities who worked not for art or for themselves, but for the market.

In these circumstances, many European artists tended to withdraw from public life to moral and intellectual positions that gave them at least the illusion of independence from (or even superiority over) the new public: art for art's sake, art for expression's sake, art for the sake of shocking the philistines, art as the product of seers and prophets that only a happy few could understand, art as the supreme value of civilization that the many must support though its benefits accrue only to the few.

Cox and his American contemporaries shared many of these ideas about art patron-

age in the past, but they were more hopeful of the future. Europe, old and decadent, might fail to recognize its greatest living artists, and they, driven mad by neglect, might reject their own artistic traditions. In America, however, Cox and his colleagues thought that things would be different. America was young and vigorous, rich and powerful, and, above all, the principal seat and workshop of democracy. Here a new art might arise that would have the support of the many without departing from the highest standards. Here the gulf between artist and public that had opened up in the nineteenth century might be closed, and art, which had once been the privilege of the few, could belong to everyone.

This was a glorious dream, worthy of young men starting out in life, and it seemed to many painters, sculptors and architects of Cox's generation that they were the ones to make it a reality. They were the first generation of American artists since the time of Washington Allston and Samuel F. B. Morse to study extensively in Europe; and when they returned from their studies, they found a newly rich people hungry for traditional culture and willing to pay for it.

They made their dazzling debut in 1893 with the richly ornamented buildings of the World's Columbian Exposition in Chicago; and for more than two decades after that, it seemed that nothing could stop them. All over the country, new state capitols, courthouses, libraries, banks, office buildings, theaters, private homes and entire civic centers were designed by American architects trained in the classical orders and decorated by Cox and his colleagues in a style that seemed to them to be, as Cox put it, "most characteristically American . . . in its conservatism, its discipline and moderation, its consonance with all great and hallowed traditions—in a word, its classicism."

During much of this time, Cox was also reaching the public through his writings. Before being gathered into books, his essays were published in the leading periodicals of the day (*Architectural Record, The Century, The Atlantic Monthly, Scribner's Magazine*) or delivered as lectures as leading American institutions of art and learning (The Metropolitan Museum of Art, The Art Institute of Chicago, Yale University). Even today, no one else writing in English can give the general reader such a clear sense of the

strengths and weaknesses of the great schools and artists of Europe and America; and in his time, his mastery of this genre was acknowledged even by critics who despised him as a painter and fought with him tooth and nail over the future of American art.

However, Cox seldom wrote in the mere spirit of art appreciation. He was the principal public spokesman for the painters and sculptors of the new American classicism, and most of his writing was devoted—directly or indirectly—to advancing its claims and recommending it to the new American public for art. A good example of his indirect approach is "The Golden Age of Painting," in which European painting from the High Renaissance through the seventeenth century is beautifully and suggestively surveyed as the source of all that is most valuable in the Western pictorial tradition. A good example of the more direct approach is "Some Phases of Nineteenth-Century Painting," in which Cox first contrasts nineteenth-century Naturalism with the more traditional nineteenth-century art that he favors and then, in a final essay on contemporary mural painting, delicately suggests that the spirit of true art moved

from France to America sometime around 1893. (In this, he anticipated the apologists of Abstract Expressionism by six decades.)

During most of his life, Cox saw Naturalism as the most immediate threat to excellence in painting. He could be as severe with academic draftsmen as with virtuosos of the loaded brush when he felt that they had fallen from a broad and classical approach into narrow Naturalism. And when he used the term "modern art," it was almost always to nineteenth-century Naturalism and its twentieth-century successors that he referred. However, in the last decade of his life, he became acutely aware of what *we* call "Modern Art."

Cox was fifty-six years old when a handful of American artists brought over from Europe more than five hundred recent paintings and sculptures representing the most "advanced" trends in European art and showed them first in New York's 69th Regiment Armory and then in other locations in Chicago and Boston. This was the new art that avant-garde European artists and critics like F. T. Marinetti, Wassily Kandinsky, Clive Bell and Roger Fry were hailing as the art of the future, the first new

European art to reach America since the art of Whistler and the Impressionists, and it is clear from Cox's writings that he had been reading about it and sympathized with the revolt against "an unintelligent literalism" in which it had its ultimate origins. But when the Armory Show gave him a first good look at the works themselves, he was appalled.

He saw the European art of the Armory Show not as a reaction against nineteenth-century Naturalism, which he could have supported, but as a revolt against everything that had been developed and practiced by Western artists since the time of Leonardo. He conceded that Cézanne, then already regarded as the founding father of the new art, had "some of the elements of genius," including "a sense of the essential squareness of houses and the essential roundness of apples." But Cox saw Cézanne as "absolutely without talent" and "absolutely cut off from tradition," and correctly predicted that Cubism would lead to pure abstraction and thus, in his view, to "the total destruction of the art of painting."

Needless to say, these opinions, which he expressed in a widely read review,[1] did not

endear him to the organizers and friends of the Armory Show; and when it came their turn to rewrite art history, they wrote him out of it except as a spokesman for all that was dusty and backward-looking in American cultural life. Yet it is clear today that Cox understood the implications of the Armory Show far better than they. The organizers of the show thought it would lead to freedom and recognition for the kind of representational painting that then passed for advanced art in America—for example, the painting of the Ash Can school. Cox thought it would lead to a possibly fatal upset in the balance between representation and abstraction that had characterized the art of painting from its beginnings up to that time and that, in his view, would always be necessary for a complete art of painting.

What it did lead to by the 1950s, when the generation now running the American art world was making its debut, was the painting of Jackson Pollock and the art criticism of Clement Greenberg. In 1904, Cox had written that Whistler had, in his late works, "sloughed off . . . everything that can be sloughed and leave a vestige of painting as an art of representation."[2] Pollock sloughed

off the last vestiges of representation, and there was nothing to see in his works but loops and swirls of pure paint. Greenberg also had forerunners in Cox's time: Kandinsky, Fry and Bell. They were the first to claim that representation was not essential to painting, though Bell was willing to tolerate it, providing it did not detract from the appreciation of "significant form," and Kandinsky still believed that painting was obliged, like music, to express complex spiritual states. Greenberg stripped the theory of painting of both these relics of the past, and painters who thought his ideas worth following were left with nothing to do but preserve the flatness of the picture plane.

Of course, the triumph of pure abstraction in American art was brief. It was largely confined to the decade of the 1950s. In the 1960s, the drip and spatter of Abstract Expressionism gave way to the soup cans and blown-up comic strips of Pop Art as the newest and most advanced thing, and all the representational elements of painting that abstractionists had banished returned, though in a form that owed more to commercial art and photography than to nature or the Old Masters.

[ xxvi ]

There even appeared a school of New Realists, repentant second-generation Abstract Expressionists who began to draw from the model and study the Old Masters. However, no one succeeded in explaining why this revival of representation was an advance over the pure abstraction advocated by Clement Greenberg; and without such an explanation, something was felt to be lacking. Thus, in 1974, Hilton Kramer, then chief art critic for *The New York Times* and a vocal supporter of the New Realism, complained that although realism did not lack its partisans, "it does rather conspicuously lack a persuasive theory. And given the nature of our intellectual commerce with works of art, to lack a persuasive theory is to lack something crucial."[3]

It may seem perverse to turn to Kenyon Cox, an early twentieth-century academician, for a satisfactory justification of the return to representation in late twentieth-century art. His failure to appreciate the virtues of Modernism arguably disqualifies him from speaking to us who are its children and who know so much better than he how crushing and complete its triumph has been. Yet it is precisely Cox's adversarial position

on the far side of Modernism that enables him to speak with such conviction across the wide gulf that separates his time from ours.

Cox always understood the importance of the formal elements of design and composition that the Impressionists and other nineteenth-century Naturalists jettisoned; and before the Armory Show, he consistently emphasized their importance as a corrective to the formlessness of purely optical realism. After the Armory Show, however, he was faced with the possibility that pure abstraction might prevail in painting, and he had to rethink or, rather, restate the relationship between the formal and the representational in such a way that justice would be done to both elements of painting.

The result was his essay "What Is Painting?" which lent its title to this volume. To my mind, this essay, if not the finest thing Cox ever wrote, is certainly the most useful one to artists and art lovers of the present day. It explains clearly and succinctly why purely abstract painting can never have the expressive power of representational painting. At the same time, it explains why even the most representational of paintings is necessarily "abstract." Such an explanation

is badly needed today and, together with Cox's writings on Winslow Homer and other classic painters, could help lay the groundwork for a new American painting.

NOTES

1. Kenyon Cox, "The 'Modern' Spirit in Art," *Harper's Weekly* (March 15, 1913). Reprinted in *1913—The Armory Show 50th Anniversary Exhibition—1963* (New York: Henry Street Settlement/Utica, N.Y.: Munson-Williams-Proctor Institute, 1963), pp. 165–168.

2. Kenyon Cox, *Old Masters and New* (Freeport, N.Y.: Books for Libraries Press, 1969), p. 252.

3. Hilton Kramer, "Seven Realists," *The New York Times* (April 28, 1974), sec. 2, p. 19. Quoted in Tom Wolfe, *The Painted Word*, (New York: Farrar, Straus and Giroux, 1975), p. 4.

# WINSLOW HOMER

# WINSLOW HOMER

## Preface

For the facts and dates of Homer's life I am indebted to "The Life and Works of Winslow Homer" by William Howe Downes, Houghton Mifflin Company, 1911. From this book, which I have accepted as the only authority on the subject, I have also borrowed a few quotations from John W. Beatty's "Introductory Note" and from Homer's own letters.

For the interpretation I have put upon the facts, and for the attempt at a critical estimate of Homer's art, I alone am responsible. Upon the validity of this estimate my little book must depend for its excuse for being.

But while the opinions expressed are my own they must often coincide with those expressed by other writers. If they did not the book might be original but would almost certainly be erroneous. I think I have said nothing because others have said it, but I have not had the vanity to refrain from

saying anything because it had been already said, or to attempt novelty at the possible cost of truth.

Kenyon Cox.

*Editor's note:* "Winslow Homer" was dedicated to Philip Littell, "whose criticism and advice on matters of style were invaluable to me."

# I

THE painters of America who have gained a certain definiteness and permanence of reputation—those whose names are as well known to dealers and collectors as are the names of leading foreign masters and whose pictures have an established and increasing commercial value—belong, almost without exception, to the generation which reached its majority shortly before the Civil War. The century and a half of painting in America may be roughly divided into three periods of approximately equal length. The first of our painters to attain any considerable eminence were purely English in origin and in training, and the earliest of them were, on the whole, the best; so that the first period may be called that of the decline of the English school in America. The second period was that of the slow evolution of a native school, and this school was on the verge of its highest achievement when the third or present period began; the period of a new foreign influence—mainly French—and of

[5]

the effort to adapt a technic learned in the schools of continental Europe to the expression of American thought and American feeling. We cannot yet tell how many of our painters belonging wholly to this last period may achieve a lasting fame. Those who seem already to have achieved it are of the time of transition, and their work marks the culmination of the native school and the beginning of the new influence from abroad.

Their birth dates fall very near together. The oldest of them, Fuller and Hunt, were born in 1822 and 1824 respectively, and Inness came in 1825. Then, after a gap of nine years, we have Whistler in 1834, LaFarge in 1835 and, in the one year 1836, Homer Martin, Wyant, Vedder, and the subject of this book, Winslow Homer. The mere list of names is enough to show the double nature of the work accomplished by the men of this generation. At the outset we have the sharp contrast between Hunt, the pupil of Couture and the friend of Millet, a teacher and a great influence if a somewhat ineffectual artist, making himself, from 1855 to his death in 1879, the apostle of that Barbizon school which was to affect, in greater or less degree, so many others of the

group; and Fuller, working by himself on his Deerfield farm, and emerging from obscurity in 1876 as the artistic contemporary of Hunt's pupils and of the young men whom Hunt's preaching had sent to Paris for their education. And the same contrast is repeated, in even sharper form, between Whistler and Homer; between the brilliant cosmopolitan who spent but a few years of his infancy and a few more of his youth in his own country, and the recluse of Prout's Neck; between the dainty symphonist, whose art is American only because it is not quite English and not quite French, and the sturdy realist who has given us the most purely native work, as it is perhaps the most powerful, yet produced in America.

Winslow Homer came of pure New England stock, being directly descended from one Captain John Homer who sailed from England in his own ship and settled in Boston in the middle of the seventeenth century. His father, Charles Savage Homer, was a hardware merchant in Boston, where Winslow was born on February 24th, 1836, and his mother, Henrietta Maria Benson, came from Bucksport, Maine, a town named after her maternal grandfather. She is said to have

had "a pretty talent for painting flowers in watercolors," and her son may have inherited his artistic proclivities from her. There were probably other seafaring men than the first Captain John among the Homer ancestry, and the artist's uncle, James Homer owned a barque and cruised to the West Indies. We cannot doubt that the love of salt water was even more deeply ingrained in Winslow Homer than the love of art, though it was not to show itself until rather late in life.

In 1842, when Homer was six years old, the family removed to Cambridge, and there his boyhood was spent. There was still much of the country village about Cambridge, and Homer and his two brothers lived the healthy life of rural New England, fishing, boating, swimming, playing rough games and going to school. An interesting memorial of this time is Homer's earliest existing drawing, reproduced in William Howe Downes's "Life and Works" of the artist, under the title of *The Beetle and the Wedge*. It represents Winslow's elder brother Charles and his cousin George Benson holding the younger brother, Arthur, spread eagle fashion by the arms and legs and about to swing his weight

violently against the rear of another inno-
cent youngster squatting on all fours in
the grass.

In the lives of artists one expects, as a
matter of course, tales of precocious talent,
but it is seldom that such evidence of their
veracity can be brought forward. Here is a
boy of eleven drawing from life, or from
memory of personal observation, a compo-
sition of four figures in complicated fore-
shortenings; indicating their several actions
and expressions with admirable truth and
economy; and, with a few lines and scratches
of shade, placing them in their setting of
sunlit pasture and distant hillside. Of course
the drawing is but a sketch and, equally of
course, the ability to make such a sketch
does not imply that of carrying it farther.
It was long before Homer could put into the
form of a definite and completed work of art
what is here suggested, but as a sketch, as a
rapid notation of the essentials of something
seen, it is such as Homer, or any other artist,
might, at any period of his career, have been
willing to sign. The essential Winslow Ho-
mer, the master of weight and movement, is
already here in implication. If many of the
"heap" of youthful drawings which the art-

[9]

ist preserved for thirty years or more were of anything like this quality it is no wonder that his father encouraged his aspirations, bought him Julian lithographs to study and, at nineteen, apprenticed him to one Bufford, a lithographer of Boston.

This was in 1855, and Homer thus became a practising artist without ever having been an art student. He seems to have been employed, at once, upon the better class of work turned out by the establishment, and to have designed as well as executed illustrated title-pages for sheet music and the like. During his apprenticeship he managed to pick up from a French wood engraver named Damereau some hints as to methods of drawing on the block, and when his two years were up—on his twentyfirst birthday —he took a studio of his own and set up as an independent illustrator. He worked at first for "Ballou's Pictorial" and later for "Harper's Weekly," and his connection with the latter periodical endured until 1875, while he continued to do occasional book illustration for several years longer.

There are many worse preparations for the career of a painter than the work of a hack illustrator. The illustrator must be ready to

draw anything and, if he takes his work seriously and does his tasks as well as he can, he is learning something every day. And he must concentrate his mind on his result, learn to tell his story and to make his intention clear. No one is so little tempted to the modern fallacy that the only business of a painter is to learn to paint, that the subject is of no importance, and that, if only one is a trained speaker, it matters little whether or not one has anything to say. The illustrator must always say something, whether he says it well or ill. He must make his picture, always, and a fresh picture each time, and his success will depend on the interest of the public in what he does, not on the approval by his fellows of the way in which he does it. Homer's work in black and white was, for the most part, independent of any written text and he seems, generally, to have chosen his subjects for himself. They are very varied and, in the course of his work as an illustrator, he experimented with almost every kind of subject he afterwards made his own as well as with many that he never rendered in color. He did not attempt the ideal or the romantic, but anything that he could see he was ready to draw, dealing impartially with

town and with country, and trying his hand
at well dressed ladies and gentlemen as at
barefoot boys and sunbonneted girls. His
first Adirondack studies, his first sea-shore
pieces, his first deep-sea scenes, appeared in
black and white.

Of the merit of Homer's drawing for illus-
tration it is difficult to judge. American wood
engraving was not, in those days, the fine
art that it afterwards became, and the blocks
on which he worked were cut with a mechan-
ical and somewhat dismal monotony. It is
only in the instances where a preliminary
water color sketch exists that we can judge
how much of beauty and of character was
sacrificed in reproduction. If his original
drawings direct upon the wood have lost as
much in the cutting they must have been far
better than we shall ever know. But what-
ever their artistic value, or lack of it, they
were of incalculable importance as a training
of the observer and the recorder of observa-
tions that Homer was.

In 1859 Homer came to New York, and this
city remained his home, when he was at
home, for twenty-five years. Here he at-
tended for a time the night class of the
National Academy of Design, and had les-

sons, once a week, on Saturdays, for a
month, from a French artist named Rondel.
They were the only painting lessons he ever
had, and in the catalogue of the Paris Expo-
sition of 1900 he duly appears as "*élève de
Frédérick Rondel*"; for in French catalogues
one must be a pupil of some one. He appears
for the first time as an exhibitor at the
Academy exhibition of 1860, with a drawing
of Skating in Central Park; probably a study
for, or a replica of, one of his illustrations for
"Harper's Weekly."

In 1861 Homer seems to have gone to
Washington to make drawings of Lincoln's
inauguration, and in the next year he was
certainly special artist for "Harper's Week-
ly" with McClellan's army in the Peninsula.
He was probably not more than three
months at the front, but his experience
during that time must have supplied him
with many more sketches and studies than
are represented in the drawings he sent
home, and from these studies he took the
subjects of his first pictures. In November
of 1862, "Harper's Weekly" published his
Sharpshooter on Picket Duty as "from a
painting by W. Homer, Esq.," and this, the
first of his works in oil, was followed by

Rations, Home, Sweet Home, and The Last Goose at Yorktown. The two latter were exhibited in the National Academy exhibition of 1863, and in 1864 Homer sent to the Academy In Front of the Guard House and The Briarwood Pipe and was promptly elected an Associate. The next year he exhibited The Bright Side and two other pictures and was made a full Academician, though this election is generally attributed to the reputation of Prisoners from the Front, then under way but not ready for exhibition. It appeared at the Academy in 1866, when the artist was thirty years old, and is one of a series of important pictures that mark off the decades of his life in a curious manner. This one may be said to announce the definite conclusion of his 'prentice years. They had been very short, and he was an Academician before any of his group except Vedder, who was elected in the same year, the author of an almost sensationally successful picture, and an artist whose work sold readily at such prices as were then current, all within four years from the beginning of his first painting.

There is something of a mystery about the present ownership of Prisoners from the

Front and it does not appear to have been shown in public since the sale of the John Taylor Johnston collection in 1876. It made a deep impression, at the time, not less upon the artists than upon the critics and the public. In 1876 Prof. John F. Weir called it "a unique work in American art" and thought it better than anything Homer had done in the intervening years; and LaFarge, just before his death, wrote of it as "a marvelous painting, marvelous in every way, but especially in the grasp of the moment." Was it not, above all, to this "grasp of the moment" that it owed its success? In technical merit it can hardly be greatly superior to The Bright Side, which is as much as to say that it must be still decidedly primitive. This latter picture represents a group of negro teamsters basking in the sun outside their tent. A certain piquancy is given to the composition by the placing of the head looking out from the tent-flaps above the loungers, but that is the only touch of purely artistic interest. The drawing is sufficient, no more; the color brown and heavy; the handling entirely without charm. The picture is interesting from its evident truth of observation in character and attitude—that

[ 15 ]

is, for its purely illustrative quality—but as painting it hardly exists. Given this same illustrative value, and a subject so interesting to the public of 1866 as that of the Prisoners from the Front, and we may account for the success of that picture without imagining it to have been much better painted than the other works of this time. They are works from which Homer's future could scarce have been predicted, and they would be already forgotten had not that future brought forth things of very different and vastly greater quality.

## II

IN spite of his precocious boyhood and his rapid success as a young man, Homer's talent as an artist ripened slowly. An Academician before he was thirty, he was forty when he produced the first of his pictures which has something of greatness in it, the first which is admirable in itself rather than interesting as marking a stage of progress; he was nearly fifty before he began the series of pictures dealing with the life of sailors and fishermen which showed him definitely as a great figure painter and an interpreter of humanity; and he was sixty when he painted one of the last and greatest of them. Finally, he was fiftyfour when he painted the first of those pictures of surf and shore, marines without figures or with figures of minor importance, by which he is best known to the great public; and ten or twelve years older when some of the best of them were produced.

If he had died at forty he would not now be considered a painter of any importance. If he had died at fifty he would be remembered as an artist of great promise and as the author of a few pictures in which promise had become performance. It is because he lived to be seventyfour that his career is the great and rounded whole we know.

There were reasons internal as well as external for this slowness of development, but the most important reasons were internal. It was, in a sense, the very sturdiness and independence of Homer's character, and the clearness of his vision of what he wanted to do, that kept him so long learning to do it. We have seen how little was the formal training he had, with what a slender equipment of previous study he set out to express himself in paint, and how his earliest works are saved from utter insignificance only by his native gift of observation, the manner of expression being worse than negligible. Now there were, even in the sixties, and even for a man with his living to earn by illustration or other hack work, opportunities for a fuller education in the technic of his profession than Homer chose to give himself; and if he had as little such education as a Chester

Harding, it was not, as in Harding's case, because there was none to be had, but because he would not have it. He was never docile enough to learn from others. While he was still a lithographer's apprentice in Boston he had said to Foxcroft Cole, "if a man wants to be an artist he must never look at pictures," and in that faith he lived and died. At no time of his career did he show much interest in the work of other men or betray any need of that give and take of discussion which forms what is known as an "artistic atmosphere," or of that criticism from those who know without which even a Donatello was afraid of deterioration. He stood alone and was sufficient to himself. When, after his first successes, he felt that he had earned a trip abroad, he went to Paris, in 1867, and spent ten months in that capital, but he did none of the things there that almost any other young artist would have done. He did not go into the schools, he did not copy old or modern masters, he did not settle in any of the artistic colonies or consort much with other artists; and if he looked at the pictures in the great galleries his subsequent work shows no evidence of it. He came back as he went, and two or three

illustrations of Parisian dance halls or of copyists at work in the Louvre and the title Picardie in the Academy catalogue of 1868 are the only things to remind us that he was ever in France.

The choice may have been right for Homer, but it was a choice that carried its penalties with it. A painter has, indeed, other things to do than merely to learn to paint, but he has, after all, to learn to paint; and to insist on discovering the way for one's self is often to take the longest road to one's destination. Homer did, in time, learn to paint sufficiently for his purpose, and though his work in oils always lacked the highest technical distinction it attained to a freedom and power of expression which fitted it admirably to his needs. But this evolution of an adequate method took a very long time, and for the next dozen years the interest in his pictures is rather in his experimental searching for the subjects that suited him than in any greatly increased mastery in his rendering of the subjects he selected.

Had Homer been actuated mainly by commercial considerations he might well have rested where he was, and have gone on, for some years at least, painting military sub-

jects. What he did was the contrary of this, and Prisoners from the Front appears to have been the last military picture he ever painted. To the same Academy exhibition in which it appeared he sent another canvas called The Brush Harrow. I know nothing of it except the title, but that title leads one to suppose that it was his first attempt at the treatment of American farm life. If any one could have painted that life, and have got out of it something equivalent to what Millet got out of the life of the French peasant, Homer was surely the man. The fact that he failed, as others have done, and has left nothing important in that field, is one more proof that the American farmer is unpaintable. His costume and his tools are too sophisticated to suggest the real simplicity and dignity of his occupation.

For the next few years Homer's subjects are very varied. He seems to be preluding in several directions, and we have, among others, such prophetic titles as The Manchester Coast, 1869, and Sail-boat, 1870. In 1872 he reverted to the memories of his boyhood and painted The Country School and Snap the Whip. This last is one of the most successful of his early pictures and has been

[ 21 ]

frequently re-exhibited. It is painted in a dry
and rather timid manner, with hot, brown
undertones, and possesses very little beauty;
but it makes such an impression of truth
that it is quite unforgettable. The drawing,
though awkward in details, is alive; the boys
are real boys and are really playing with all
their might; the landscape, with its little red
school-house, is thoroughly characterized;
and even the sunlight, though false in color,
is so well observed as to degrees of light and
dark, and casts shadows so true in shape, as
to be real, hard, glittering sunlight. It is
difficult to imagine anyone's loving the pic-
ture very much, but no one can help respect-
ing it. The Country School is a very different
production, a sketch rather than a finished
picture—the small figures so slightly painted
as to be transparent in places, allowing the
benches to be seen through them—but a
sketch possessing a breadth of tone and a
charm of handling exceptional in Homer's
work. But for the subject, it might almost
pass for an early Whistler.

Already, in such a work as Snap the Whip,
Homer is beginning to make us feel the glory
of out of doors, but to express it fully he
needed a larger and rougher sort of life to

paint, as well as a more mature manner of painting it. In 1873 he spent a summer on Ten Pound Island in Gloucester Harbor, the immediate result of which was some charming watercolors of coast scenes, including Mrs. Lawson Valentine's delightful Berry Pickers, and in 1874 he went, for the first time, to the Adirondacks. Here, in the life of hunters and guides, was matter to his mind, and his style rose with it. In 1876, when he was forty years old, he painted the first of what may be called his masterpieces, The Two Guides. The brown underpainting is still present, but the handling is larger and freer, with a directness and suppleness comparable to that of his later work. On a mountain ridge overgrown with scrubby bushes stand the guides, axes in hand, one, an old man with long gray beard, pointing out some landmark to his taller and younger comrade. Beyond the foreground ridge is a valley filled with fleecy cloud that rises in ragged shapes against the higher and more distant peak, and floats away to dissipate itself in the bright sunshine of a summer morning. The picture is full of the joy of high places and the splendor of fine weather. Nothing else that I know of in pictorial art

so perfectly expresses the spirit of Shakespeare's wonderful image:—

—"And jocund day
Stands tiptoe on the misty mountain tops."

More than once, in later years, Homer reverted to the camp life of the Adirondacks for his subjects but, to my mind, this first of the Adirondack series remains the finest of all. Indeed it was, for long, unmatched in its power by anything else he did. The year that it was painted, harking back to The Bright Side of eleven years earlier, he went to Petersburg, Virginia, to study the negroes again, and in that and the next year or two he painted The Visit from the Old Mistress, The Carnival, and several other subjects of Negro life; sober and excellent genre pictures, but certainly without the "Homeric" lift of his great successes. Then he is at Houghton Farm, trying again, and again failing, to find inspiration in the life of the American farmer; or at Gloucester and Annisquam, doing Schooners at Anchor and the like, but not yet feeling, or not rendering, the grandeur of the sea. His illustrations for "Harper's" ceased to appear a year before The Two Guides was painted; his occasional

book illustrations disappear after 1880; and
in 1881 began that experience which was, in
so many ways, decisive for him, his two
years' stay among the fisherfolk of Tyne-
mouth, near Newcastle, in England.

For even this most native of American
artists was deeply influenced by a foreign
sojourn, only it was a new view of nature that
affected him, not a new inspiration from art.
In this English fishing town his own peculiar
range of subjects was revealed to him; here
he first felt to the full the romance of the sea
and of those who go down to the sea in ships.
Here he first felt the majesty of the breakers,
the irresistible might of the surf. Here he
painted his first scenes of wreck and acquired
that sense, which never left him, of the
perils of the deep. And in Tynemouth, also,
he found, or perfected, his means of expres-
sion. The work he did during his stay there,
and after his return, is distinguished from
that which went before not merely by a
greater dramatic intensity and a broader and
more profound feeling, but by striking alter-
ations of style.

The first and most important of the effects
of the Tynemouth visit upon Homer's style
is the awakening in him of a sense of human

beauty and, particularly, of the beauty of womanhood. Hitherto he had made some unconvincing attempts at beflounced ladies in bustles and chignons, and had drawn, with much more feeling and veracity, certain slim Yankee girls in limp skirts and gingham sunbonnets. Now he saw for the first time, in these robust English fishwives, a type of figure matching in its nobility and simplicity the elemental forces of nature; a type which lent itself admirably to his love of weight and solidity. Not from art, but from life, he learned the meaning of classic breadth and serenity, and his idea of figure drawing was transformed and enlarged. The memory of this type remains ever with him, and henceforth his women be they nearly pretty or frankly ugly, are, like his men, grandly and generously built.

It may well be that the large, slow gesture of these figures had some influence in the sudden development in Homer of a sense of the rhythm of line. Certainly it is in his great Tynemouth watercolors that the possession of this sense is decisively announced. He had always a strong feeling for spacing; from the beginning he put his subject rightly upon his paper or his canvas, and balanced his full

and empty spaces with felicity. It is in such compositions as Inside the Bar and A Voice from the Cliffs that he adds to his pattern the element of flowing, leading and reduplicating lines, and becomes, what he remains, a master designer. A Voice from the Cliffs is as complete in its unified grouping of three figures as anything you shall find in art, and Homer himself could not improve upon it. Some four years later he took it up again, on a larger scale and in oils, when it became Hark! the Lark; but it lost as much in beauty by the absence of the great bounding-line of the cliff and, especially, by the omission of the boat and sail, which carries on so happily the line of the outstretched arms, as it gained in height and dignity by the addition of the lower part of the figures. Both are admirable compositions, but the earlier seems to me the finer of the two.

Another important element of Homer's art that seems to have come from his studies on the shore of the North Sea is his feeling for the beauty of atmosphere, the enshrouding mystery of air that is charged with moisture, the poetry of fog and mist. His earlier works were painted in the clear, sharp air of his native New England and, for the most part,

in full sunlight, and everything stands out in them hard edged and implacably revealed. In The Two Guides this glittering mountain clearness is exhilarating, but oftener it is rather distressing in its explicitness. At Tynemouth he learned to envelop his figures in fleecy softness and to place his landscape *in* the sky rather than in front of it. Something of the old hardness returns in one or two of his later pictures, usually where it intensifies the sentiment of the subject, and in his subtropical scenes he combines his old love of sunlight with that fullness of color which alone makes intensity of light bearable and beautiful; but his new sense of the enveloping atmosphere is a permanent acquisition, without which the creation of his great sea dramas would hardly have been possible.

These new and important elements of Homer's art, brought with them, of necessity, a new system of coloring and a new handling of material. The work he did during the two years he spent in Tynemouth was entirely in watercolor, so that the changes brought about in his method of painting in oil must be looked for in the pictures painted immediately after his return to America. In these pictures the brown under-painting has en-

tirely disappeared, the general tone becoming cool and silvery, while the paint is laid on directly with a free and full brush. It is henceforth modern painting that Homer practises, marked by nothing of the old timidity and thinness and showing, on the other hand, no search for technical niceties of any kind. He attacks his subject with forthright simplicity and sincerity, caring only for the truth of his representation and scarcely at all for the manner of it, and in this his art is characteristic of his time—of that latter end of the nineteenth century in which all the best of it was produced.

Thus, in matter and in manner, Homer has definitely found himself. After this time, though not all his work is of equal value, it is all mature work; all marked with the characteristics that his name calls up for us; all sealed with his seal. And though he is never to cease from experimenting, from going afield after new subjects and making new and surprising discoveries, yet he shows us only new aspects of one clear and decided personality. We have no longer to deal with fore-shadowings of the Winslow Homer that is to be, but with varying manifestations of the Winslow Homer that is.

# III

As if to signalize his arrival at the full maturity of his talent, Homer left New York in 1884, taking with him two unfinished canvases, The Life Line and Undertow, and settled himself at Prout's Neck, where he was farther removed than ever before from all extraneous artistic influences. There he made his home for the rest of his life, and there he painted all those pictures of his later years which have assured his fame.

Prout's Neck is a rocky promontory on the east side of Saco Bay in the town of Scarboro, Maine. What it is like no admirer of Homer's pictures needs to be told but, during much of his life there, it was not so lonely a place as one would be tempted to imagine. Arthur B. Homer had discovered the point in 1875 and regularly spent his summers there from that year. He was joined, later, by his father and his brother Charles, and Winslow had visited them there more than once before he decided to build a cottage and studio and make it his permanent residence. We are told that the Homers "bought up most of the land on the water front, and set out to develop the place systematically as a summer resort,"

[ 30 ]

with the result that, before the artist's death, there were sixtyseven houses on the neck and seven hotels. In such a place he could not lead quite the hermit-like life which legend has given him, but he was pretty effectually secluded from professional companionship, and as he grew older fewer people of any sort were admitted to his studio. He lived alone, cooking for himself and, it is said, cooking extremely well, and employing only a man who came in each morning to "do the chores." He was fond of a certain amount of manual labor, building stone walls, dog houses and the like, and cultivating an old fashioned flower and vegetable garden. At one time he even attempted to grow and cure his own tobacco and to roll his own cigars.

There is nothing surprising in the fact that Homer, who was now becoming more and more definitely a painter of the sea, should have chosen for his summer home a place where he could live continually with his chosen subject; but almost any other man would have retained a studio in the city for those months when even he found the climate of Prout's Neck too rigorous and its solitude too absolute. Almost any other man would have taken some pains to maintain his

[ 31 ]

relationship with his brother artists and to keep in touch with what they were doing. It is characteristic of Homer that when he retired to his sea-shore studio he shut the door after him. About 1888 he ceased to contribute voluntarily to the exhibitions or even to pay much attention to invitations to exhibit, and most of his pictures shown after that date were borrowed from owners or dealers. When Prout's Neck became uninhabitable he went south to Florida or the Bahamas and filled his portfolios with the wonderful watercolor sketches we know, and by March he was back again in Maine. Except for rare appearances, one or two of them for the purpose of serving on the juries of important exhibitions, his fellows knew him no more; and many of his younger contemporaries, myself among the number, never so much as saw the man.

Homer's first voyage to Nassau and Cuba took place in the winter of 1885–6, though the two important oil paintings of West Indian subjects, The Gulf Stream and Search Light—Santiago, were not finished until 1899. During these later years, also, his trips to the Adirondacks were repeated, and his search for study combined with recreation

took him into Canada, but the greater number of his pictures, exclusive, of course, of his deep-sea subjects, were painted not only in but of Prout's Neck, and the place is indelibly associated with his name.

The two pictures Homer took with him to Prout's Neck had been conceived in 1883 at Atlantic City, where he had gone especially to study the subject of The Life Line and where he witnessed the rescue from drowning which suggested Undertow, and they had been begun in his New York studio. The first was rapidly completed and exhibited in 1884, and the second was finished two years later. The series of works belonging entirely to his Prout's Neck period begins with the two great pictures of 1885 dealing with the lives of the Banks fishermen, The Fog Warning and The Herring Net. In 1886 Homer was fifty, and again the decade is marked off by a picture of especial importance. This time it is the noblest and the quietest of all his figure pictures, Eight Bells, and just ten years later he rose again to something like the same level of serene power in The Look-out—All's Well. The last of his pictures of seafaring life was the extraordinary Kissing the Moon of 1904. The series of great pictures

[ 33 ]

of rock and surf, in which the sea is itself the principal subject, the human figure being altogether absent or reduced to a minor role —the series which marks Homer as the greatest of marine painters—seems to have begun in 1890 with Sunlight on the Coast and the first Coast in Winter (there is another picture, of a year or two later, with the same title) and thereafter one or more such pictures can be placed in each year until 1897. After that date there are fewer of them, though the Early Morning after Storm at Sea is of 1902 and the last of them is the last picture he finished, the Driftwood of 1909. To name but the most important, the Luxembourg picture, A Summer Night, is of 1890; The West Wind is of 1891; High Cliff—Coast of Maine is of 1894; Cannon Rock and Northeaster are of 1895; and Maine Coast and Watching the Breakers of 1896.

There are those who object to the more dramatic of Homer's subject pictures, such as The Life Line and Undertow or the much later Gulf Stream for their "story-telling" quality. If, indeed, it is an artistic sin to be interested in life and death as well as in painting—to care for the significance of things as well as for their shapes and colors—

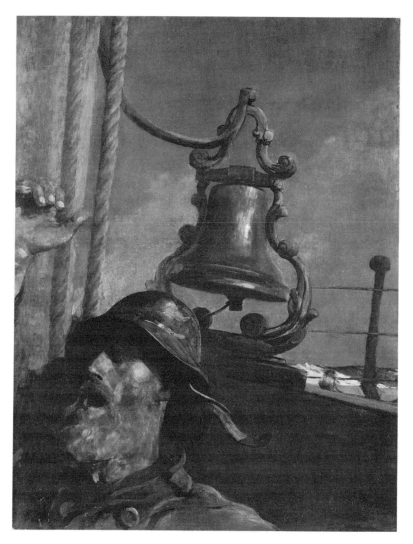

Plate 1. Winslow Homer, *The Lookout—All's Well.*
Boston, Museum of Fine Arts.
(William Wilkins Warren Fund.)

then Homer must bear the odium of this sin
with Michelangelo and Rembrandt and al-
most all the greatest artists of the world.
But, be it noted, it is never a trivial anecdote
that Homer tells, but a story of big and
simple issues and of powerful human appeal;
and it is never a special tale, needing knowl-
edge of something outside the canvas for its
comprehension. He attempts no complicated
narration but seizes upon a single moment,
in which all that it is necessary to know of
what has gone before or what is to come after
is implicit, and he depicts that moment with
the utmost directness and power, disencum-
bering it of all side issues and of all unimpor-
tant accessories. It is not whether an artist
tells stories that is important, but what
stories he tells and how he tells them, and I
know no pictures that could better serve than
these of Homer's as examples of the kind of
stories that are suited to pictorial telling and
of the manner in which such stories should
be told.

It is only in the first of them that the illus-
trative interest at all overbears that which is
more purely pictorial, and this is not because
of too much interest in the story, but because
the picture, as such, is not so perfect as those

of a little later date. The concentration of attention on the fainting figure of the woman, the energy in the attitude of the sailor who carries her, the sense of rapid motion conveyed by the diagonal line of the rope and the blowing scarf and gown—these are not faults but virtues, and virtues of a high order. One could perhaps wish that the gown were not torn quite where it is, but this is a fault of illustration, not a fault of painting. It is because neither the drawing nor the color are quite at Homer's highest level that the picture must take a second rank.

Undertow is quite as vivid and as gripping in the telling of its story as The Life Line, but its technical merits are far greater. The composition of the linked figures makes an admirable pattern, and the figure drawing is Homer's highest achievement in that line. Nowhere is his feeling for robust beauty so evident as in the almost classic proportions of the women clasped in each other's arms, and the only face clearly visible is like the face of the Greek Hypnos. It would be a great picture if it had no story at all—it is the greater because it has a thrilling story grandly told.

In this picture the artist's old delight in

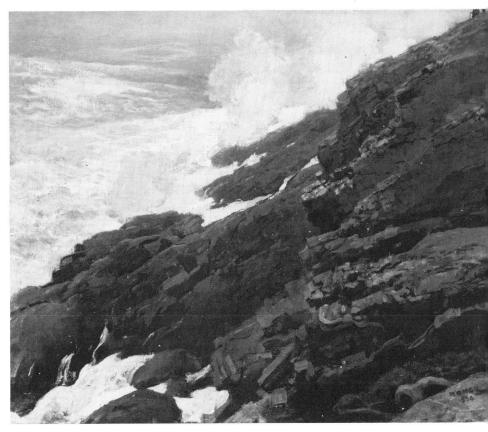

Plate 2. Winslow Homer, *High Cliff—Coast of Maine.*
Washington, D.C., National Museum of American Art,
Smithsonian Institution. (Gift of
William T. Evans.)

Plate 3. Winslow Homer, *The Gulf Stream.*
New York, The Metropolitan Museum of Art.
(Wolf Fund, 1906.)

hard and brilliant sunlight is put to use in intensifying, by contrast, the tragic character of the subject, and it is so used again in the deeper tragedy of The Gulf Stream; but even this most dramatic of Homer's pictures, superbly illustrative as it is, is by no means an illustration only. The figure of the starving negro on the dismantled boat is small and carelessly drawn, but the play of line through the whole composition is magnificent, the color is richer and more powerful than in anything else its author did in oils, and there are passages of sheer rendering, like the distant ship and the rainbow spray from the tail of the nearest shark, which are inimitable.

But it is where the story is least explicit—where there seems no story, but only masterly painting—that Homer's genius for the telling of his story is most wonderful. To paint a simple, every-day occurrence, a part of the routine of life, and by one's treatment of it to reveal its deeper implications and make manifest the dignity and the romance of the life of which it forms a part—that is what Millet did for the tillers of the soil and what Homer does for the fisherman and the sailor. Take, as an instance of this, The Fog Warning. Here is a halibut fisher rowing in with

his catch and, as his dory rises on the back of the long wave, looking over his shoulder to make sure of the direction of the schooner to which he is returning. Nothing could be simpler than the attitude of the man, rowing steadily and easily, and there is no suggestion of tempest or wreck in this dark sea barely breaking into a white-cap here and there under the influence of a fresh breeze. But across the horizon lies a long bank of fog, and from it rise diagonally two or three ragged streamers which show that it is beginning to move toward us. It is enough, and one is as conscious of the most insidious and deadly of the fisherman's perils as of the matter-of-course way in which it is met as a part of the day's work.

In the greatest of salt sea epics, Eight Bells, there is not even so much suggestion of danger. Here is a cloudy sky through which the sun breaks dimly, casting a gleam upon a flat and tumbled sea, and against it two or three lines of cordage show that the ship rides on an even keel. Upon the level deck stand two men in oilskins, the skipper and his mate, occupied with the most regularly recurring of their daily tasks, the taking of the noonday observation. They do it as a maid would

wash the dishes or as a farmer would hoe his corn, yet one is made to feel to the full the importance of this daily act upon which the safety of the ship depends. Exactly in the routine nature of the business seems to lie a great part of its significance, and the whole life of the sailor is included in it.

It is in reality this same gift of story telling —this faculty of dwelling on the essentials of the subject and of excluding or subordinating less important things—that makes Homer's surf pictures the triumphs they are. Whistler could make The Blue Wave, or some of his late sea pieces, bits of pure decoration. Homer, also, was not insensible to this decorative beauty of the sea, as he has shown now and again, but generally he seizes upon the weight and bulk of water, upon the battering and rending power of the wave, as upon the things essential to be told, and these things he depicts as no one else has ever done. There has never been any difference of opinion about this latest phase of Homer's art, and his pure marines are universally accepted as the greatest ever painted. Yet I think the kind of genius that created them is present in even fuller measure in the finest of his figure pictures.

After 1900 Homer's powers may be said to have been on the decline. He was still to do things that we should be sorry to lose, but his greatest pictures were painted, and his inspirations came more rarely. He had never allowed himself to work by formulae, and he could not go on painting from sheer inertia. He had always been dependent upon the immediate suggestion of nature or on the vivified memory of such suggestion, and was apt to feel, after each period of exhausting creation, that there were no more inspirations to come, and that his work was done. As early as 1893, just after the receipt of that gold medal of the Columbian Exposition which was the first of those honors which fell thickly upon his declining years, he wrote: "At present and for some time past I see no reason why I should paint any pictures." These moments of lassitude—one can hardly call it despondency, for he was fully conscious of the value of his work—became more frequent as he grew older, and more than once he declared his intention of painting no more. In 1907, a month or two before he finished in two hours of strenuous work from nature that Early Morning after Storm, begun two years earlier, which seems to strike

a new note of beauty in his work, he wrote to Miss Leila Mechlin: "Perhaps you think I am still painting and interested in art. *That is a mistake.* I care nothing for art. I no longer paint. I do not wish to see my name in print again."

The inspirations always returned and he always began again to paint. Even after his first serious illness, in 1908, an illness which made him, for a time, nearly blind and nearly helpless, he would stay in his brother's house for only two weeks. Leaving a note behind him he departed, early one morning, to resume work in his studio.

He had, however, little more to do there. He partly recovered from this first illness, and in 1909 he painted two or three canvases which have all his old originality and unexpectedness if not all his old power. The next summer he began to fail visibly, but maintained that he was "all right" and wanted nothing but to be left alone. When at last he had to take to his bed he refused to be moved from his own house, and there, where all his greatest work had been done, he died on the twenty-ninth day of September, 1910.

## IV

So FAR as we can judge by his effect upon us, his contemporaries, and without waiting for the verdict of posterity, Winslow Homer was unquestionably a great artist. He has given us pleasures and sensations different in kind from those which we have received from other artists of his time and, perhaps, superior to them in degree. He has shown us things which, without his eyes, we should not have seen and impressed us with truths which, but for him, we should not have felt. He has stirred us with tragic emotion or, in the representation of common everyday incidents, has revealed to us the innate nobility of the simple and hardy lives of hunters, fishers and seafarers. Finally, he has realized for us, as no other artist of any time has done, the power and the grandeur of the elemental forces of nature, and has dramatized for us the conflict of water, earth and air. His genius has been felt alike by artist, by critic and by layman, and it has been acknowledged almost as fully by that contemporary posterity, intelligent foreign opinion, as by

the universal assent of his countrymen. No other American painter of his generation has been so widely recognized except that one who was, in temper and accomplishments, almost his exact antithesis, James McNeill Whistler.

For, surely, no greatly successful artist ever had less care than Homer for those decorative and aesthetic qualities which Whistler proclaimed, in theory and by his practise, the whole of art. There is nothing gracious or insinuating, hardly, even, anything reticent or mysterious, about the art of Homer. His pictures will not hang comfortably on a wall or invite you discreetly to the contemplation of gradually unfolding beauties. They speak with the voice of a trumpet and, whether they exhilarate or annoy you, you cannot neglect them. They have none of the amenities of the drawingroom, and you might almost as well let the sea itself into your house as one of Homer's transcripts of it. Even in a great gallery they often seem too strident, too unmitigated, too crude. If they do not conquer you they surprise and disconcert you.

But this asperity has no kinship with the vulgar noisiness of those painters who, think-

ing of the conflict of the exhibitions, determine to outshout their fellows that they may be heard. Homer is not thinking of exhibitions, to which he seldom cared to send, any more than he is thinking of the final destination of his picture on someone's walls. He is not thinking of an audience at all, but only of the thing he has seen and of his effort to render it truthfully. He places himself in direct competition with nature, and if his work seems harsh or violent it has become so in the effort to match nature's strength with his own. He painted directly from the object whenever that was possible, and it was often possible to him when it might not be so to another. He painted his All's Well entirely by moonlight, never touching it by day or working over it in the studio. He had a portable painting house constructed, that he might work from nature in the bitterest weather, and he used to hang a canvas on the balcony of his studio, in the open air, and study it from a distance "with reference solely," as he said, "to its simple and absolute truth." This habit of fighting nature on her own terms he carried into work that must necessarily be done from memory, and his studio pictures show the same pitting of his

powers against those of nature as do his direct
transcripts from the thing before him. He
knew quite well that pictures so painted
could not be properly seen on the walls of a
house or gallery, and he once advised a friend
to look at one of his canvases, then in a
dealer's window, from the opposite corner,
diagonally across the street.

And if Homer has nothing of Whistler's
aestheticism he has almost as little of Inness's
passion or of Homer Martin's reverie. Com-
pared to such men he is quite impersonal.
He has no lyrical fervor; makes no attempt
to express his own emotion or his own mood.
His is the objective attitude of the dramatist,
and however much nature may stimulate or
excite him, it is her passion and her mood
that he is trying to render, not his own. He is
too obviously capable of such excitement,
and too dependent upon it for his best results,
to be called a cool observer—let us rather call
him an exalted observer; but an observer and
a recorder of things observed he essentially
is. He is a kind of flaming realist—a burning
devotee of the actual.

Being such an observer he was always
making the most unexpected observations,
and painting things that were not only un-

painted till then but, apparently, unseen by anyone else. His watercolor sketches, in which he set down with astonishing succintness and rapidity the things he saw, are a vast repertory of such surprises; but even in his more deeply considered and long wrought pictures he is constantly doing things of a disturbing originality—painting aspects of nature which another, if he had seen them, would consider unpaintable. For Homer is afraid of nothing and trusts his own perceptions absolutely, having no notion of traditions that must not be violated or of limits that cannot be overstepped. That he has seen a thing, and that it interested him, is reason enough for trying to paint it. Whether he fails or succeeds is hardly his affair—whether the result is pleasing or the reverse is nothing to him—"I saw it so; there it is."—The next time it will be a new observation, and until there is a new observation, he will paint no more.

Many men have sat by a camp fire at night and have enjoyed, in a dreamy way, watching the long curves of light cut into the blue darkness by the ascending sparks. Who but Homer would have made them not an accessory but the principle subject of a picture?

Who but Homer has seen or painted such a thing as that flock of ravenous crows, starved by the long winter, hunting a live fox through the heavy snow which retards his superior speed—one of the most superb animal pictures in the world, yet produced by an artist who has painted no other? He wishes to paint the sea by night, the foam of breakers dark against the glittering wake of the moon. Who else would not have feared to disturb the serenity of nature by the presence of figures, or would have dared more, at most, than the black, almost formless, group of silent watchers on the rocks? Homer cuts his foreground with the long, straight line of the platform of a summer cottage or hotel, and places on it, illumined by artificial light and so large as to become almost the principal subject of the picture, two girls waltzing together. They were there; he saw them and painted them so, and he triumphs. The girls and the sea dance together, and the very spirit of A Summer Night is fixed upon the canvas. Everyone has seen the moon rise at sunset, and many men must have seen the figures in a boat when the boat itself was hidden in the trough of the sea. If any painter saw it, before Homer painted his Kissing the Moon, he

assuredly thought the subject impossible. Homer admits no impossibilities, and having seen it he painted it, the three heads red against the gray-green sea and the moon like a fourth in the group, only a touch and a sweep of light on the shaft of an oar to indicate that there is anything to support these solid figures in their strange position. You gasp, once, at the unexpectedness of the impression, and then accept it as obvious truth.

These surprise pictures are not always, or necessarily, Homer's best; some of his greatest successes are attained when dealing with subjects that anyone might have chosen. But in his treatment of such subjects there is always the sense of new and personal vision; the things have not been painted by him because others had painted them, but rather in spite of that fact. He has seen them afresh for himself, and he does not choose to be deterred from painting them because others have seen them also. In a hundred little things you will have the evidence of the lucidity, the acuity and the originality of his observation. The unexpectedness is merely transferred from the whole to the details.

Such being the observer, the recorder of

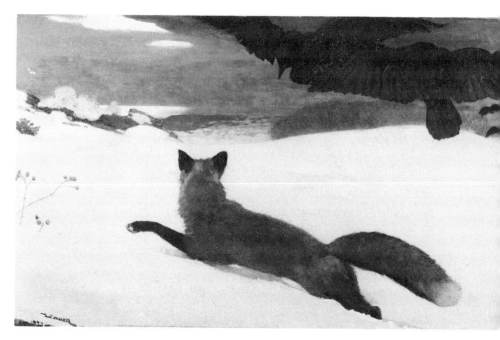

Plate 4. Winslow Homer, *The Fox Hunt.*
Philadelphia, Pennsylvania Academy of the Fine Arts.
(Temple Fund Purchase.)

observations spares no pains to make his record as truthful as possible. He will not trust his memory or his notes any farther than he must. He will produce as nearly as possible the conditions of his original observation, that the details may be filled in with his eye upon the object; and he will do this not because his memory is weak, but rather because it is so strong that he is sure not to lose sight of his original impression while verifying the details by renewed experiment. The studio in the old University Building in Washington Square, which he occupied from 1861 to 1884, was a room in the tower with a door opening upon the flat roof of the main building where he could pose his models beneath the sky. Most artists of his time painted, as most artists still do, direct from the model; and many of them would have been glad of his opportunity to paint in the open air. Not many, perhaps, would have pushed the love of exactitude so far as he did when he painted the figures of his Undertow from models kept wet by continual dousing with buckets of water kept at hand for the purpose. This reminds one of some of Meissonier's expedients for securing accuracy; the result was different because Homer had a far

[ 53 ]

firmer grasp of the total effect than Meisso-
nier ever possessed, and did not allow his
pursuit of minor facts to obscure his vision
of the essential ones.

There are other tales of his scrupulousness,
such as his propping up the dory of The Fog
Warning, at the necessary angle, against a
sand dune on the beach and posing his fisher-
man model in it; or his modelling in clay the
ship's bell of All's Well when he could not
find one to his mind in the junk shops of
Boston; but more impressive are the evi-
dences of another kind of scruple, an anxiety
for exactitude of effect which reminds one
more of Monet than of Meissonier. He often
waited weeks and months for just the effect
he wanted, and seemed to his intimates
unreasonably idle, because he could not go
on with the picture he was interested in and
could paint nothing else until that was com-
pleted. Shooting the Rapids, now in the
Metropolitan Museum of New York, was
begun in 1904, and Homer expected to
complete it easily as he had made many
studies for it; but he could not satisfy himself
without another trip to the Upper Saguenay
to restudy it from nature, and it remained
unfinished at the time of his death. The Early

Morning after Storm at Sea was two years on his easel and, during that time, was the subject of a rather voluminous correspondence with the dealers who had ordered it. Homer's excuse for delay is always that he must "have a crack at it out of doors," as he is not satisfied to work from his original study. In March of 1902 he writes: "After waiting a full year, looking out every day for it—I got the light and the sea that I wanted; but as it was very cold I had to paint out of my window, and I was a little too far away— it is not good enough yet, and I must have another painting from nature on it." Finally, seven months later, he writes again: "The long looked for day arrived, and from 6 to 8 o'clock A. M. I painted from nature— finishing it,—making the fourth painting on this canvas of two hours each."

To Homer's own consciousness this acuteness of perception and this thorough and pains-taking realization were all there was to his art. He had no patience with theories and would seldom talk about painting at all. A fellow artist, since distinguished as a mural painter, once tried to express his admiration for the composition of line and space in Homer's pictures, but he found the master

blankly unresponsive and inclined to deny
the existence of any such qualities either in
his own work or elsewhere—professing, in-
deed, not to know what was meant by the
language employed. This can hardly have
been affectation in him—one cannot conceive
Homer as affected in anything. He seems
honestly to have believed that it is only neces-
sary to know how to see and, above all, to
know a good thing when one sees it, and then
to copy the thing seen as accurately as possi-
ble. He believed that he altered nothing and
said to Mr. John W. Beatty: "When I have
selected a thing carefully, I paint it exactly
as it appears." It is an illusion shared by
other painters of our day, and one can see
how Homer might have cherished it with
regard to his marines—how, having chosen
well, he might not consciously change so
much as the line of a rock crest or the color of
the shadow under the top of a wave. It is
more difficult to see how he could have been
unaware of the powers of arrangement and
interpretation implied in the creation of his
figure pictures, but he seems to have been so.
He was not averse, upon occasion, from men-
tioning the merits of his work, but it is always
accuracy of observation and of record that

he praises; and if we accept his own estimate of himself it is as a gifted reporter that we shall think of him, hardly as a creator.

# V

IT IS, of course, quite impossible to accept such an estimate as final. Extraordinary as are Homer's powers of observation and of record, such powers will not, alone, account for the effects he produced. A veracious reporter he undoubtedly was, but he must have been something more and other than a reporter however veracious. His great pictures are either intensely dramatic or grandly epic, and neither dramatic intensity nor epic serenity were ever attained by veracity alone. They are attainable, in pictorial as in literary art, only by style. If the effects are great the art must be great in proportion; if the effects are vivid the style must be keen and clear; if they are noble the style must be elevated. Consciously or unconsciously, Winslow Homer was an artist, and it becomes a matter of interest to examine the elements of his pictorial style, to test their weakness or strength, to determine, if possible, by what means his results are attained. Beginning with the least important of these elements let us study his technical handling of his material, his employment of the medium of

oil painting; then his treatment of light and color; then his draughtmanship, his knowledge of and feeling for significant form; finally, reaching the most fundamental of artistic qualities, let us consider his composition and the nature of the basic design to which the other elements of his pictures are added or out of which they grow.

While felicity in the handling of material is the least important of artistic qualities it is by no means without importance. Without his extraordinary virtuosity Frans Hals would be a nearly negligible painter, and the loss of his exquisite treatment of material would considerably diminish the rank of even so great a master as Titian. Or, to take a more modern instance, think how much of Corot we should lose with the loss of his lovely surfaces and his admirably flowing touch. Homer's technical handling of oil paint is entirely without charm, and it is abundantly evident that he triumphs not through but in spite of it. Mr. Beatty has said, meaning it for praise: "No one, I think, was ever heard to talk about Homer's manner of painting, or about his technical skill, as of special importance." He is so far right that no one has found Homer's technic, in the limited sense

of the word, a reason for liking or admiring his paintings, but many have found it a reason for disliking them; and to some of the artist's most sincere admirers his technical limitations remain a stumbling block in the way of their free enjoyment of his great qualities. In his early work his handling is hard, dry and timid. Later it attains to force and directness, and sometimes to great skill, but never to beauty. It is perhaps at its best in such a picture as The West Wind, where the sureness of touch and economy of means are striking and, to some degree, enjoyable. The picture looks as if it had been painted in a few hours, without a wasted stroke of the brush, and its workmanlike directness communicates a certain exhilaration. But this impression of spontaneity, which is the highest pleasure Homer's handling is capable of giving, vanishes with further labor, and there is nothing to take its place. His surfaces become wooden or wooly, his handling grows labored and harsh and unpleasing. At best his method is a serviceable tool; at less than its best it is a hindrance to his expression, like a bad handwriting, which one must become accustomed to and forget before one can enjoy the thing written.

If Homer's color is not, like his workman-
ship, a positive injury to his expression it
seldom reaches the point of being a positive
aid to it, at least in those great paintings
which are the most profound expressions of
his genius. In both color and handling his
slighter sketches in watercolor reach a stand-
ard of excellence he was unable to attain in
the more difficult medium. Many of his
marines are little more than black and white
in essential construction, and are almost as
effective in a good photograph as in the orig-
inal. In The West Wind, for instance, the
whole of the land and the figure that stands
upon it are of a nearly uniform brown, while
the sky is an opaque gray, of very little
quality, brought down to the edge of the
earth in one painting. Across this the white
of the breakers is struck with a few frank,
strong touches. The contrast of brown and
gray, of transparent and opaque, is pleasant;
but the whole expression of the picture is in
its shapes and its values; its color, as color,
is nearly negligible. This is an extreme case,
yet in most of the coast scenes the color is
really of little more importance, though the
perfect notation of degrees of dark and light
often gives an illusion of color which is not

actually present. In some of the figure pictures color is carried further. In The Herring Net and Eight Bells the grays of sky and water are much more subtly modulated, the dull yellows of the sailors' oilskins are very true and delicate, and, in the former picture, the rainbow gleams of the fish in the net are a fascinating element in the total effect. Once or twice, where the lowered key of moonlight has helped him—in All's Well for example— Homer comes near that unification of all the separate notes of a picture by one prevailing hue which we know as tone, and at least once, in The Gulf Stream, he reaches towards a fully orchestrated harmony, the blues, especially, in that picture, being superbly rich and varied.

But to understand how far Homer's color, even in these examples, is from that of the true colorists, we have only to compare his work with that of such contemporaries and compatriots as Inness and Martin. Inness's harmonies are full, vibrant, rich, including, on occasion, both extremities of the scale. Martin plays a more delicate flute music, full of tender modulations and tremulous sweetness. But in both the color is the very texture of the work which could not exist without it.

With Homer the color, at its best, is an agree-
able ornament which he can very well dis-
pense with.

And if Homer was never extraordinarily
sensitive to color, there is some evidence that,
in his later days, he became partially color-
blind. This evidence first appears, curiously
enough, in the richest piece of full color he
produced in oils, The Gulf Stream. That pic-
ture was a long time in his studio, and he may
well have added the unexplained and unre-
lated touch of pure scarlet on the stern of the
boat at a time when his sight was beginning
to fail. Certainly the scarlet is so vivid, and
so without visible reason or connection with
other things, as to suggest that he did not see
it as we do, and that his eye was growing
insensitive to red. In his latest work this
scarlet spot recurs more than once, and is the
more startling from its appearance in con-
nection with a coldness and harshness of
general tone that would of itself suggest a
state akin to color blindness.

There can, on the other hand, be no doubt
whatever of the strength of Homer's native
gift for form and for expressive line. Almost
from his childhood he made drawings which
have the incisive truth, in attitude and ex-

pression of the sketches of a Charles Keene, and, after his Tynemouth studies, his figures, especially of women, attain a grandeur and nobility of type which makes them almost worthy to be compared with the majestic figures of Millet. In no other part of his art does he show so much sense of beauty as in some of these grave and simple figures with their ample forms, their slow gesture, their quiet and unforced dignity of bearing. At its highest level his drawing of the male figure is, if less beautiful, almost equally impressive; and his grasp of attitude is almost infallible. Whatever his people are doing they do rightly and naturally, with the exact amount of effort necessary, neither more nor less, and with an entire absence of artificial posing. Infallible, also is his sense of bulk and weight. His figures are always three-dimensional, and always firmly planted on their feet—they occupy a definite amount of space, and yield to, or resist, a definite amount of gravitation or of external force.

These are among the greatest gifts of the figure draughtsman, and there can be little doubt that Homer had the natural qualifications for a draughtsman of the first order. But no man, whatever his natural gifts, ever

mastered the structure of the human figure without a prolonged investigation of that figure disembarrassed from the disguise of clothing. A profound and intense study of the nude is indispensable to the mastery of its secrets, and for such study Homer had little opportunity and less inclination. He received no training from others and, in the confidence of his strength, failed to appreciate the necessity of giving it to himself; and his figures, though right in bulk and attitude, are often almost structureless. This lack of structure is seldom so painfully apparent as in the rounded pudginess, like that of an inflated bladder, of the woman in The Life Line, but even in his best figures there are regretable lapses and passage of emptiness. The arms of the three girls in A Voice from the Cliffs are beautifully and naturally arranged, but they are not what a trained draughtsman could call arms—there are no bones or muscles under the skin—and even the figures in Undertow, his most strenuous and most successful piece of figure drawing, are not impeccable, not without regions of woodenness or puffiness.

Perhaps wisely, he never again made such an effort—for at fifty, if ever, it is time to use

the acquirements one has rather than to strive for new ones—and his figure drawing relapses, in his later work, into summary indications, sufficient for his purpose but slighter and slighter in structure.

But if Homer had neither the right kind nor the right amount of training for the figure draughtsman, he had the only right and true training for the draughtsman of rocks and waves, and no one has ever drawn them better. Constant observation had taught him all that it is needful to know of their forms, and had fully supplemented his natural gifts. No one has so felt and expressed the solid resistance of rock, the vast bulk and hammering weight of water, the rush and movement of wave and wind. It is the suggestion of weight and movement that makes his figure drawing impressive in spite of its lapses—it is in the suggestion of weight and movement that his drawing of land and sea is unmatched and unsurpassable.

A sense of weight and of movement is, however, much more a matter of design—of the composition of line—than of drawing in the usual meaning of that word. Indeed, the sense of movement can be conveyed by nothing else but composition. The most

accurately drawn figure of man or horse or
bird will refuse to move unless its lines, and
the lines of surrounding objects, are so ar-
ranged as to compel the eye of the spectator
to follow the direction of the desired move-
ment. It is by composition, therefore, that
Homer obtains his effects of movement, and
it is by composition that he obtains all his
great effects. From the very first he shows
some of the qualities of a master designer; he
always places his subject rightly within the
rectangle of his border, he always balances
felicitously his filled and empty spaces; and
as his power of observation becomes more
and more acute his power of design keeps
pace with it, his most original observations
being infallibly embodied in equally original
designs.

An admirable instance of the expressiveness
of Homer's composition, at a comparatively
early date, is the little watercolor of Berry
Pickers of 1873. At first sight it is a simple
transcript from nature, with little style in
either the drawing or the color, yet it is full
of a charm difficult to account for. And then
one notices that the lines of all the subordi-
nate figures lead straight to the head of the
taller girl, standing alone on the left, and

that she has a blowing ribbon on her hat. The line of that ribbon takes possession of the eye, which is carried by it, and by the clouds in the sky, straight across the picture to the other end where, so small as to be otherwise unnoticeable, a singing bird sits upon the branch of a bare shrub. By that subtle bit of arrangement the air has been filled not only with sun and breeze but with music, and the expression of the summer morning is complete. That Homer himself may have been unaware of what he had done is suggested by the fact that when he reproduced this composition, reversed by the engraver, in "Harper's Weekly" he utterly spoiled it by the introduction of another figure, at what has become the left, which disturbs the balance and attracts the eye away from the bird. Whether the change was made to please the publishers, or for some other reason, the music has gone and the picture is dead.

Now look at a quite late picture, The Search Light of 1899. It is almost totally without color, and has not even that approach to unity of tone which moonlight sometimes enabled Homer to attain. In handling it is poor and harsh, and there are no objects in it which require more of the draughtsman

than a fairly correct eye for the sizes and shapes of things. Yet the picture is grandly impressive. How is this impressiveness secured? It can be by nothing but composition, and by composition at its simplest. The perfect balancing of two or three masses, the perfect coördination of a few straight lines and a few segments of circles, and the thing is done—a great picture is created out of nothing and with almost no aid from any other element of the art of painting than this all important one of design.

It is always so with Homer. The gravity, the
· sense of serious import, the feeling that the action in hand is one of great and permanent interest, not a trivial occupation of the moment, is given to Eight Bells by the masterly use of a few verticals and horizontals. The rush and swoop of The West Wind is a matter of a few sweeping and reduplicating curves. The patterns of The Fox Hunt and All's Well are as astonishingly fresh and unexpected as the observations they contain and control.

Perhaps the greatest test of a designer is his use of little things to produce unexpectedly great effects, and a remarkable instance of this is to be found in The Gulf Stream.

Remove the trailing ropes from the bow of the tubby boat and its helpless sliding into the trough of the sea will be checked, the ghastly gliding of the sharks will be arrested, and the fine wave drawing will not avail to keep the picture alive and moving.

In Homer's mastery of design we have a quality which is, if not precisely decorative, preëminently monumental; a quality which explains the desire, once expressed to me by La Farge, that Homer might be given a commission for a great mural painting; a quality which makes one regret the loss of the mural decorations he actually undertook for Harper and Brothers. In this mastery of design we have, undoubtedly, that which gives Homer his authoritative and magisterial utterance; that which constitutes him a creator, that which transforms him from an acute observer and a brilliant reporter into a great and original artist. A poor technician, an unequal colorist, a powerful but untrained draughtsman, his faults might almost overbear his merits were he not a designer of the first rank. Because he is a designer of the first rank he is fairly certain to be permanently reckoned a master.

# VI

In that chapter of his "Your United States" which deals with art in America Mr. Arnold Bennett tells us that one of his reasons for coming to this country was his desire of seeing the pictures of Winslow Homer, that when he saw them he did not like them, but that, coming upon an exhibition of Homer's watercolors, he was forced to reconsider his judgment. He found "these summary and highly distinguished sketches" to be beautiful, thrilling and "clearly the productions of a master." One may guess that Mr. Bennett did not see the best of Homer's pictures in oil as, assuredly, he did not see much else in American art that might, or should, have interested him; but it is quite possible that further study would have left him of the same opinion, and that he would still have considered the watercolors superior to the oils. If he did so he would only be in line with a great deal of modern opinion which prefers the immediacy and vividness of the sketch to the ponderation of the considered picture, and which rates the multitude of Millet's draw-

[ 71 ]

ings and pastels higher than The Gleaners
or the noble Woman with Buckets in the
Vanderbilt collection. Indeed, there is better
reason for such a preference in the case of
Homer than in that of Millet, for Millet was,
what Homer never quite became, a master
of oil painting, and could give a richness of
color and a beauty of material to his pictures
which Homer was quite incapable of em-
ulating.

Homer's earlier watercolors are neat, care-
ful, rather tinted than colored, but pleasanter
and far more skillful than the oil paintings of
the same period. The transparency of the
washes and the deft decisiveness of touch
give them a charm and sparkle proper to the
medium. They are already the production of
a more competent workman than their au-
thor ever became in the sister art. The Tyne-
mouth series, not all of which were painted
in Tynemouth, for some of them are dated
several years after the painter's return to
America, differ from both the earlier and
later work in being complete pictures, care-
fully composed and elaborately wrought. As
such one thinks of them in their place among
the other compositions of their creator, not
with the rapid and astonishing notes and

sketches of his later years. It was a collection of these later sketches that Bennett saw and admired. It was by a collection of such sketches that Homer chose to be represented at the Pan-American Exposition of 1901. It is by these sketches that many artists and many critics of today would consider Homer most likely to be remembered.

There must be reasons, more or less valid, for a preference so vividly felt—felt, at times, by Homer himself—for these watercolors over his more elaborate works in oil, and one of these reasons I have already touched upon; it is Homer's extraordinary technical mastery of the medium. If, from the first, he painted better in watercolors than he was ever able to do in oils, it may be said that, in the end, he painted better in watercolors— with more virtuosity of hand, more sense of the right use of the material, more decisive mastery of its proper resources—than almost any modern has been able to do in oils. One must go back to Rubens or Hals for a parallel, in oil painting, to Homer's prodigious skill in watercolor, and perhaps to the Venetians for anything so perfectly right in its technical manner. His felicity and rapidity of handling is a delight, and to see the way, for instance,

in which all the complicated forms and fore-shortenings of the head of a palm tree are given in a few instantaneous touches, each touch of a shape one would hardly have thought of, yet each indisputably right in character, is to have a new revelation of the magical power of sheer workmanship. Even Sargent's stupendous cleverness in water-color is not more wonderful, though Sargent seems to be thinking a little of the brilliancy of his method, whereas Homer is thinking, single-mindedly, of the object or the effect to be rendered, and is clever only because he is sure of what he wants to do and seizes instinctively on the nearest way of doing it.

And this swiftness and certainty of hand is delightful not merely for its own sake but because it insures the greatest purity and beauty of the material. The highest perfection of oil painting depends upon complicated processes which are almost impossible to the painter from nature, impatient to set down his observations while they are immanent to his mind; and these processes our modern painters have, for the most part, forgotten. The perfection of watercolor depends, large-ly, upon directness and rapidity. The mate-rial is never so beautiful as when it is washed

in at once, with as little disturbance by reworking as may be, the white paper everywhere clear and luminous beneath and between the washes. It is the ideal material for rapid sketching from nature because the sketcher, instead of sacrificing technical beauty to directness of expression, gains greater beauty with every increase of speed. Therefore, for the fastidious in technical matters, Homer's sudden notations of things observed have an extraordinary charm which comes of the perfect harmony between the end sought and the means employed. The more his mind is fixed upon the rendering of his impression and the less he thinks of his material the more beautiful his material becomes. The accuracy of his observation, the rapidity of his execution and the perfection of his technic increase together, and reach their highest value at the same moment. The one little square of paper becomes a true record of the appearance of nature, an amazing bit of sleight of hand, and a piece of perfect material beauty; it gives you three kinds of pleasure, intimately related and united, and each in the highest degree.

Following from this technical superiority and closely connected with it is the second,

and more important, superiority of Homer's watercolors; they are vastly more beautiful in color than are the best of his oil paintings. Oil painting, in its perfection, is capable of a depth and splendor of color which watercolor painting can never equal, but oil painting as it is generally practised today, and as Homer practised it, is relatively poor and opaque in color, muddy and chalky or brown and heavy. Almost any watercolor painter, if he will refrain from emulating the solidity of oil paint and eschew the use of Chinese white, can attain a purity and brilliancy of tone which is very rare in modern oil painting. A master of the material, like Homer, capable of striking in a hue with its full intensity at once, with just the gradations and modulations he wishes it to have, can make every particle of his color sing, and can reach effects either of force or tenderness that are impossible to the flounderers in that pasty mass which modern oil painting too readily becomes.

Of course the use of a particular method does not radically alter the nature of the man who employs it, and so, although Homer's color is far better in these watercolor sketches than in his oils, he does not, even in them,

become, in the full sense of the words, a true colorist. He is never one of those artists for whom color is the supreme and necessary means of expression. His art does not live in color and by color as the art of a musician exists in and by musical sounds; but, aided by the beauty and transparency of the material, he shows himself in his watercolors, as he seldom does in oils, an acute and daring observer and recorder of the colors of nature. He is not expressing deep emotions in color, writing lyrics or composing symphonies; he is only telling you what he has seen. But he has seen all sorts of surprising things, sometimes beautiful, sometimes strange, often violent and almost savage, and he tells of them with a perfect impartiality and in a language of the utmost perspicuity and vigor. The intense blue of a tropic sea, the red and black of a stormy sunset, the spots on the gleaming sides of a leaping trout, the deep plumage of a wild duck—all these things are set down at a white heat, swiftly, sharply, decisively, before the impression has faded, and they are set down, therefore, with the greatest truth, the greatest vividness, the greatest intensity.

It is, finally, this immediacy of impression,

this instantaneousness of vision, even more than the beauty of technic or the purity of color which are its accompaniments, that is in itself the great charm of Homer's water-colors. And the diversity and multiplicity of his observations are as remarkable as their freshness and their truth. Apparently there is nothing he has not seen and painted at one time or another. Figures, landscapes, sea, boats, architecture, still life, the shadow of the North Woods or the pitiless southern sun; about all these things—about anything, from a dashing cataract to a lemon on a plate—he can tell you something new and unexpected. He is one of the greatest observers that ever lived, and in these sketches you may watch him at his work, catch his excitement at the discovery of some new effect or some hitherto unnoticed truth, see what he saw and feel what he felt, with the least possible impedi-ment between his mind and yours. No won-der Arnold Bennett found such sketches thrilling. You are reading the note books of a sort of reporter *in excelsis* of nature's doings, and you are delighted with his accuracy, astonished at his variety, overwhelmed by his prodigal abundance. If you share the modern love for facts and have anything of

the modern carelessness of art you will ask for nothing more, and will prefer such notes to any possible work of art that might be constructed from them.

If, on the other hand, you are one who feels that a complete work of art is something different from and more than a sketch, you may still enjoy these sketches intensely while asking for your fullest satisfaction something more definitely designed and more deeply considered. With all their brilliancy these amazing notes are only notes, and Homer was capable of something more than notes. Hundreds of these sketches were set down for their own sake and never referred to again. Many of the oil pictures seem to have had no specific preparation, but to have been begun directly from nature or from a memory enriched by the constant study of nature. But now and then one can identify the original watercolor sketch and the picture painted from it, and then one can see clearly the defects which are an inevitable accompaniment of the merits of such sketching. You cannot have at the same time, and in the same work, the merits of the sketch and of the picture; and if the picture is inferior in spontaneity to the sketch it is as manifestly

superior to it in concentration and power. In the Memorial Exhibition of Homer's works, held at the Metropolitan Museum in 1911, the original watercolor of Hound and Hunter and the final painting of the same subject hung together, and the comparison of them was instructive. At first sight the watercolor was the more taking. It is exhilarating in the fresh sparkle of its handling, and the color, if not rich or intense, is clear and cool. The oil picture seemed heavy and snuffy by contrast and, as mere painting, rather uninteresting. Yet the oil picture is almost inexplicably impressive and remains firmly fixed in one's memory while the watercolor has faded from it. The difference is in countless little changes which have transformed a bit of reporting into a masterly design. Everything has been so adjusted and so definitely fitted into its place that the result is that sense of permanence and of unalterableness which is perhaps the greatest feeling a work of art can produce.

It is this relative lack of design which makes the watercolor sketches of Homer, perfect though they are as sketches, inferior to his great compositions in oil. They are marvelous, they are admirable, they are distin-

guished, but they are sketches. They remain the small change of that great talent which could produce Eight Bells or The Fox Hunt. In their sharpness of seeing, their vivacity of handling, their luminous and intense coloring, they give a different pleasure from that which we receive from the masterpieces—a pleasure, at times, even more keen—but, as I think, a pleasure of a somewhat lower kind.

It is, however, a matter of very little importance whether we like better Homer's watercolors or his oil paintings, since it is the same man who produced both. And, indeed, the difference between his performance in the two mediums is a difference of degree rather than of kind—a difference of relative emphasis only—the whole Homer being, after all, necessary to account for anything he did. The consummate designer of the great compositions based his design upon the same acute observation that delights us in the sketches; the brilliant sketcher, though he does not carry design to its ultimate perfection, is yet always a born designer, so that almost any one of his sketches has the possibility of a great picture in it, and his slightest note is a whole, not a mere fragment. To lose any part of his work were to lose

something that no one else can give us. Add to the broad humanity, the power of narration and the magnificent design of his major works the exhaustless wealth of his masterful and succinct jottings of natural appearances, and you have the sum of Winslow Homer—surely one of the most remarkable personalities in the art of this or any country in the latter part of the nineteenth century.

# CONCERNING
# PAINTING

*PART I*

WHAT IS PAINTING?

# I

## PAINTING AS AN ART OF IMITATION

THE task I have here set myself is to con-
sider what the art of painting essentially
is and how it resembles or differs from
the other fine arts and, so far as I can, to
determine in what desires or instincts it
originates and to what faculties of the hu-
man mind it appeals.

In such an inquiry there is always a danger
that one may form a theory on an in-
sufficient knowledge of the facts and bind
oneself by a premature definition and thus,
arguing from false premises, get further
from the truth in proportion as one argues
logically. One of the most curious instances
of such an error is in a book which made a
sensation in its day—Tolstoi's "What Is
Art?" In that book Tolstoi began by
formulating a plausible definition of art
and then, by powerful and perfectly logical
reasoning from that definition, demon-

strated to his own satisfaction that many of the world's heroes of art, Shakespeare and Beethoven, Michelangelo and Titian, were either not artists at all or were bad artists while the maker of child's dolls is a good and true artist. Strangely enough, the extraordinary nature of his conclusions does not seem to have awakened any doubt in his mind as to the validity or the adequacy of his definition. At the present time there is an immense amount of such theorizing going on about art, and particularly about the art of painting, which seems to take no account of the history of the art it is concerned with. It has long been a commonplace with the makers of theories that painting should tell no stories; it is now proclaimed that painting should not paint anything, and that the art is just about to reach its final and proper form by the "defecation"—the word is not mine—of its representative element.

If we wish to avoid errors and extravagances, we must examine the art of painting as it is and has been. If we can find out what have been its most permanent characteristics throughout the long ages during which it has been practised and in all the

countries in which it is practised to-day, we may, perhaps, reasonably assume that these characteristics are those most essential to its nature. It is only from a knowledge of what painting is that we may hope to generalize as to what it should be, and if we dare risk any definition it must be at the end of our inquiry, not at the beginning.

The history of painting, and of its twin art, sculpture, is as long as the history of mankind—it may even be said to be longer, for we know something of these arts as they were practised by primitive races of men about whom we know little but what their carving and their painting reveal to us. Perhaps as early as 100,000 B. C., at any rate during the quaternary period, which is supposed by geologists to have ended about ten or twelve thousand years before the beginning of the Christian era, a race of men inhabited the caves of western Europe who lived by hunting and fishing. They were vitally interested in the animals on which they lived and they have left a series of remarkable representations of these animals carved in bone, drawn with

[ 89 ]

incised lines upon bones and antlers, or painted in colors upon the walls of their caves. The carvings seem to be a little older than the drawings and to show that sculpture, as has been the case in all subsequent periods of art, developed before painting; but the arts are largely contemporaneous and clearly differentiated, and the pictures on the walls are true paintings, not merely outlined but attempting color and some degree of light and dark. The paintings and drawings represent the mammoth, the reindeer, the salmon, the wild horse, the bison, and the boar with singular truth of form and with a truth of action which has never again been attained until our own day.

What is most curious about these paintings, however, is that they are purely naturalistic and imitative, with no trace of a decorative motive, or an ornamental arrangement. There has been some speculation as to whether these representations may not have had a magic purpose, and have been intended to give the delineator power over the thing delineated, and from what we know of the ideas of primitive man the supposition is a likely one; but it is evident that such a supposition will not

account for the origin of the art. Man
must have learned to make an image of
things before he can have thought of that
image as giving him power over the things
themselves. He must have made the first
images in obedience to some deeply im-
planted instinct, and that instinct one
must believe to have been another form of
the instinct of imitation which controls
the play of children and which originated
the art of acting. Some modern researches
into the art of savages seem to show that
even those patterns which are apparently
most meaningless originated in some imi-
tation of natural forms, and that the earli-
est art of all primitive peoples was like
the earliest art we know, an art of realism.
What is certain is that painting, as a
separate art, was already in existence at
the almost inconceivably remote period of
the cavemen, and that it was an art of
representation.

This race of cavemen seems to have died
out and to have been succeeded by other
and alien races. In the bronze age, though
there was a civilization in many ways much
more advanced than that of the cavemen,
there seems to have been little art except a

form of decoration by incised lines which have for us no representative value. If there was anything like painting, it has not come down to us, and what attempts at sculpture we know are of the grossest and most rudimentary description.

Anything that we can recognize as painting emerges for the first time from its long eclipse in the art of ancient Egypt, somewhere about 4,000 years B. C., and it emerges as it disappeared an art of representation. Egyptian painting differs in many ways from the art of the cavemen. It is vastly inferior to it in its representation of life and movement. In many technical matters it is superior. It is from the first extremely conventional in its manner of drawing and in the number of attitudes it admits, and it grows more conventional rather than less, but it introduced man for the first time as the principal subject of art. The whole life of man from the King on his throne to the tiller of the fields, his actions and occupations, his houses and tools and costumes, his knowledge of this world and his beliefs as to the next, is depicted for us on the walls of temples and of tombs.

From the earliest Egyptian art to the art of our own time the history of painting in all countries is fairly well known to us. There are gaps in it where much has been destroyed, but there is always enough remaining to give us some fair notion of what the destroyed art must have been. And in all countries and all ages the art has been essentially the same. It has flourished at one time and decayed at another, it has been practised differently by different races and nations, it has varied enormously in the materials employed, in the method of employing them, and in the degree of imitation attained, but the object has always been the same. In all times the painter has striven to represent, as truly as his knowledge, the materials at his disposal and the conventions of his time would permit, things and actions existing or conceived of as existing. In all times which we think of as times of progress in art there has been an increasing truth of representation, as in the Italian Renaissance from Cimabue to Titian. In the times we think of as the great epochs of art there has been a high degree of such truth. In the times we think of as the times of decadence there

has generally been a lessening of such truth.

From the whole history of art as we know it, we can only conclude that, in its essential nature, painting is the art of representing on a plane surface (in contradistinction to sculpture which works in three dimensions or, as we say, in the round) the forms and colors of objects. Its origin is in the instinct of imitation. Its most fundamental appeal —not necessarily its highest appeal but its most universal and necessary one—is to the sense of recognition. What first of all pleases us, in looking at a painting, is the recognition of the thing represented and of the truth of the representation.

From all this it might seem that the more exact the imitation of nature, in all particulars, the more pleasure the imitation will afford; and that the best painting is that which most nearly attains to an exact imitation. This conclusion has been drawn again and again, and by men whose knowledge and intelligence are sufficient to give their opinions great weight. Did not Leonardo da Vinci himself, one of the greatest of painters, proclaim that the finest paint-

ing is that which most nearly resembles the reflection of nature in a mirror? Yet the experience of mankind has, I think, conclusively proved that this is not true, and that, entirely apart from those non-imitative qualities of art which we are to consider later, in the nature of pictorial imitation itself, it is not the imitation in all respects the most exact which affords the greatest pleasure.

Let us take, for an example, an art rigidly limited in its degree of imitation by the nature of the means employed, like Greek vase-painting. The vase-painter had no tools but a fine pointed brush and black paint. He was limited to such truths as he could represent with lines or with a few flat masses, that is, to truths of contour. He could give no idea even of the color of objects, still less of the light that falls on them or the shadows cast by them, of their surrounding by air or of their softening by distance. Yet if the contours he drew be true in themselves the eye will at once recognize and rejoice in that truth as fully as if all other truths were added. It may even recognize that truth more rapidly and rejoice in it more fully because there

are no other truths to distract the attention. Add to the truths of contour so much truth of color as may be given without regard to light and shadow and you have as much truth as has satisfied the Oriental nations and nearly as much as satisfied the Greeks and the artists of mediæval Europe.

But it is not only from the limitations of the material employed or from lack of knowledge that artists have abstained from complete and exact imitation. In the development of the art of painting from the early Renaissance to our own day, new orders of truth have been added one after the other to its domain. To truths of contour and of the colors of objects have been first added truths of form as shown by light and shade, giving roundness and projection, and truths of color as affected by light and shade, marking the difference between colors in light, in shadow, and in reflection; then truths of light and shadow for its own sake, not merely revealing form or varying color, but even disguising form and color; finally truths of light and of air as of an ambience in which all things exist and by which all things are visible.

But as each new order of truth has been

added there has been some loss in the sharpness with which the old truths have been expressed. In the first place, as the artist's attention has been fixed on one truth he has felt less interest in the others; in the second place, as he has wished to direct the attention of his public to one truth he has deliberately neglected others; in the third place, he has found that the expression of the various orders of truth in their highest degree, in any one work, is physically impossible, one order of truth obscuring another, fulness of light and shade obstructing the perception of the contour, and clearness of line interfering with the expression of light and shade. We have therefore, in all art, a number of voluntary or necessary abstentions, and the more sure a painter is of what he wants to do the more certain he is to avoid close imitation of those qualities of things which are not to his purpose. We know that the very same Leonardo who declared that painting should be a mirror, refrained from painting whole categories of truth which he had seen and noted, and we know why he did so. In his note-books there are careful descriptions of effects painted only in our own day, and

very clear explanations of the causes of them. He saw the blue shadow of the impressionists and knew why it is blue. He saw the cold light on the tops of leaves, the golden green of transmitted light when the same leaves are seen from below, and the interruption of this light where the shadow of one leaf falls upon another. And when he has described all these things, with the acuteness of the most modern observer of effects of light, he adds: "These things should not be painted, because they confuse the form."

Any one who knows much of modern painting and of the painters of to-day will know how completely this attitude has been reversed. Our contemporary artists have for the most part come to look upon explicitness of form almost with horror, and to consider definition of contour as a grievous fault. If they were asked why they hate a definite or what they would call a hard line, those of them who are capable of giving a reason would say: Because it interferes with the representation of nature's light and nature's mystery. They are perfectly right from their point of view, but so was Leonardo from his. There never has been and there never can be a complete

art of painting, a perfect imitation of nature. There are only partial imitations in which one or another truth is gained by the sacrifice, in greater or less degree, of all the rest.

Not only is anything like an exact imitation of nature impossible for these reasons and for others—such as that nature's range from light to dark is many times greater than the range between white paint and black, that nature's detail is so intricate and minute that the human eye cannot follow it or the human hand render it, that at all points nature escapes from us and defies our poor means of imitation—but an exact imitation would not be desirable even were it possible. Now and then, by careful limitation of the subject-matter of painting to what is most nearly imitable, by a suppression of the individual preferences of the artist, and by exhaustive study and painstaking labor, something measurably like true imitation has been attained, with the result that the beholder is left unmoved and almost uninterested. The reason of the ineffectiveness of such fairly exact imitation is not far to seek.

We have seen that the fundamental ap-

peal of imitative art is to the sense of recognition, but as it is obvious that we can have no pleasure in the recognition of the thing itself, which we perform unconsciously and automatically at every waking moment, so we get little from the recognition of a reflection of it which is so like as to be indistinguishable from the thing. It is only as the reflection is different from the thing reflected that it interests us. The mere reversal from right to left of the reflection in a mirror may yield some slight interest. The reflection of a landscape in still water is much more interesting because its difference from the real landscape is greater. That nature should seem upside down is a much greater difference from its normal appearance than that it should be merely reversed from right to left, and besides this, reflections in water are generally different in degree of light and in color from the objects that cast them and, if the standpoint of the beholder is much above water-level, are different in form also because seen from a different angle. The presence of the landscape itself enables us to measure these differences, and we receive a degree of pleasure from the

recognition of the same objects under new aspects.

Even a striking difference in scale, in the apparent size of things, may afford something of this pleasure. I remember that, as a child, one of my treasured possessions was a diminishing glass, or double-concave lens, made from the bottom of a broken tumbler. I would sit for hours in the "back lot" behind our house gazing through this bit of glass and taking delight in the recognition of familiar objects reduced to such tiny dimensions. Something of this pleasure we get from miniatures and statuettes, and their small scale is undoubtedly a part of their interest for us. But a perfect imitation of nature would not be like the image in a diminishing glass or that reflected in water or in a mirror; rather it would be like a bit of nature seen through a perfectly clear window-pane. Whatever pleasure this bit of nature might afford us, through its essential beauty or interest, such an image would also afford us, but it would not give us any specifically artistic pleasure— any pleasure differing in kind or degree from that afforded by nature. The func-

tion of the artist would be reduced to the making of duplicates which we might enjoy in the absence of the original scene. We have seen that painting cannot make such duplicates, but it can do something much more to the purpose. It can make us sharers in the superior organization of the painter, can reveal to us in painting things we should not have seen for ourselves in nature, or make us recognize more instantaneously and more poignantly qualities of things that we should, if left to ourselves, have perceived much more slowly or dully.

The business of the painter as imitator is to give us, temporarily, the benefit of his power of vision, of his training and knowledge, of his perception of the significance of things, and by so doing to give us an unwonted sense of physical and mental efficiency which is in the highest degree pleasurable. We feel ourselves, for the moment, possessed of clearer senses, of more lively emotions, of greater intellectual powers, than we had imagined; we live more intensely, and rejoice in our perception of this intensity of life. This the painter effects by a selection of the

characteristics of objects to which he wishes to attract our attention, dwelling upon the things he wishes us to see and eliding those he does not wish us to concern ourselves with, exaggerating here and suppressing there, consciously or unconsciously falsifying his representation in a thousand minute particulars so as to force us to see what he sees, not what we see when unaided, and giving a greater semblance of truth by his very infidelity to fact. His rank as an artist will depend largely upon whether the truths to which he directs us are important and essential or unimportant and trivial, and also upon the degree of exaggeration which he finds it necessary to use, the greatest artists usually employing delicate and restrained exaggerations while lesser men resort to exaggerations which are violent and extreme.

The aim of the great draftsmen of the human figure, for instance, is to make us feel in the sharpest and clearest manner its form and structure, its movement or action, the articulations of its bony framework, and the stresses and relaxations of its muscles and tendons. For this purpose a myriad of trivial and unnecessary

details are ignored or slighted, the great forms are selected and dwelt upon, every line and touch becomes charged with the highest significance, and the bosses and hollows are so far exaggerated that we become acutely conscious of them and feel that we could pass our hands over them and follow the undulations of the surface with our finger-tips. This is what Berenson means by "tactile values," the stimulation through the eye of the sense of touch, and he is quite right in thinking it one of the most important elements in the art of figure-painting.

And now another and a curious exercise of the imitative faculty is brought about. We become the imitators of the imitation, and feel inspired to put ourselves into the attitude so clearly realized for us; we feel in our own bodies the stresses and the relaxations we have been made to observe, and through feeling these are put into the mental state that caused them. By painting bodies the artist has forced us to paint souls. By the representation of the forms and movements of the human figure Michelangelo has made us feel the languid rousing into consciousness of the

new-made Adam and the creative energy of the outstretched arm of the Almighty from whose finger flows the vivifying spark.

It is by a similar process of elimination and exaggeration that all the miracles of art are produced. It is by slight accentuations and slight suppressions that the portrait-painter makes us divine the character of his sitter. It is by such means that the colorist reveals to us the beauty of nature's hues and the chiaroscurist the mystery of nature's light and shade. By dwelling upon those changes in appearance which mark the recession of objects into distance, Perugino can give us a sense of infinite space in which we move and breathe freely and feel, as Berenson has said, "at one with the universe." By dwelling upon the mystery of shadow Rembrandt can cause us to feel the mystery of life, and by a deepening of nature's gloom and a heightening of nature's radiance he can make us aware of the presence of the supernatural. In all these ways pictorial representation may be life-communicating and life-enhancing, and may therefore give us that highest of pleasures,

the sense of superiority to our ordinary selves.

As men imagine things unseen always in the terms of things seen, their wildest fancies being but the shifting and the recombination of the elements of known objects, the beings imagined by men are as much within the purview of imitative art as are the beings of the actual world. The painter of little imagination constructs these beings by the mechanical union of the separate parts of existing beings, each of these parts being literally copied from the thing itself. The painter of profound imagination feels what would be the nature and the character of a being uniting the characteristics of two or more actual beings, and by selection and exaggeration so modifies all the parts of things which he copies as to conform them to the compound nature. He thus gives to his imagined beings a life of their own, realizes and externalizes them, and forces us to believe in their objective existence. From man's loftiest conception of spiritual power, as in gods and angels, to his most terrible or most playful fancies, as in devils and

mermaids and hippogriffs, we accept them unquestioningly, saying "so they must be, they cannot be otherwise." And thus believing, for the moment, in the reality of these beings and feeling profoundly and instantaneously the imaginative truth of the representation of them, we get the pleasure of recognition and of a sense of our enhanced power of perception and appreciation in an even greater degree than we can get it from the picture of real and familiar things. When we look at Blake's plate of the "Morning Stars Singing Together," we feel that we, too, can see heavenly visions; when we gaze at Boecklin's grotesque monsters we feel that we, too, have voyaged in strange waters and know a siren or a sea-centaur when we meet them. Have we not all lived among those strange feathered creatures of Hokusai's and *seen* them carry bundles on their preposterous, elongated noses?

The selective imagination thus deals alike with the creations of fancy and with the world of reality. As it forces you to see and recognize the things that are not, so, in the things that are, it forces you to see and to recognize what it chooses. All rep-

resentative art proceeds by so selecting, accenting, or suppressing facts as to make us see more vividly the qualities of things than we could do by our own efforts; but there are two great categories of artists distinguished by those qualities of things upon which they dwell and which they cause us to recognize.

One set of artists, in representing any object or person, will be most interested in noting the differences between that object or person and all others of the same kind; the other set of artists will be most interested in recording the likeness of the object or person to others of its kind. One school deals with the individual, the other with the typical; one with character, the other with beauty. We call these two categories of artists realists and idealists, and we are apt to think that realism and idealism are much more opposed in their methods than they actually are. We think of the realist as attempting exact imitation and of the idealist as hardly imitating at all. But, as we have seen, the attempt at exact imitation is essentially inartistic. The true, or imaginative realist is as far from attempting pure imitation as the

[ 108 ]

idealist and selects as carefully as he the qualities of things on which he shall insist. And the idealist finds in nature the things he selects for accent as surely as does the realist. When the realist tells you: This particular man had such a mouth and nose, and this oak-tree was so twisted and thwarted by salt winds; when the idealist tells you: Thus is man made and this is the form of an oak; they are each but selecting from the multiplicity of the real what shall express and enforce their idea of truth. The extreme of what one may call the realistic ideal, the ideal of the expression of individual character at the expense of the typical and the universal, is the art of caricature, and it is obvious that caricature is further removed from literal imitation than is the loftiest idealism. Realism and idealism are but the modes of selective imitation. Their difference is not that one selects and the other does not, or that one imitates and the other does not, but only that they select and imitate different things. Either mode of selection may give us a masterpiece; on the one hand, a portrait by Rembrandt; on the other, a Madonna by

Raphael. And no artist was ever consistently idealist or realist, for the habitual idealist will now and then delight in some trait of individual character, the habitual realist afford us some glimpses of typical beauty.

As painting represents not only objects but actions, as it represents not merely men and animals, but men and animals doing as well as existing, it cannot, if it would, avoid telling stories. The instant you admit into painting any action whatever, no matter how simple, you admit some suggestion of what went before the action and of what is to follow it and of the cause and intention of the action— that is, you admit some element, however slight, of story.

Indeed, it is difficult to paint so much as a piece of still-life without hinting at a story; for if the objects chosen are congruous and such as might naturally come together, their collocation will suggest some reason for their being where they are, if it is no more than that dinner is preparing; while if the objects chosen are such as would not naturally be found together,

the spectator is set to wondering how they came there and to inventing some tale to account for their assemblage. If he sees a beefsteak and a spilled pipe, he will think the cook is untidy; if he sees a dead fish and a lady's fan, he will speculate as to why the mistress left her fan in the kitchen.

You cannot paint a landscape without story-telling, for the mere indication of the hour of the day or of the season of the year will bring to mind the hours or the seasons preceding and following the hour or the season chosen. If you have been successful in giving any life to your land-scape, it will have a sense of continuousness and progression, and will tell the story of the change of the year, of the dawning of the day, or of the coming on of night. If there are any houses in your picture, or any tilled fields, they will tell something of the history of man. If it is perfectly wild nature that you have painted, that fact will tell the spectator that man has not yet come, or has come for the first time in his person, he being the explorer of that solitude.

With any representation of the human

figure the difficulty of avoiding a story becomes still greater. Indeed, it becomes so impossible that I have not been able to discuss significant figure-drawing without showing how, in the hands of a great master like Michelangelo, it can tell the mighty story of the creation. But so far from trying to avoid story-telling, the figure-painters of all times and countries have told stories with all their might, and one may almost say that the greater the artist the more determinedly has he set himself to tell stories. They have not only told stories of that generalized type which they could not well avoid—stories of the life of man and of his habitual actions— but they have told stories of the most specific kind, they have recounted their country's history and, above all, its myths and legends, the tales in which it has crystallized its philosophy and its religion.

Look where you will, to the art of the Egyptians and the Assyrians, the art of the Greeks and Romans, the art of the Chinese and the Japanese, you will find nothing but stories, stories, stories. The artists of the Renaissance covered the walls of their churches with the stories of the

Bible, and Raphael and Michelangelo told more stories and told them better than the others. The Venetians told Bible stories, too, or retold in their own language and for their own day the old tales of Greece and Rome. The Protestant Rembrandt told the old stories over again in a new way for a people that did not particularly want them and preferred its own portrait. The French painters of the eighteenth century told light and lascivious tales for a frivolous society, and Hogarth told moral tales for the serious British public. The classicists told stories seriously and sometimes pompously, the romanticists told them poetically or melodramatically, and even the sturdiest of realists tell stories of real life, though they disdain legend and romance. The telling of stories has been so all but universal in the history of the imitative arts that the question is not whether they may advantageously tell stories, but only what stories they may most advantageously tell and how they may best tell them.

The human delight in a story has undoubtedly led painters at different times to tell stories that were not worth the

telling, or that could not be clearly told in painting; and as bad painters have drawn ill or colored ill, so they have told stories badly. In the British art of the last century there was a deal of sentimental or humorous anecdotage, illustration of novels and the like, which was used as a sauce to disguise bad painting. Hogarth, who was a good and sound painter, allowed his moralizing tendencies to lead him into the telling of stories which are too complicated to be told by the means proper to his art, and found it necessary to explain himself by written labels—marking papers "bill" or "mortgage," as who should say: This is a sheep—or to pack twenty incidents into the space of one. Greuze told his stories theatrically, setting the attendants at a humble deathbed into wild attitudes of frenzy and despair. His story-telling is as false as his cold and disagreeable color. It is not so that the great painters have told stories.

They have chosen some story of vital import, of great dignity, of universal interest. They have so chosen it that it may be told in its essential part by the attitude and gesture of the principal figures, and

[ 114 ]

they have generally chosen a story so well known that, the critical moment being depicted, the memory and imagination of the spectator will at once supply all that went before or comes after it. And having so chosen, they have bent all their powers to the telling of the chosen story as fully, as forcibly, and as clearly as possible, purging away everything unnecessary to that end, avoiding all useless accessories, concentrating upon the few essential facts, the few necessary attitudes and gestures.

It is the peculiar glory of Giotto that he so told a whole cycle of Bible stories and of stories of the lives of saints that the manner of their telling was fixed and that for two hundred years his versions of them were repeated with but slight variations. It is one of the great glories of Raphael that his manner of telling another such cycle has not yet ceased to dominate our imagination, so that we can see certain subjects in no other way than as he saw them. Michelangelo's frescoed epic of the Book of Genesis is the most sublime creation of pictorial art, as Rembrandt's romances from the Apocrypha and his tales of the Man of Sorrows are the most poign-

antly human. Finally, within the lifetime of many of us, Millet told the story of man's life of labor, of the sowing of the seed and the reaping of the harvest, of the guarding of the flocks, the hewing of wood and the drawing of water, with the same authority and the same finality. We cannot hear the word sower without seeing the "august gesture" of that striding figure against the sunset; we cannot hear of gleaning without seeing those bent backs and fingers groping in the stubble. For in painting as in poetry, the story once fittingly and completely told is told forever.

For at least fourteen thousand years, then, from the time of the cavemen to our own day, painting has been an imitative art, and it seems likely that it will continue to be so. That it should, within a few years, entirely reverse its current, and should flow in the opposite direction for thousands of years to come seems highly improbable, not to say incredible. Yet we are gravely told that it is about to do this; that, at the hands of a few enthusiasts it has, by the abandonment of its representative element, reached its final

[116]

and definite form, and that no further changes are possible. Henceforth, as long as men live in the world they are to be satisfied with a non-representative art— an art fundamentally different from that which they have known and practised and enjoyed.

We have seen something of what mankind would lose by such a change were such a change possible. In the next chapter we shall see what pleasure-giving elements of the art of painting would still remain for his enjoyment.

# II

## PAINTING AS AN ART OF RELATION

PAINTING is, as we have seen, by its origin and nature, an art of imitation, but it has never been, except perhaps in its earliest forms, solely an art of imitation. It has always been akin to the other fine arts, some of which have no imitative element, or next to none, but all of which deal in relations or proportions, in the ordering of something for the attainment of harmony and unity.

There are two possible classifications of the fine arts which cut across each other, and which group the arts differently. Thus, if we group the arts according to whether or not they are imitative in their nature, we have on the one hand painting, sculpture, and acting as essentially imitative arts, and on the other hand architecture and music, which exist independently of imitation and only occasionally and in-

cidentally imitate anything. Dancing, partaking of the nature of both acting and music, stands about half-way between these two groups. By another classification we may group the arts according to the sense to which they appeal and the mode in which they exist. Music and poetry appeal to the ear and exist in time. Architecture, sculpture, and painting appeal to the eye and exist in space. Acting and the dance appeal to both senses and exist in both modes. But by whatever classification we divide the fine arts, there is one principle which unites them. Whether they be imitative or non-imitative, arts of time or arts of space, they are all arts of relation.

Music, which is almost entirely non-imitative, being an art of time, deals with the proportions and relations of simultaneous or successive sounds. Architecture and sculpture, the one as non-imitative as music, the other as essentially imitative as painting, both deal with the relations of solid forms in space. Painting, as an art of relation, deals with the characters and relations, in two dimensions only, of spaces, lines, and colors, of degrees of

light and dark, and of the materials and means with which these are produced. Although such an art can hardly be said to exist, it is possible to conceive of an art in which these elements and their relations should exist independently of all imitation—an art which, on the analogy of "absolute music," we might call absolute painting. What we have now to do is to consider these relational elements of the art of painting, and the manner in which painting deals with them, as nearly as possible as if painting were such an absolute or non-imitative art. Afterward we can consider how the relational and the imitative sides of painting work together to produce a more powerful effect than either could produce without the other.

What we shall have first to examine is that dominating principle of all the fine arts which is known as composition—that principle of order and arrangement which is less an element of any art than the general law to which all its elements must be submitted to produce that unified result, all the parts and elements concurring in one expression, which constitutes a work

of art. In painting we call this principle design, and for convenience we consider it generally as ruling over the disposition of lines and spaces only, though it must in reality control equally the use of all the elements of the art. After considering pure design, the principle of arrangement, we will give some consideration to the elements with which it works, to their character and power of expression, and we shall then be able to judge of the resources of painting as an absolute art.

Painting, being an art of space in two dimensions only, begins with the simple plane or surface on which the work of art is to be created; this primary space or surface must, in the nature of things, have definite boundaries. It may be of any shape, but is most commonly rectangular. In painting connected with architecture the boundaries are often fixed beforehand, but in independent painting they are determined by the painter himself, and his first task is to determine on the shape and size of the surface on which he is to work and on the proportion of its length to its breadth.

This primary space once determined,

whether by external conditions or by the artist himself, the first step toward transforming it from an empty space into a work of art is to divide it into subordinate spaces, or what we call masses, which shall be of interesting and agreeable shapes and agreeably related to each other and to the whole space to be covered. Some of these spaces will be relatively simple and empty like the background of a panel of ornament; others will be subdivided into still smaller spaces and filled with details like the ornament itself; and the most fundamental principle of design is the division of space and the balance of filled and empty spaces. But if an effect of unity is to be created, certain of these spaces or masses will be given predominance over the others. There will be generally one mass more important than all the others, and there will be subdominant masses each of which will have subordinate masses bearing the same relation to it as it bears to the principal mass. The dominance of the principal mass may be marked by its size, by its centrality of position, by its isolation, or by all of these means. It is evident that, other things being equal,

the largest mass will be the most important, but a small mass in the centre of a symmetrical composition will be more important than a larger mass elsewhere, and a mass which is isolated from others will gain importance from the lack of near rivalry.

In Raphael's "Disputa" in the Vatican he wanted to make the Host in its monstrance extremely important, as it is about it that all his personages are occupied. The whole field of the painting is a lunette—roughly, a semicircle with a narrow rectangular strip added below. The disk of the monstrance is very small, but by placing it almost at the mathematical centre of the bounding curve (it is really a trifle higher, at the level of the spring of the arch which is a little less than a semicircle) and by allowing no other object of interest near it, he has succeeded in making it dominate the whole vast composition.

It is evident that the boundaries of the masses in any design, whether or not they are defined by a drawn outline, have the properties of lines. There may also be lines within the masses and imaginary

lines made by the relations of points, as a spray of foliage may be surrounded by an imaginary curve drawn from leaf-end to leaf-end—a curve which we can see, although it has no material existence. The whole of a design, therefore, is covered by a network of lines, real or imaginary, the great function of which is to bind together what has been divided.

After division of space comes unification by line, or rather they come together; for when we are inventing the spaces, we are necessarily inventing the lines that bound and unite them. Now the eye naturally tends to follow a line, moving along it from end to end and noting its general sweep and direction and its deviations from this general direction; and the lines of a good composition are so arranged as to lead the eye where the artist chooses, generally toward the mass which he has determined shall be the most important. There are many ways in which this may be done, but the most obvious are by radiation from, or more strictly by convergence to, the centre of interest, and by circling around this centre, like the radiating and concentric lines of a spider-web.

Of course the composition of line is seldom as obvious as this example, but however complicated the composition may be, and by however devious a route the eye may be led, it is led inevitably to the point to which the artist wishes to lead it, and is fixed there, so that on whatever part of the composition the spectator first glances, he shortly finds himself looking at this point of interest and contentedly resting there.

But pure design has two other means of action to reinforce its effects. We have seen that it tends to make two kinds of spaces, the filled and the empty spaces, or the subject and the field or background. Now this division may be emphasized either by light and dark, or by color, or by both. The filled spaces will be either lighter or darker than the background, the extreme instances of this being the old printers' ornaments and initials, which are white on black, and the silhouette, which is black on white. Or the filled spaces may be both lighter and darker than the ground, which becomes a half-tone between the extreme light and dark of the subject. Or again, though this is rarer, the ground may be

divided into light and dark and the sub-
ject treated in half-tone or, as in heraldry,
countercharged, light on dark and dark
on light. By any of these methods the im-
portance of the principal mass may be
marked by a greater contrast with the
ground. It may be the lightest mass where
the contrast is of light on dark, the darkest
mass where the contrast is of dark on
light, or may have the strongest contrasts
of light and dark where the relief is of
variety on monotony. And all these meth-
ods are capable of varying degrees of em-
phasis which shall mark the subdominant
and sub-subdominant masses. If the relief
is rather of color than of light and dark,
as of blue on red or red on blue, or of varied
colors on a relatively neutral ground, there
is the same possibility of graduated em-
phasis by the gradations of vividness of
color and contrast.

In the arrangement of the masses which
are to be thus bound together by lines
and emphasized by light and dark, or by
color, there are a certain number of well-
understood and frequently employed meth-
ods, such, for instance, as the pyramidal
composition, in which the principal mass

is placed at the apex of a triangle of which subordinate masses form the base. This is frequently supplemented by the placing of half pyramids at either side the central pyramid, forming wings to the main composition, and the bounding-line of these subsidiary groups often forms a curve of suspension, like a great garland hung behind the main group and visible only at the ends. But the methods of arrangement possible are quite literally infinite, and afford endless scope to the genius and originality of the artist, some of the best compositions in existence being so surprising and seemingly capricious that one knows not how to analyze them. There is, however, one principle of arrangement that always plays a large part, and that may generally be clearly perceived in its operation—the principle of balance. In design as in physics, two masses of the same importance or weight, at equal distances from a centre, will balance each other, or two masses of different importance and weight will balance each other, if the distance from the centre is in inverse proportion to the weight. The principle of the symmetrical composition is the principle

of the scales, and in such compositions the point of interest is generally at the pivot. The principle of the unsymmetrical composition is that of the steelyard, and in that form of composition the centre on which the unequal masses depend is generally an ideal point. But the restfulness and pleasurableness of the design will depend very much on the accurate adjustment of weight to distance and the consequent sense of balance.

As long as we consider painting as an absolute or non-imitative art, there is little to be said of the character or expressiveness of masses in themselves. Imitation, by bringing in the appearance of bulk and projection, would give a new character to them; but without that, they have little other character than that of the lines which bound them. Light and dark, until imitation transforms it into light and shade, has little expressiveness except for its emphasis of spaces. But lines and colors have characters of their own which it is now necessary to consider.

The most obvious distinction between various kinds of lines is the distinction be-

tween straight lines and curves. Straight
lines will always express rigidity and stiff-
ness while curves will suggest some sort
of growth or motion; but straight lines
vary in expression according to their posi-
tion and direction. The horizontal line is
always suggestive of repose; it is the line
of resting water, of the earth of alluvial
plains, of everything that has reached a
state of equilibrium. The vertical line is a
line of stability, of direct opposition to the
force of gravity, of strength and vigor.
Most compositions in which the sentiment
of restfulness and enduring peace is to be
expressed are built on a combination of
verticals and horizontals. Oblique straight
lines vary in expression according to their
combination with other lines and may
express anything from tottering to vigor-
ous thrusting; but they nearly always
express some form of motion.

As straight lines express strength, so
curves express softness, and the softest
of curves are those approaching the cir-
cular or made up of sections of circles. An
infusion of straightness into a curve will
give it stiffness and vigor, and the most
lively and elastic curves are those ap-

proaching straightness at one end and curving more and more rapidly toward the other. In the double or S-shaped curve, unless it is very restrained in its degree of curvature, there is nearly always a sense of vuluptuousness and floridity which may sink to feebleness and aimlessness, like a limp string. It is the characteristic line of the baroque and the rococo. With a sufficient element of straightness in them, however, such curves may ripple or flame or flow gently like a river in a plain. All these characters of lines may be the result of association, or they may have some deeper reason, but they are there, in the lines themselves, without regard to what the lines may be used to represent, and are among the most valuable means of artistic expression. Finally, as to their manner of fulfilling their function of leading the eye from one point to another, some lines do this gently and flowingly and the easy movement of the eye which they induce is pleasurable. There are others which deviate suddenly, which jar and shock, and such lines may be stimulating and exciting or even painful to follow. There are arrangements of line which are rest-

less and uneasy; there are others that are intolerable. There is almost no emotion or state of mind, from tranquillity to horror, that may not be suggested by the character and arrangement of pure lines.

There has been, for the last hundred years, a great deal of investigation of the laws of color and much has been written on the subject, but as yet little has been found out that is very helpful to the artist, and our knowledge has not enabled us to handle color with the felicity of the artists of the sixteenth century, or the Oriental of any time, who had no such knowledge. The effects of color must, like the effects of sound, be based upon the relations of wavelengths, and it would seem that they should present no greater difficulty of scientific formulation; but there is one vast difference between the way in which music handles sound and the way in which painting handles color. Music uses only a few definite notes whose relations are known and calculable. Painting uses, or may use, all possible notes, selecting as it pleases from an infinite series, and it never maintains one note unaltered but modulates and varies it almost infinitely. Nothing but a highly

trained sensitiveness to color has ever enabled an artist to do this with certainty, and all theory breaks down in attempting such a problem. But apart from the laws of harmony and contrast of color, there are certain qualities of colors, like the characters of lines, which we are able to recognize and, in some cases, to give a scientific account of.

There are hot and cold colors; stimulating colors and colors that are soothing or depressing; luminous and non-luminous colors; advancing and retiring colors. The colors toward the red end of the spectrum are warm, those toward the blue end are cold, but violet, having a tinge of red, as if it began a new octave, is less cold than blue, and red is not so hot as orange. The most luminous of colors is yellow, and there is a pretty regular gradation from yellow either way, through orange and red to violet, and through green and blue to violet, violet being the least luminous of all colors. Scarlet is an extremely exciting color, yellow is cheerful, green pleasant and soothing, blue and violet are depressing, and violet especially so. In general the warm and luminous colors tend to

come forward and the cold and non-luminous colors to retire, and this without any regard to representation or the appearance of nature. A scarlet pattern will detach itself and stand forward from a blue ground.

But as artists almost never use true spectral colors, but all sorts of modified and broken tints, there are whole modes or tones of coloring possible which affect the character of each of the colors. The whole tone of coloring may be neutral and gray, and it may be either muddily and heavily neutral or delicately and exquisitely neutral. It may be bright and vivid, as in mediæval illumination, which always gives a sense of gayety and sometimes of purity; or it may be sober, or deep and rich and full, or again sombre and gloomy, or even violent and stormy. In color, as in line, there is almost an infinite range of expression.

Finally, as the painter is performer as well as composer, there is in painting a beauty of technic which answers to the beauty of accomplished performance in music. It is based on the mastery of materials and their proper and appropriate

[ 133 ]

use, and in its lower forms is nothing other than good workmanship. But even workmanship has considerable expressional value. It may create exquisite surfaces and give a feeling of preciousness to mere oil paint by its subtlety of manipulation. It may be quietly perfect, or ruggedly strong, or it may have the gay dash and brio of virtuosity. In the hands of the great masters the workmanship is constantly varied with the mood of the work or the needs of the moment, now delicate and enigmatic, now direct and vigorous, now almost brutal. In art nothing is to be despised and mere workmanship is far from despicable.

These, then, are the elements which painting as an art of relation offers to the artist. Upon these elements he plays as the musician upon his keyboard, using their various characters to express his moods and emotions. His great aim, as in all the fine arts, is to produce a perfectly harmonious and unified result—to make, as it were, a little universe of his own in which order shall visibly reign. His harmony must include variety and

contrast, not merely for the interest of variety and contrast in themselves, but because they are necessary to give the fullest sense of the triumph of order. It is when order and unity are seen to dominate multiplicity, variety, and even opposition, that they are felt as a vital and conquering force, and there is little merit in a harmony attained by the absence of all individuality in the things harmonized.

Why might not such an art of relation, shaking off all imitation, and relying entirely upon the expressiveness of colors, lines, and spaces, be as satisfactory an art as absolute music, or as architecture, neither of which relies upon imitation?

It is somewhat difficult to give a reason why colors and lines should make a weaker appeal to the emotions and to the imagination than sounds, but I think experience proves that they do so. The nearest thing to such an art as we have imagined, a non-imitative and purely relational art of painting, is to be found in pure ornament, though even ornament, except in the geometrical decoration of the Moors, has seldom been entirely divorced from rep-

resentation, and the best ornament con-
tains a great deal of representation. But
has the best ornament that ever was painted
produced any deep effect on the feelings,
roused any great emotion, or excited any-
thing more than a mild interest? It can
please in an unexciting way, and, if it is
very complex, can stimulate the curiosity
of him who beholds it and set him to the
threading of its mazes; but it can hardly
do more. We must conclude that painting,
as an art of pure relation, would be rad-
ically inferior to music. It is easier to show
how and why it would be inferior to archi-
tecture.

Architecture deals with all the elements
of form and color that are at the command
of painting, and even, in its own way,
with that of workmanship, and with other,
and vastly important elements, which
painting has not. It can, in the first place,
attain to the sublimity of size, which is
impossible to painting; any attempt at
very great size in painting rendering it
impossible to see the work as a whole and
therefore depriving it of all effect. It com-
poses in three dimensions and therefore
has actual space at its command and can

work upon the powerful emotions aroused by a sense of space; and its three-dimensional composition gives it the advantage of an infinitely varied aspect as seen from different points of view. Finally, architecture can call in the lighting of the sun and play of shadow upon its surfaces, so that the same building shall have a thousand varying aspects even when seen from the same point, and shall yet, if it is properly composed, be always a unified whole and a work of art. Painting is strictly limited as to size, is quite flat, and quite unvarying. It is entirely limited to its own resources and can hope nothing from the play of light upon it, being either well-lighted or ill-lighted, no more. As a non-imitative art, being denied size, space, and change which architecture has, and having nothing which architecture has not, it would be an art of less resources and of less range.

Painting, then, needs all the resources of imitation to produce any great effects, and the first result of the union of imitation with such a purely relational art as we have been discussing is the immense strengthening of that relational art itself

by the acquisition of new elements of great expressional value.

We have seen that the mere gradations from light to dark, or the mere contrast of light and dark, as long as there is no imitative suggestion, has little power of expression and produces little effect on the imagination; but once the suggestion of imitation is admitted and white is conceived of as light and dark as shadow, the art is possessed of one of the most powerful of imaginative stimuli. Instead of dealing with lighter and darker spaces, as one does in simple pattern-designing, the artist is dealing with radiance and gloom, and in their mingling and their contrast, in the infinite variety of their relations, there is a whole world of dramatic and emotional expression. But this transformation of light and dark into light and shade, which is brought about by the introduction of imitation, endows the relational art with yet other elements of the highest value for purposes of expression. It creates for painting the illusion of a third dimension, and gives it the power of modelling, making it a sharer with sculpture in the relations of boss and hollow, which are

the essence of that art, and a sharer with architecture in the relations of space and size. If it cannot give actual space or actual size, it can, by the use of this illusion, suggest space and size beyond the limits possible of realization to architecture, giving the appearance of miles of distance where architecture gives the reality of yards, and suggesting the bulk of an alp where architecture realizes the bulk of a pyramid.

By these additions painting as an art of relation is raised from a rather poor and ineffective art to one of the richest and most effective of all. But imitation not only brings new elements to the art of relation, it greatly enhances the effectiveness of all its elements by giving a visible intention and direction to their employment. By the choice of objects and actions, of a scene to be represented, of the subject in a word, it determines the mood of the work of art and the emotions and sensations which it shall be the aim of the artist to evoke. The selection of lines and colors, the treatment of light and shade, even the manner of workmanship and the very touches of the brush are controlled and guided by a definite purpose and set to

a particular task, and this definiteness of purpose not only clarifies the work of the artist but greatly enhances his effectiveness. For the choice of subject gives the clew to the imagination of the beholder, predisposes him to the mood which the artist has aimed to induce, and makes him ready to feel the expressiveness of the work, and of all the elements of which it is composed. He is like a tuned string, ready to vibrate to the faintest sounding of a note that would not otherwise have stirred him.

But if painting cannot do without imitation, still less can it do without an art of relation. In the one case it would be a meagre and ineffective art, in the other it would cease to be an art at all. For the spaces and lines, the colors and degrees of light and dark with which painting deals as a relational art are the very tools of imitation. They are necessarily present in every painting, and they necessarily have their characters and relations, and if these characters and relations are not so chosen and controlled by art as to be helpful to the expression of the subject,

they will be hurtful to it. As soon as a picture represents an object and a background it contains the elements of division of space. It may be well-designed or ill-designed, but it cannot escape from design. As soon as the contour of an object is drawn there is an arrangement of lines, and if these lines are not well-arranged they will be ill-arranged, and if their inherent characters are not in accord with the character of the subject, they will be in disaccord with it. As soon as any attempt is made to represent the color of objects there is a scheme of coloring which is either harmonious or inharmonious, appropriate or inappropriate. No matter how strictly imitative a painting may be in its intention, its mere existence sets up relations of all sorts, and unless its purpose is entirely utilitarian—if it has any intention to give pleasure—these relations must be considered and made beautiful and expressive.

We have seen, however, that the aim of painting is very seldom exact imitation and that all the higher qualities of imitative art are dependent upon selection, emphasis, and suppression, that the chosen

characters of things may be more instan-
taneously and more powerfully apprehended
than they could be in the presence of the
things themselves. These selections, exag-
gerations, and suppressions are made upon
the principles of relational art. The actual
shapes and colors of objects are modified
to take advantage of the inherent character
of lines and colors. A line is straightened
here because straight lines express strength
and rigidity, or more curved there because
curved lines suggest grace and movement.
Colors are intensified to express passion or
clarified to give lightness and gayety. Thus
all the higher effects of imitation are not
only very greatly enhanced by the arts
of relation, they are dependent upon them
and cannot exist without them.

We have seen the great importance of
significant figure-drawing—of what Beren-
son calls tactile values—but such drawing
is entirely dependent on the expressiveness
or the relations of boss and hollow which
painting has taken over from sculpture,
and on the expressiveness of lines and their
arrangements. Motion is only expressible
in art by composition of line, by the choice
and arrangement of lines for that express

purpose, and no accuracy of observation or exactness of record of the forms and positions of the limbs will make a figure of a man or beast seem actually to move—nothing but composition will do it. In the same way it is by composing in depth—by the careful proportioning of suggested recessions, one beyond another—that Perugino and Raphael achieve the wonderful spaciousness and serenity of their landscape backgrounds. It is by composition of light and shadow, not by mere imitation of natural effects, that Rembrandt makes painting express mystery, romance, even the supernatural.

It is this double aspect of painting that makes it the extremely complicated, difficult, and exacting art that it is. Every particle of the surface of a picture must represent something and represent it with sufficient accuracy to give the illusion of imitation, yet every particle must be a part of a unified scheme of composition or rather of a series of schemes overlying and crossing each other, a composition of lines and masses, a composition of light and shadow, a composition of color, even a composition of the very brush marks

[ 143 ]

and of the variations of workmanship and of texture. And all of the representation and all of the composition in these various modes must work together for one end. Every particle of nature represented and every particle of the means employed in representation must be so modified and controlled that the result may be a unified and intensified expression of that character of the subject which has most impressed the artist and of the feelings and emotions with which that character has inspired him.

Painting, then, is necessarily a mixed art, partly an imitative art and partly an art of relation. As an art of relation it is allied to the other fine arts and deals with its material as they deal with theirs. As an art of imitation it differs from music and architecture and is allied to sculpture in that the material it deals with corresponds with and represents the appearance of objects outside itself. Imitation gives it its substance, relation gives it its form. Its most necessary and fundamental aim is imitation. Its highest is the attainment of unity through the submission of all its elements and their relations to the principle

of design—the creation of a limited and visible order instead of that vast and invisible order of the universe which we must believe to exist but which we cannot apprehend.

The equal mastery of all parts of this complicated art is impossible to any one man, though some of the greatest masters have come surprisingly near to such mastery. A sufficient mastery of all these elements to prevent any part of the work from contradicting and enfeebling the rest is essential. And the compensation for the enormous difficulty of the art is its immense wealth of resource—a wealth which has never been and is never likely to be exhausted.

We have now reached the end of our examination of the art of painting as it has always existed in the world. We have tried to find out what have been the aims of painting and how it has accomplished them—what painters have tried to do and how they have done it. We have tried to enumerate the elements of the art and to ascertain their value for representation and for expression, and we have tried to

[ 145 ]

formulate some of the laws by which these elements are made to work together for the production of a single effect. Perhaps we may now feel ready to attempt something like a definition of the art, but we must remember that, as painting is one of the most complex of the arts, our examination of it can hardly have been complete, and that if any important consideration has escaped us, our definition will be so far insufficient. We must endeavor to make it inclusive rather than exclusive, and must be ready to admit that, if anything which the world has accepted and loved as painting is in any important character inconsistent with our definition, the fault is with the definition.

Taking up our examination point by point, then, our tentative definition would be something like this: *The art of painting is the selective representation on a plane surface of objects or actions, real or imagined, by means of spaces, lines, colors, and variations of light and dark, all of which elements, as well as the materials employed, have been subjected to some principle of order for the attainment of unity.*

This definition is admittedly tentative

and probably incomplete; but I do not think, whatever it may lack, that it includes anything which is not a necessary and essential part of the art. I think it is demonstrably true as far as it goes, and indeed I am afraid that it will seem too obviously true to be worth all the time it has taken to arrive at it, rather than that it will seem false. But it is just the obvious that is always being forgotten or denied, and it is therefore the obvious that needs constant reassertion. If my analysis and my consequent definition are as obviously correct as I hope they are, we may take it that the art of painting is at least as complex as I have represented it, that none of the elements I have enumerated can be spared from it, and that recent efforts to improve it by eliminating half its difficulties and more than half its resources are doomed to failure.

The two great and opposite dangers to the art are, that absorption in representation shall lead to forgetfulness of its more abstract qualities as an art of relation, or that interest in these abstract qualities shall lead to the neglect or denial of representation. The first was the great danger

to art during the later part of the last century. To-day, in a natural reaction against an excess of imitation, we are running into the opposite extreme; and that is the more dangerous of the two, because what it neglects or denies is the most necessary and fundamental part of the art—its very substance rather than its form. There will always be some oscillation between the poles of representation and relation; but good art will always try to find a place of balance between them, and the greatest painting will always be that which attains the greatest degree of truth as an art of imitation compatible with the highest beauty and expressiveness as an art of relation. On no other and no easier terms can mastery be achieved.

*PART II*

THE GOLDEN AGE OF PAINTING

# I

# THE CULMINATION OF THE RENAISSANCE

Just at the end of the fifteenth century, after two hundred years of delightful if incomplete creation or of strenuous study of nature and of technic, the art of the Italian Renaissance reached a sudden and brilliant maturity. For a brief period it produced a series of supreme masterpieces. Then, everywhere but in Venice, that decline began which has continued until now. Venice maintained the supremacy of Italian art until nearly the end of the sixteenth century, but with the beginning of the seventeenth the leadership in art passed definitely to the races of the North.

The suddenness of the change from an art still more or less primitive to the full-blown art of the high Renaissance, and the briefness of the period of splendor, may be best shown by a few dates. The

first picture of the new and fully matured style, Leonardo's "Last Supper," was probably painted in 1497. Within fifteen years, that is, by 1512, the ceiling of the Sistine Chapel and the frescos of the Camera della Segnatura had been completed, and when Raphael died, in 1520, the decline had already begun. In 1505 Raphael, then just beginning to break away from the method of Perugino and to establish his own artistic personality, had begun a fresco of "The Trinity with Saints and Monks" in San Severo at Perugia. He left it unfinished, and the lower part of it was painted, after his death, by Perugino himself, still practising with diminished power the old manner from which Raphael had so entirely freed himself. Even Correggio, the youngest and the most revolutionary of the giants of the high Renaissance, who transformed painting beyond the dreams of Michelangelo or Raphael, had completed his work and died in 1534. Yet Lorenzo da Credi, Leonardo's fellow pupil in Verrocchio's studio, younger than Leonardo by seven years, survived until 1537, a primitive to the end.

Nothing can account for the extent and

the rapidity of this change but the extraordinary genius of four men: Leonardo, Michelangelo, Raphael, and Correggio; and the art of this short and wonderful time of culmination is essentially their work as the art of the long decadence that followed is deeply tinged by their influence. Without any one of them the high Renaissance would have lacked something essential to its peculiar glory. Without any one of them the art of the succeeding age must have been profoundly different from what it actually was. Always excepting the Venetians, who need separate consideration for many reasons, their contemporaries were either survivals of the past, like Perugino and Botticelli; men of talent but of little original force, like Fra Bartolommeo and Andrea del Sarto; or their own followers and imitators. Doubtless there are good historical reasons why the culmination should have come at that time, or, what is really the same thing, why the decline should have begun immediately after them. Doubtless their time moulded them and colored them, as it fostered them and gave them their opportunity. But there was no one else who could have used their op-

portunity as they used it, and in their turn they moulded and colored their age.

The earliest of the four, Leonardo da Vinci, was, in a sense, rather a precursor of the high Renaissance than a full sharer in it. Twenty-three years older than Michelangelo and thirty-one years older than Raphael, he was already a mature and world-famed artist when they were beginning their careers, and in his later years he completed very little work of importance. Painter, sculptor, architect, engineer and man of science, as well as musician and courtier, he allowed his varied interests to distract him from artistic creation, and of the few things he actually painted most are lost or ruined. Enough remains for us to see that his task was to push all parts of the art of painting to the very verge of perfection, not to carry any one of its elements to the highest possible point. His composition has an amplitude and a dignity hitherto undreamed of, his draftsmanship an expressiveness and precision hitherto unattainable. One could scarcely imagine anything better composed or better drawn than are his best works

had not Raphael and Michelangelo shown us what that something might be. It is so with everything else, with the noble casting of his draperies, with his treatment of light and shade, probably with his mastery of color, though it is now impossible to tell what his color may really have been. It is in the treatment of light and shade that he was most the innovator, and he has been called the inventor of chiaroscuro, but even here he did not go the whole way. So much of light and shade as is necessary to express the full roundness of objects he thoroughly mastered. He added the third dimension to the two which had hitherto almost sufficed for painting, and incurred the risk of blackness to insure the perfection of modelling. Of light and shade as a separate element of art, capable of its own range of expression—of light and shade which veils form rather than reveals it—he knew nothing, or chose not to utilize such knowledge as he had.

For, as we saw in Part I, it is necessary to distinguish between what Leonardo the scientific investigator had learned of the aspects of nature and what Leo-

nardo the artist thought fit for artistic employment. He was a tireless student of all kinds of natural phenomena, and of many things he had learned a great deal that has been rediscovered only in our own time. Among other things, as his note-books prove, he had studied effects of transmitted and reflected light, understood the difference between diffused daylight and sunlight with its crisp-edged shadows, saw the blue shadow which has been introduced into modern painting by the Impressionists and knew the reason of it. He attempted none of these things in painting and he tells us why. These things, he says, after a long description of the effects of sunlight upon foliage—of the color of the sky in the high lights, of the yellow light where the sun shines through the leaf and the interruption of this light where the shadow of one leaf falls upon another—these things should not be painted "because they confuse the form."

The Florentine ideal in art was the utmost realization of form. Leonardo was a true Florentine, and he introduced into painting just so much of light and shade

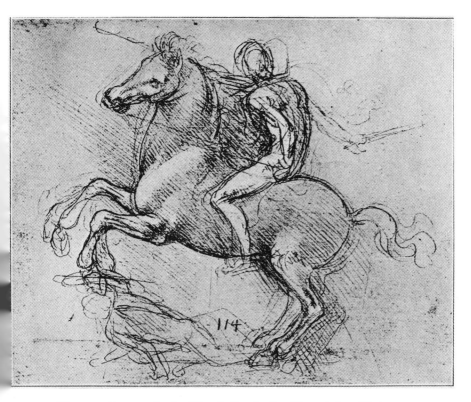

Plate 5. Leonardo da Vinci, *Study for Equestrian Statue.*
Windsor, England, Windsor Library.

as should assist in this realization, no more. It is his use of modelling that is his most personal contribution to art. Much rhapsodical nonsense has been written about the "Mona Lisa" and her enigmatic smile, and there have been endless speculations as to her character and the meaning of her expression. It is all beside the mark. The truth is that the "Mona Lisa" is a study of modelling, little more. Leonardo had discovered that the expression of smiling is much more a matter of the modelling of the cheek and of the forms below the eye than of the change in the line of the lips. It interested him, with his new power of modelling, to produce a smile wholly by these delicate changes of surface; hence, the mysterious expression. Poets may find "La Gioconda" a vampire or what not—to artists with a sense of form her portrait will always be a masterpiece because it is one of the subtlest and most exquisite pieces of modelling in existence. It is perfect as the surface of a Greek marble is perfect, beautiful with the beauty of a lily-petal, and is well worth the years of study and of labor that it is said to have cost.

Another of Leonardo's innovations was less fortunate. The technic of fresco-painting, with its necessity for direct and immediate attainment. of the desired result, was ill-suited to his temper, which loved to ponder deeply and to caress into final perfection by an infinity of retouchings. He abandoned it, and painted his "Last Supper" in another medium which is now said not to have been oils. Whatever it was it proved ill-suited to mural decoration, and the painting must early have begun to scale from the walls. To-day it is a wreck in which the nobility of the composition is all that is discernible of what was once a masterpiece. Whether a similar fate overtook his "Battle of the Standard," which he began to paint upon the wall of the Palazzo Vecchio in Florence, we do not know. It has utterly disappeared and we can judge of it only by fragmentary copies.

So much of Leonardo's work was left unfinished, so much of it has perished, that we must form our estimate of him as an artist rather from his countless drawings than from the few paintings that remain to us. They are among the most

delightful things in the world, infinitely delicate and refined yet full of masculine power. There are single sketches of his which are comparable only to the finest fragments of Greek sculpture as an assurance of a consummate art which the world no longer possesses.

All the painting of the high Renaissance is based upon Leonardo's acquisitions. Even Michelangelo must have studied and admired him, though he would not admit it, and we know that Raphael humbly imitated him. He achieved a colossal reputation, yet outside Lombardy the traces of his personal influence are small, and Lombardy produced no great masters. Luini, too old to have been properly his pupil, caught something of the grace of his smiling heads and the charm of his subtle modelling, and made with these elements a secure place for himself. Among the master's more direct following Sodoma is perhaps the most considerable person, and many of us feel that his swooning Catherines and effeminate Sebastians could well be spared. But the precursor had made the ways straight, and the younger men who came after him had each but to

explore a little further one of the paths
he had marked out.

At first sight Michelangelo may seem
almost as versatile a genius as Leonardo
himself. He, also, was painter, sculptor,
architect, and engineer, and he was, be-
sides all these, a poet of true power. Yet
his task was a much narrower one than
that of Leonardo. In the three arts he
practised, his work was to express the
Renaissance ideal of energy, and to ex-
press it by means of the Florentine ideal
of significant form. He is essentially the
draftsman and his special distinction is
to have pushed significant draftsmanship
further than it had ever gone before or
has ever gone since.
Not that this means, as has so often been
said, that he knew nothing of color. The
world is slowly learning that he knew a
great deal about color, and that his great
central masterpiece of painting, the ceiling
of the Sistine Chapel, is, within the limits
of what is possible to fresco-painting or
profitable for decorative art, one of the
world's masterpieces of coloring, entirely
harmonious and admirable, held together

throughout its vast extent with an absolute control and an astounding science. But the mere fact that it has taken the world nearly four hundred years to learn this is evidence enough that it is not the most important thing about the art of Michelangelo. Within his limits, also, he is a master of composition, but his mastery of composition seldom extends beyond the single group. When he uses many figures there is almost always a certain confusion, a lack of clarity and order. Where he seems to have no limits is in his amazing draftsmanship and in the gigantic energy which that draftsmanship could express.

It had been the effort of the Florentine school for two hundred years to master the human figure. It had been its distinction to rely upon the gesture and expression of the human figure for its greatest effects. No one since the Greeks knew the human figure as Michelangelo knew it, and no one has relied so exclusively upon the human figure as his means of expression. Not merely in sculpture, but in painting, he banished everything else. Landscape is reduced to the barest symbolism—to the

most rudimentary indication. Drapery be-
comes a mere aid to the revelation of the
movement and structure beneath it. Noth-
ing is important but the realization of the
figure itself as a solid bulk in space, the
exact notation of its structure of bone
and muscle and tendon and of their inter-
actions and stresses. The roll of the thorax
upon the pelvis, the tension of a muscle
in action, the heavy dragging of it when
relaxed, these are the things on which
Michelangelo concentrated his power. With
them he carries the expression of human
energy to the height of the sublime.

His drawing is never merely correct, and
it is sometimes careless. From the first he
indulges in any exaggeration that will gain
his end. But he is not indifferent to beauty,
and the languid Adam of his "Creation of
Man" is almost as nobly gracious as his
Creator is majestic and full of sweeping
power. Gradually the exaggerations are
exaggerated, the beauty disappears in the
effort to attain the utmost force. Bulk is
increased beyond the possibility of nature,
and attitudes are strained and contorted.
When he painted the "Last Judgment"
he had lived far into the decadence and

had become, as it were, the chief of his own imitators. He had lost his sense of color; he had never had sufficient grasp of composition to organize so vast a concourse of figures; but, above all, his forms had become swollen and monstrous. Instead of grandeur there is grandiosity; instead of eloquence there is inflated rhetoric; in place of the true energy of the high Renaissance there is the fantastic display of energy which we know as the baroque.

Though he was a sculptor, born and bred, and painted under protest, Michelangelo found the highest expression of his genius in the painting of the vault of the Sistine; but there is a side of his nature that shows itself most decisively in his sculpture—the romantic and melancholy side. His greatest statues were produced in the years between the painting of the vault and that of the "Last Judgment," and show neither the triumphant and almost joyous energy of the one nor the pompous simulacrum of energy of the other. Rather they show us thwarted energy, energy struggling against and crushed by fate. There is a titanic and rebellious

melancholy in them that is scarcely any-
where to be found in his painting.

We know that he was of a melancholy
temperament, soured by dyspepsia and
embittered by the thwarting of his great
projects. We know that he grieved deeply
over the degeneracy of the time and the
degradation of his native Florence. But
there are reasons in the nature of the art
of sculpture and in Michelangelo's training
and technic for this sense of struggle. It
is a struggle against the laws of sculpture
itself. He was a sculptor in the strictest
sense of the word, a cutter of stone. He
did nothing in bronze that has come down
to us, and he did not, as many modern
sculptors do, design freely in the clay,
leaving the problems of the actual execu-
tion to others. He was accustomed to getting
his statues out of the block, and he respected
the block in which he worked and liked to
preserve something of its four-squareness
in the completed statue. Now the limits
of the block will not greatly hamper the
sculptor whose aim is tranquil and monu-
mental beauty—to the sculptor whose aim
is energy they must ever serve as a con-
straint, and his figures will seem to be

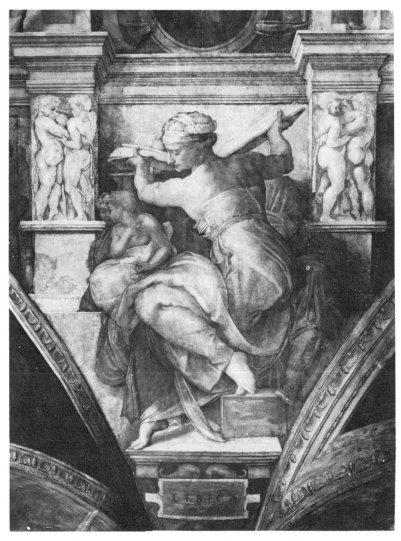

Plate 6. Michelangelo, *The Libyan Sibyl*.
Rome, the Vatican, Sistine Chapel.
(Photo: Alinari Art Resource.)

Plate 7. Raphael, *The School of Athens*.
Rome, The Vatican Museums.
(Photo: Ludovico Canali.)

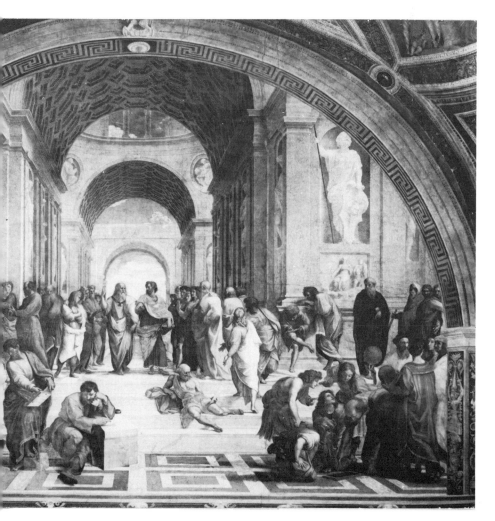

struggling to free themselves from the stone. Michelangelo's successors forgot the block entirely and their figures attitudinize in complete obliviousness of it. For him the cramped postures enforced by the limits of the stone had an expressional value, and he came more and more to leave a part of the stone unremoved that the struggle for freedom from it might be emphasized.

Neither his own impatience, the exigence of his powerful employers, nor any other external circumstance will account for the number of Michelangelo's unfinished statues. A concentration of effort upon the torso and a comparative neglect of the extremities plays its part. So, perhaps, does a love of contrasted surfaces, rough against smooth, and a love of mystery. But essentially his statues remain unfinished because he found that so they expressed his mind and temper, and that they ceased to do so when he tried to complete them.

His followers and successors understood neither this temper nor the method by which it expressed itself. They imitated his forms and attitudes—they never

thought of imitating his unfinish, which was to them a negligible accident. It was not until our own day that it became an easy trick of the studios, lending a false air of mystery and of romance to the work of any whipster who has neither energy with which to struggle nor the austere self-restraint which makes conflict inevitable.

In his old age, when the physical labor of sculpture had become too hard for him and he no longer knew how to paint, Michelangelo devoted himself to architecture, and the swelling curve of Saint Peter's dome is his latest expression of supreme energy nobly self-limited and self-controlled. In architecture his example was even more decisive than in painting or sculpture. When painting and sculpture were rapidly declining in Italy, architecture remained a living art, fantastic at times and extravagant but full of vigor; and the architecture of the baroque is essentially the expression of energy. Its forms and the direction of its effort were both largely determined by his practice, as the forms and the spirit of the other school of Renaissance architecture, the academic,

[ 169 ]

were largely derived from the work of Bramante and of Raphael.

As Michelangelo was born to give in his art the highest expression of the Renaissance ideal of energy, so Raphael was born to express the equally cherished, if partly inconsistent, ideal of serene and ordered dignity, of a clear and spacious existence governed by intelligence and right reason; and nothing could be more unlike the proud and tortured spirit of the great Florentine than the sunny wholesomeness of Raphael's nature. His training was as unlike Michelangelo's as his personality. Born in Urbino, he was brought up at one of the most cultivated courts in Italy, and early became the friend of Bramante and of Castiglione. He inherited the Umbrian tradition of large and open distances and gently smiling figures, and while he amplified and elevated his style, he never lost the Umbrian sweetness.

A part of his reasonableness was his docility and, brilliantly precocious as he was, Raphael was one of the most teachable of men. He remained faithful to the manner of his master, Perugino, until he

could do better work in it than Perugino himself. Then he went to Florence for further education and diligently studied everything from which something might be learned. From Masaccio and Filippino he learned to tell a story clearly and to give a large simplicity to his attitudes and his draperies. He studied Michelangelo's drawing and Leonardo's light and shade and was not above taking lessons in composition from a man so much his own inferior as Fra Bartolommeo. His task, at first, was less to originate anything than to absorb everything that had been originated by others—to do together what others had done separately, and to do it with a final and accomplished grace which no one else had been able to capture. Yet, from the beginning there is a personality in his very impersonality, and the mark of his individuality is the lack of individual bias. No one else, not even Leonardo, could produce an art so rounded and balanced; no one else could give such airy spaciousness to the smiling landscape; no one else could fill it with men so noble or women and children so beautiful; no one else could create a world without evil, in-

habited by a race of ideal beings in whom we rejoice to believe. His way of telling the Bible story has become the way of all the world, his ideals of dignity and beauty have dominated us all, and no one has been able to free himself entirely from Raphael's vision of a serene and perfectly ordered universe.

He was seldom successful in representing any vehemence of action, and it was not his function to evoke pity or terror. His world is a world of peace and tranquillity, and its dominating character is orderliness. Now in art, the very principle of order is design, and Raphael was the greatest master of design that the world has seen. The perfection of ordered design —the mastery of formal composition— was his gift to the world, and to it everything else was subordinated. He could draw with correctness and even with some vigor, but the strenuous draftsmanship of Michelangelo would have been too insistent for his purpose, even had he been capable of it. His drawing must be simplified and enlarged to fit it for his use, and he did not much care if it became empty. He was working in arrangements

of lines and spaces, and that they should tell as such, it was necessary that the spaces should not be too much cut up with smaller forms and that the flow of the lines should not be too much interrupted with minor accents. The "grand style" of his draperies is a matter of composition, and it was because composition was his principal affair that he was indifferent to textures and to the character of stuffs which he could paint admirably when he chose. His use of color and of light and shade is similarly conditioned. Each of these elements is sufficiently studied to be an agreeable accompaniment to a scheme of composition, but neither is allowed to attract too much attention to itself.

The perfect opportunity for the development of his new style and for the display of his personal qualities was given to Raphael when Pope Julius II commissioned him to decorate the room called the Camera della Segnatura in that Vatican within whose walls Michelangelo was even then at work on the vault of the Sistine. In the four years between 1508 and 1512 these two supreme and widely dissimilar works were completed. Those four

years are the real culmination of the
Renaissance. As Michelangelo never again
found a subject so suited to his powers as
the story of the Creation and the fall of
man, so Raphael here found, or was given,
a subject exactly suited to his—the com-
plete illustration of the Renaissance ideal
of culture in its fourfold division of the-
ology, philosophy, poetry, and law. In the
decorative framework left by Sodoma he
placed fourteen compositions. On the ceil-
ing are four medallions, each containing a
personification of one of these divisions of
learning, and four rectangular panels con-
taining the stories of "The Temptation of
Adam," "The Judgment of Solomon," and
"The Flaying of Marsyas," and a figure
leaning over a celestial globe which must
be meant for "Science." In the great
lunettes of the longer walls he painted
below "Theology" that picture of the
church militant and the church triumphant
which has come to be called "La Disputa,"
below "Philosophy" that gathering of the
philosophers and scientists of the ancient
world which is known as "The School of
Athens." On the shorter walls he placed
"Parnassus" below the winged figure of

"Poetry," and below "Justice" the allegory
of "Jurisprudence" and two smaller frescos
of historical subjects—"Gregory IV De-
livering the Decretals" and "Justinian De-
livering the Institutes"—the foundations
of ecclesiastical and civil law.

The first painted of the greater composi-
tions was probably the "Disputa," and
in the upper part of this there are still
reminiscences of the manner of Perugino
and Pintoricchio, though neither of them
was capable of the thought which trans-
formed the flat wall into the semidome or
apse of a cathedral, any more than either
of them was capable of the clear yet in-
tricate grouping and the infinite variety of
the lower part. In the other frescos every
trace of the earlier manner has disappeared.
They are the unapproachable examples of
what composition may accomplish, noble
and gracious in their ordering, perfect in
their balance, endlessly lovely in their
interweaving of line, fitting their spaces
with sovereign mastery and ease.

Even Raphael himself could do nothing
so perfect again. In the "Mass of Bolsena"
and the "Delivery of Peter" he attained
to fuller coloring and attempted new effects
of lighting. In the "Sibyls" of Santa Maria

della Pace and the Farnesina frescos of the story of Cupid and Psyche he composed for new spaces with nearly his old felicity. But he had commissions for far more work than he could execute, he was increasingly interested in architecture and the recovery of that ancient world which seemed the realization of his dream of order. He came to rely more and more upon a throng of pupils and to leave to them not merely the execution but the design of the works of which he was only nominally the author. He wore himself out early, and though he died at thirty-seven, he had outlived his best powers and his art was on the decline.

He left behind him what was, for three centuries, the greatest name in all art. If it is not so authoritative to-day as it once was, it is because we have drifted far away from the ideals of which he was the incarnation. He is forever the type of what we know as the classic spirit, and when the world has tired of individualism and of lawlessness it will again find in him the highest expression of order and of noble submission of the individual to law.

If Correggio was a less supremely great artist than Michelangelo or Raphael, yet

his art is even more surprising and unaccountable than theirs, and a more strikingly original genius than his has never appeared. If Michelangelo invented the baroque, Correggio foreshadowed the rococo. His pictures seem a century—one might almost say two centuries—later than those of his contemporaries, and it is almost impossible to believe that he was but nine years younger than Raphael and that he died a year before Michelangelo's "Last Judgment" was begun. His full greatness was hardly realized and his influence was certainly not at its highest until the eighteenth century.

This delay in the establishment of his fame was partly due to the isolation in which he worked, and this isolation makes the revolution he wrought in the art of painting but the more wonderful. He must have had an opportunity to study the works of Mantegna at Mantua, for from them he took the hint of his figures foreshortened from below. He was more or less influenced by certain Ferrarese masters who are, after all, artists of a minor importance. There is no proof and little probability that he ever saw Rome or

knew anything but by report of the work of his greatest contemporaries. The pictures now accepted as his early works, like the example in the Metropolitan Museum, have little merit and show little promise, and the series of masterpieces in his own personal style begins with the frescos painted in the Convent of San Paolo in Parma, probably in 1518, when he was twenty-five years old. The rest of his short life was passed in Parma or in his native town of Correggio, entirely apart from the great currents of Italian art.

It is a strange art that he invented—an art at once joyous and sentimental, frankly sensuous and intolerably affected—an art from which the last vestige of formality is banished—an art full of agitation, of airs and graces and posturings, of rumpled draperies and naked limbs—an art in which angels and loves are confounded, and in which the spiritual rapture of a crowned Madonna is indistinguishable from the physical ecstasy of Io in the arms of Jupiter. It is, above all, an art flooded with light or swooning in shadow. His innovations were innumerable. In decoration he broke up the architectural frame-

work entirely, brought pulpy clouds across his arches for his saints to sit on, and transformed the dome above into an opening of heaven thronged with soaring figures seen from below in such realistic perspective that one's first, and almost one's last, impression is of a tangled fringe of legs. In his altar-pieces he abandons the consecrated pattern, places the Madonna at one side of the centre, or builds up one of the lateral groups while lowering the other, composes on the diagonal and establishes a new and picturesque balance of inequalities in place of the old formal balance of equalities. Even in coloring he introduces a glowing richness to be found nowhere else except in that art of Venice of which he can have known nothing, or a silvery coolness to be found nowhere else at all. In the technical handling of material—the mastery of pure painting—he has had no superior and hardly a rival.

But all these innovations, admirable or the reverse, are as nothing compared with his invention of chiaroscuro, of which he is the supreme master in Italian art. With him light and shade ceases to be a mere means of securing relief and becomes a

separate element of art of the highest ex-
pressional value. He could do anything
with it, and it becomes at times the real
theme of his work. It is not for nothing
that the "Nativity" at Dresden, the whole
picture illuminated by the miraculous light
from the body of the divine Child, and
the yet more wonderful "Madonna of
Saint Jerome" at Parma, have received
the traditional titles of "La Notte" and
"Il Giorno." Night and day, light strug-
gling through darkness and light joyously
triumphant and universal, these are his
true subjects. With Correggio light and
shade becomes mystery and poetry, an
escape from the real, a heightener of senti-
ment, above all a veil and mitigant of
voluptuousness. Such pictures as his later
mythologies, his Ledas and Ios and Danaës,
would be intolerable and indecent if ex-
pressed in the precise and revealing manner
of an earlier art. Bathed in floating and
languorous shadows which half hide, half
reveal them, his pearly nymphs are re-
moved into a seductive dreamland of ro-
mantic and unreal passion.

Tintoretto was to make a more dramatic
use of light and shadow—there is no drama

in Correggio—Rembrandt was to make it expressive of a new pathos and a deeper mystery; neither they nor any one could achieve by its means such varied and such consummate beauty. What Michelangelo was to drawing and Raphael to composition Correggio was to light and shade. Of the greater elements of painting there remained but one to be fully mastered, the element of color, and the mastery of it was to employ not one artist but a whole school.

With the death of Correggio the golden age of Italian painting, outside Venice, comes to an end. The later art divides itself into two main streams which cross and intermingle—the stream of the baroque springing from Michelangelo and the stream of the academic springing from Raphael. The later Florentine school is given over to an imitation of Michelangelo, to a frantic effort to simulate his energy by exaggerating his writhing poses and burlesquing his display of anatomy. One of the worst instances of this sort of thing is Bronzino's "Christ in Limbo," a monstrous affectation that makes one wonder how its author

could have produced his grave and admirable portraits. A better work is Daniele da Volterra's "Descent from the Cross," which is, however, mainly interesting because it was imitated by Rubens. But the influence of Michelangelo, modified by that of Correggio, runs through the whole art of the sixteenth and seventeenth centuries, wherever it is not academic, and even the rococo of the eighteenth is ultimately traceable to them.

As Raphael was above all the apostle of order, it was inevitable that his works should become a sort of canon, and that what he chose freely to do or not to do should be made a binding rule upon his successors. What he had chosen to do was right; what he had not chosen to do was wrong. He was supposed to have fixed the limits of "the grand style" and to have pointed out the only road for those who would produce an elevated and "correct" art. But there have always been those who could distinguish between the natural felicity of Raphael's own invention and the rigidity and woodenness of his imitators, and in our day we have relieved him of some of the poorer works that

he carelessly allowed to pass under his name. Whenever and wherever there has been an artist of truly classic feeling and of true power of design there has been a devoted admirer of Raphael who has made the master a source of inspiration rather than a principle of inhibition. Among his right followers we may reckon Poussin and Ingres and Paul Baudry.

In the latter part of the sixteenth century the Caracci founded the school of the Eclectics, which endeavored to unite the merits of all other schools; to compose like Raphael, draw like Michelangelo, use Correggio's chiaroscuro and Titian's color. Like all attempts to be a little of everything, it became not very much of anything. The qualities it tried to reconcile were incompatible in their nature, and the refusal to sacrifice one to another ended in the sacrifice of all. The school lasted near a hundred years and produced many most respectable and accomplished but rather tiresome pictures which it was once the fashion to admire only less than those of the greatest masters. More recently it has, perhaps, been the tendency to underrate them, and something might now be said

in their defense if one had time and patience for it. Later still, and perhaps as a revolt against this school, came the Naturalists, coarse in feeling, violent in light and shade, blackish in color, but with a certain brutal strength and vitality. They, at least, had the capacity of being ancestors and, through Ribera, they begat the Spanish school of the seventeenth century.

But Italian art was dying. Henceforth the living art of the world was to be produced elsewhere.

## II

## THE VENETIANS

WE are apt to think of the Venetian school of art as much later in date than the other schools of Italy, and there is indeed some justification for this thought in the facts of the case. The Venetian school of painting was late in beginning and late in ending. Until the latter part of the fifteenth century it produced little that the world would hold in remembrance were it not for what came after it, and it continued to produce masterpieces of a high order until nearly the end of the sixteenth century, when the art of the rest of Italy had become a sterile imitation. Even in the seventeenth century the art of Venice was not without some lingering sparks of vitality, and in the eighteenth it flamed up again for a moment before its final extinction. Yet Venetian art arrived at maturity almost at the same moment as that of the rest of Italy. Giorgione was but two or three years younger than Mi-

chelangelo and was five or six years older than Raphael, and even if we place Titian's birth, as some modern writers would have us do, thirteen years later than the traditional date of 1477, he was still four years older than Correggio. It is the intense vitality of the school which kept it at its height full fifty years after the decline had begun elsewhere, and its fecundity which made it the direct ancestor of our modern art, that mislead us, a little, as to its chronology.

But there is no illusion in the other feeling we have, that Venetian art is profoundly different from that of the other Italian schools. Venice produced a splendid architecture, but it is an architecture of color or of effect rather than an architecture of structure or of form. She produced very little sculpture worthy of consideration. But she produced a school of painting which is one of the supreme manifestations of the human spirit, so that the very words "Venetian art" have come to mean "painting" and little else. And the one element of the art of painting which the Venetians developed further than any other, the element of painting

which they made specially their own, is just that element which is most distinctive of the art and least to be found in any other—the element of color. This reliance upon and this mastery of color is, however, only the most striking of the differences which separate the art of Venice from that of the mainland. The difference in choice and in treatment of subject-matter is nearly as great, and the difference in temper is almost greater.

Climate doubtless had some influence in giving its peculiar character to Venetian art. The schools of color have nearly always been the product of wet regions, where the air is saturated with moisture, where atmosphere becomes visible while solid objects seem tremulous and wavering; and the opalescent light of the lagoons must have had its effect upon the Venetian painters. But indirectly the lagoons exercised an even greater influence by isolating and protecting the Venetian Republic; by separating it from the mainland, so that it might grow rich and prosperous in its own way, without much outside interference; by making it a sea-power and a nation of traders, whose trade lay

[ 187 ]

to the East. During a large part of its history Venice was more intimately associated with the Eastern Empire than with the rest of Italy. It was its intercourse with Byzantium that kept it a nation of mosaic workers when elsewhere Italy was developing the art of the *frescanti*, and mosaic is essentially an art of color while fresco-painting is an art of form. It was its trade with the East that familiarized it with rich stuffs and splendid brocades. It was its isolation that made it safe and well-governed and prosperous, and enabled it to keep even the Roman Church in some sort of tolerable subjection to the civil power. The art of the rest of Italy was religious or scientific or intellectual. The art of Venice was poetic or sensuous or naturalistic. It was, above all, secular and even worldly, delighting to represent the pride of life and the joy of living.

For whatever reason, it is certain that Venice did produce a school of art of this entirely distinctive character—a school more homogeneous and more abundant than almost any other, and one in which there are so many secondary masters, often of very great merit, that the rôle of the

individual genius is less decisive than elsewhere. Individual geniuses it had—masters of the very highest rank—but perhaps the school as a whole would not have been very different, though much less glorious, if they had not lived. To get any view of it we must consider its achievements and its methods as a whole, and then devote some attention to the few great individualities which stand out above their fellows.

One of the most notable originalities of the Venetian school is its early abandonment of ecclesiastical rigidity even in the treatment of religious subjects. From the early years of the sixteenth century, before the great frescos of Michelangelo and Raphael had been completed in Rome, the Venetians had begun to paint what were known as *Santi Conversazioni* or informal groups of holy personages, generally in a landscape setting, talking quietly together. Such pictures have neither the regular pattern of the conventional altarpiece nor any attempt at story-telling or dramatic action. Except for the aureoles, which are not always present, they might be scenes of domestic genre. The next

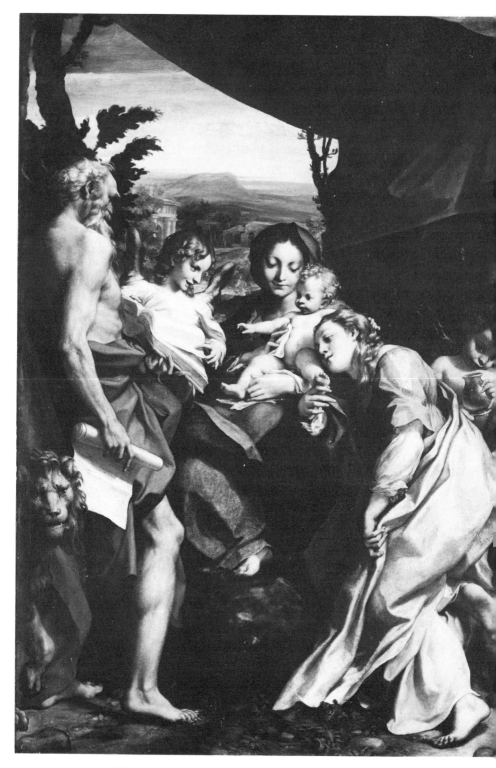

Plate 8. Correggio, *Madonna with Saint Jerome.*
Parma, Pinacoteca. (Photo: Alinari Art Resource.)

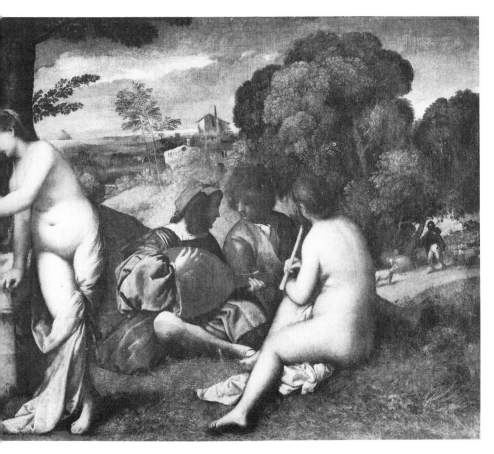

Plate 9. Giorgione, *Partie Champêtre*. Paris, Louvre.

step is easy to take, and in these same years conversations no longer holy are painted—pictures of men and women, nude or draped or clothed in contemporary costumes, seated under the trees and making music or eating and drinking together—pictures in which, if they have any definite subjects, the subject has become so unimportant that we have forgotten what it is. They are full of poetry and romantic charm, these pictures; they are never coarsely or meanly realistic; but they mark the beginning of our modern tendency to accept life and nature as the sufficient subjects of art. They no longer have any object outside themselves. They are no longer aids to devotion or books for the illiterate, or even, in any proper sense, decorations. They are just pictures, self-limited and self-contained, with no other end to serve than to be beautiful and enjoyable possessions—with them our modern art has definitely begun.

One of the most notable of the characteristics of modern art is its interest in landscape, and this also comes to us directly from the Venetians. In their conversation pieces the landscape background plays a

vastly more important part than it had ever done elsewhere. The figures are not in front of the landscape, they are in it, and in many of them the importance of the landscape becomes so great that they might properly be called landscapes with figures. The final step of removing the figures altogether they never took, but neither did Claude or Poussin, whom we all admit to be primarily landscape-painters. Giorgione and Titian were the first painters to show a deep interest in landscape for its own sake. They painted it with far more truth than any of their predecessors or contemporaries, and they gave it a beauty and nobility that are still unequalled.

In technic as in temper and in treatment of subject the Venetians are the ancestors of the moderns. Some of them occasionally painted in fresco and, of necessity, the earlier men painted in tempera. Neither of these processes fully satisfied the Venetian love of color, and they eagerly seized upon the new process of oils, commonly said to have been brought to them from Flanders by Antonello da Messina. Wherever they got it, they rapidly made it

their own and developed its special qualities to the highest possible point. Fortunately, they did not repeat Leonardo's experiment of painting with it directly upon the plaster. They preferred, even in mural decoration, to substitute framed canvases for paintings upon the wall itself. Fresco they inclined to reserve for the outside of buildings, and most of their fresco-paintings have disappeared, while their great paintings in oil are intact even when discolored and embrowned by age.

For a long time the Venetians retained in their paintings the underground of tempera, and it is difficult to know when, if ever, they finally abandoned it. It is a question of little importance to the layman except as it bears upon the preservation of their works, for the painting we see is in oils and the material of the underpainting has little bearing on the results attained. At first this surface painting was entirely in transparent glazings, and by these glazes was achieved a splendor and richness of color hitherto unknown. But, much as the Venetians loved this decorative splendor, it did not satisfy them. Grad-

ually the glazes are broken up, opaque and semiopaque tones are added, the surfaces are thumbed and kneaded; finally, light and atmosphere are added to color, complete illusion is attained, and we have the full portrayal of the colored world— that world about us which, so far as our vision is concerned, exists only in light and color. It is scarcely possible to go further in this direction without arriving at modern impressionism.

With this glorification of color goes a necessary and profound modification of form. It is not merely because the Venetian ladies and courtesans were. big and blond and sleepy that Venetian art introduced a new type of beauty into the world. The Venetians were sometimes indifferent draftsmen, but their lack of insistence upon structure is not merely carelessness or inefficiency. The best of them could draw superbly within definite and self-imposed limits. But because they cared supremely for light and color and atmosphere they melted away their contours and simplified their masses, created large united surfaces for light to play over, painted out all minor accents, and sub-

stituted infinitesimal gradations of color for definite statements of form. By these means they attained the peculiar irradiation of flesh which is one of its greatest beauties at the same time that they formulated an ideal of the female figure which is more nearly Greek than anything else in painting. These massive, white-skinned Venetian women are sisters of the women of Phidias, and, as the late George Frederick Watts has acutely remarked, if one were trying to reconstitute the pediments of the Parthenon one might conceivably supply missing figures from those which Titian has painted, never from those drawn or carved by Michelangelo.

The revolution which brought in all these changes in the art of painting seems to have begun in the workshop of Giovanni Bellini. Some beginnings of it may be found in the later work of Bellini himself, but Bellini was long-lived and a student to the last, and in his old age he learned from his own pupils something of this new style which they had inaugurated. The leader of the innovators was apparently that fascinating and somewhat mysterious

person, Giorgione, and he is, as nearly as any one, the indispensable man in Venetian art. But his fellow students, Palma and Titian, were probably about of his own age and one of them was certainly his equal in genius, so that there is no reason to suppose that the new manner would not have taken something like the same form without him. Indeed, we cannot tell how far he himself may have been influenced by these colleagues whom he certainly influenced in turn.

We know little of Giorgione himself except that he was big and handsome and an accomplished player on the lute, and that he died of the plague at the age of thirty two or three. We know almost as little, with any certainty, of what he actually painted, for the works traditionally ascribed to him have been so much disputed by various critics that there are only three of them whose authenticity is unquestioned: "The Castelfranco Madonna," the so-called "Soldier and Gypsy," now known as "Adrastus and Hypsipyle," and "The Three Philosophers" or "Æneas, Evander, and Pallas." "The Castelfranco Madonna" is a beautiful picture, but it

would hardly of itself account for Giorgione's legendary importance as the founder of a school. There is a softness and a poetic charm in it that are personal, and the landscape plays a somewhat greater part than was usual at that time, but the composition is formal and there is nothing strikingly new in the work. But in the "Soldier and Gypsy" the whole Venetian school is implicit. The very uncertainty of the title is symptomatic; the story to be told was so unimportant that no one knows certainly what it is, and that the picture represents Adrastus and Hypsipyle is but a modern guess. Here we have an informal and naturalistic composition with comparatively small figures in a dominant landscape, a young man standing at ease on one side, a nearly nude woman suckling a child upon the other, the whole centre of the canvas taken up with a rolling thunder-storm over a distant city. There is no action, and the two people pay little attention to each other. The figures are not so massive as they are to become, but there is already, in the figure of the woman, that smooth and simplified drawing, that sacrifice of precise accent to breadth of

light, which is characteristically Venetian,
and her very pose is one that is to haunt
Venetian art, appearing again and again
in the works of Tintoretto and Veronese.
The "Partie Champêtre" of the Louvre
was surely painted by the same hand as
the "Soldier and Gypsy," and if so it is
one of Giorgione's most perfect and most
mature works. The composition is more
concentrated and more masterly but equally
informal, a marvellous composition held
together one knows not how. The drawing
is firmer and more solid, but it is drawing
of the same sort. These young men play-
ing upon lutes are the brothers of Adrastus,
these women are the sisters of Hypsipyle,
more full-blown and ampler. The color is
incomparably rich and glowing, with a
sober yet fire-shot harmony. No one has
yet pretended to find a subject for it. Its
subject is youth and love and music, na-
ture and life. If it is less technically perfect
than some things which were to come after
it, it has a depth of romantic and poetic
feeling which no later work can show. It
remains a masterpiece among the world's
masterpieces, a picture more loved than
any other by those who feel its abiding
charm.

It is this depth of poetic feeling that marks all Giorgione's work, and is almost the only test of its authenticity. It is shown in his wonderful portraits, it is shown in his "Venus" at Dresden, the first of those nude figures painted for their beauty alone, which became so common in Venetian art. Titian, who is said to have finished it after his friend's death, imitated it again and again, copied it, indeed, almost line for line, but though he added a new richness of technical resource, he never equalled its serene and noble beauty. There are a few other pictures that are pretty generally accepted as by Giorgione. There is a whole series of works which are claimed alternately for him or for Titian or some minor member of the school. Even if they are not his they help to show us what he was like—what was the kind of picture sure to be attributed to him. In the end we can make out a definite and original artistic personality of the highest order of genius, and a profound and lasting if not absolutely decisive influence on the formation of the Venetian ideal of art.

It is difficult to know just what part was played by Titian during Giorgione's

lifetime. Was he Giorgione's equal in age and almost his equal in performance, dividing amicably with him the decoration of the Fondaco de' Tedeschi, or was he, as some would have it, a lad of eighteen when that work was completed, the humble follower and assistant of an already celebrated master? Or is the truth, as would seem intrinsically probable, somewhere between these extremes? His earliest works are inextricably confused with those of his friend, and the critics will probably never arrive at any perfect agreement as to which of them painted certain well-known canvases. Some of these seem, indeed, to have been painted by both of them, for there is a constant tradition that Titian was intrusted with the completion of the works which Giorgione left unfinished.

But whatever Titian's share in the golden morning of Venetian art, its noonday splendor was for him. After the death of Giorgione he rapidly became the acknowledged head of the school, retaining that position against all rivals during his long life, and the first two-thirds of the sixteenth century are full of his glory. No artist was

ever more splendidly successful. He could paint anything and paint it in a way pleasing to everybody. He was prodigiously industrious and turned out an incredible number of works of all kinds—portraits, easel-pictures, altar-pieces, mythologies, nudities, vast decorations—all of them supremely able and many of them masterpieces of the highest order. He was a perfect man of the world, the friend of princes and emperors, a wealthy and respected citizen, Count Palatine of the Empire and Knight of Saint Iago; and his fame was coextensive with the civilized world. When the plague at last carried him off, in 1576 (a patriarch of eighty-six years, according to the lowest count, of ninety-nine according to that more commonly accepted), all rules were broken to give him a public funeral. He was a man born to succeed in the world and meaning to do so; moral, perhaps, rather from a certain coldness of temperament than from any nice scruples of conscience; able to enjoy the society of a scamp like Aretino or to be complacent to the vices of the rich and great without personally sharing in them; a trifle avid of honors and of money; just and honor-

able in his dealings, yet jealous of any rivalry; a character well-regulated and admirable rather than entirely sympathetic.

He painted continuously for seventy or eighty years on end, and his works are almost as various in manner as in subject. He lived through a time of rapid changes, and his later work is as different from his earlier as the world of the end of the sixteenth century was different from the world of its beginning. But there are great differences also among the pictures of any one time. He was a many-sided man, with multiple interests and abilities, experimenting in new directions and brusquely returning upon himself to execute new variations on an earlier theme; and he would not admit that any one could do what he could not, and must enter into direct rivalry with anything accounted successful, pitting himself, now against Dürer for minute finish, now against Michelangelo for vigorous and colossal forms. If, upon the whole, we prefer the productions of the first half of his career, we must remember that that half includes the work of some forty years and brings him nearly

or quite to the age of sixty. All his later work was the production of what, in any one else, would have been old age; yet at the very end of his life his prodigious vitality was capable of technical innovations which, for good or evil, profoundly influenced the subsequent course of art.

While youth and early manhood endured he retained something of the Giorgionesque romance, and his first task was to carry to a higher perfection the Giorgionesque tradition. Apart from the works which may be either his or Giorgione's we have a series of unmistakable Titians, saintly or secular conversations, which culminate in that exquisite vision known as "Sacred and Profane Love"—a picture with nearly all Giorgione's poetry and passion and more than his accomplishment—a picture of more closely woven tissue, firmer in its drawing, of a nobler style in its draperies, more delicate in its surfaces, and more flower-like in the mingling of lovely hues. Then he enlarges his canvas and complicates his scheme, adds more figures, risks a certain diffusion, but holds together by his color and his light what the line alone would have left straggling. There is

not much poetic intensity in the "Bacchanal" of the Prado, or even in the "Bacchus and Ariadne" of the National Gallery, but there is freedom and energy, an abounding joyousness and a magnificent science. Or he concentrates himself, becomes thoughtful and serious, attains to a brooding solemnity in that unique and inimitable picture, the "Entombment" of the Louvre —a perfect composition by one who was not naturally a composer.

For it is not so much a lack of religious feeling as a lack of decorative feeling—a lack, above all, of a spontaneous genius for composition—that gives a certain hollowness and theatricality to Titian's great altar-pieces, to the "Assumption of the Virgin" and the "Pesaro Madonna." There is the same hollowness and theatricality in nearly all his larger pictures, whatever the subject. They are composed, but they are composed by main force, and the attitudes of the figures are imposed upon them by an arbitrary scheme. Or if he escapes this danger he falls into confusion, or into a certain emptiness and commonplaceness. He is at his best in comparatively small canvases; in his portraits of dignified men

or beautiful women, in his little pic-
tures of two or three figures, in his single
nudes, like the delicious "Venus" of the
Tribuna, or half-lengths like the "Flora."
He has left us a multitude of such things,
painted as no one else has ever painted,
with such fusion of lovely tones, such
glow of light and color, such variety of
touch, crisp or melting and tender, such
perfection of surface and texture as makes
of a few square feet of canvas a source of
endless delight—"infinite riches in a little
room."

This is his ultimate distinction, and in
this he is the representative Venetian,
that he was not a poet or a composer or
a draftsman, but precisely the greatest
painter in the stricter sense of the word
that ever lived. And yet, before this or
that masterpiece, one feels that reserva-
tions are ungracious, that comparisons are
only possible with the greatest, that there
is in him a balance of all good qualities
which is almost but not quite unparalleled.

As he grew old a certain bluntness and
even coarseness of feeling becomes more
conspicuous in the work of Titian. His
sensuousness becomes sensuality and some-

times sinks to grossness. His female figures grow fat and creased and their faces become blocky and stupid. He becomes pompous and emphatic, and in such attempts at the grandiose and the Michelangelesque as the decorations of Santa Maria della Salute reaches the point of intolerable flatulence. His admirable technic begins to break up, his color becomes hot and disagreeable, his brush-work thin or crumbling and heavy. Nearly everything he painted after 1540, and it is half his life-work, could be removed with gain rather than loss to his fame—nearly everything except a few of his very latest pictures. In his extreme old age there is a sudden revival of fire. The old technic has gone altogether and a strange new one takes its place—a technic in which nothing is precise, in which a maze of colored strokes builds the figures out of space. Conventional composition is entirely abandoned and a new composition of unexpected angles and odd spottings comes into being. The color becomes cool, the browns and reds giving place to grays and blues. Finally, there is a strange smouldering passion, a fierce intensity, in such a picture as the

"Entombment" of Madrid that is singularly different from the almost brutal callousness of the work of a few years earlier. In the last picture of all, "The Pietà" of the Venice Academy, the flame has burned out, leaving but a heap of ashes.

No other painter than Titian ever more nearly resumed a whole school in his proper person. Before him Venetian art was still primitive. It progressed with his progress, and its character was most perfectly fulfilled in the work of his prime, while its secondary masters were dominated by his influence when they were not directly his pupils. In his later years it would have been in full decline but for the work of two younger men, Veronese and Tintoretto, who survived him by twelve and eighteen years, respectively.

And, indeed, the elder of the two, who outlived the younger, brilliant as are his finer performances, is, in a sense, a decadent painter. Ever since Ruskin, with the enthusiasm of a pseudo-discoverer, found in Tintoretto's pictures not only thoughts and meanings which had never entered the painter's head, but objects and

incidents and figures which he had not placed upon his canvas, it has been the fashion to exalt that artist to a place entirely beyond his merits and to overrate him even more than he had been underrated. He was a man of something of Michelangelo's temperament without the Florentine austerity or the Florentine training—a man of furious and turbulent energy without curb or restraint—and he wreaked himself in a violence of improvisation in which composition, drawing, color, and sound method were all sacrificed in the effort at self-expression. He came upon the stage just as Titian was entering upon the second half of his career, when the beautiful workmanship of that master's prime was as much a thing of the past as the lyric mood of his youth. Tintoretto is essentially a painter of the baroque, a painter in whom all sense of measure is lost, with whom dignity is almost impossible, and tranquillity quite inconceivable. Everything is bustle and hurry. Figures never stand upright, they rush and tumble and fall headlong. They cannot sit or recline without agitation, and the apostles of the "Last Supper," as at San Trovaso,

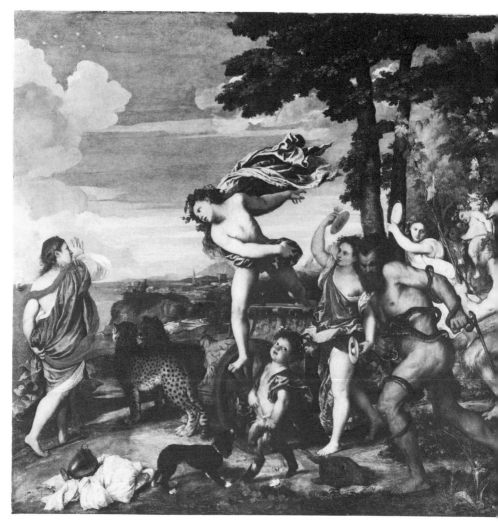

Plate 10. Titian, *Bacchus and Ariadne.*
London, National Gallery.

Plate 11. Tintoretto, *Saint Jerome and Saint Andrew.*
Venice, Ducal Palace. (Photo: Alinari Art Resource.)

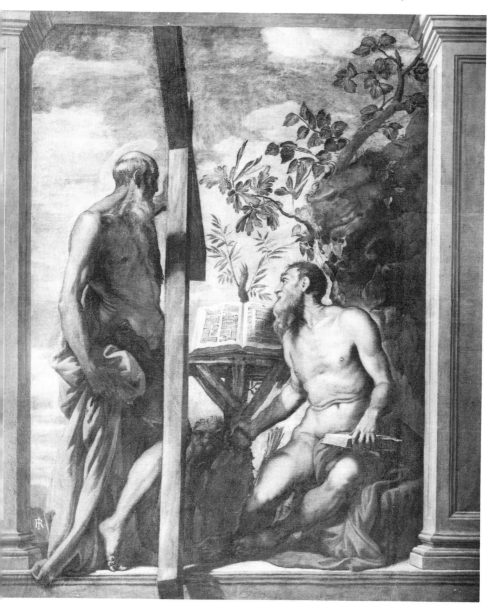

look as if a bomb had suddenly exploded in the middle of the table. One of them cannot so much as pick up a wine-flask without a violence of theatrical gesture as if he were about to throw it at an enemy's head.

He had taken as his motto "the drawing of Michelangelo and the coloring of Titian," but he was as far from understanding the one as the other. He knew the figure well, after a fashion, but his study of Michelangelo went no further than an imitation of the long-legged type of the women on the Medici Tombs and an exaggeration of their twisted movement. He was always in a hurry, and his drawing is almost always cursory and calligraphic and sometimes inexcusably careless. He wanted no more drawing generally than would convey the sense of vigorous action, and was content to rest with that. His color is violent, running to strong contrasts, cold rather than warm, with a tendency to blue and sharp pink; or it is of a nearly uniform ashy gray. That is, as nearly as we can judge of it, for there are few of his pictures that have not blackened or faded. His impetuosity and his mania for speed

would not allow him to give the necessary time to the complicated processes of Venetian technic, and he knew no other. Perhaps the small prices for which he was willing to work rather than be unoccupied led him to economize in the quality of his materials. At any rate, while many of his canvases never were anything more than vast sketches, almost all of them are ruined.

His most original contribution to art is his treatment of light and shade. He was fond of experimenting with little manikins, hung up by strings and lit by candles, and he invented a new chiaroscuro, audacious, capricious, but often fascinating; barred his figures with arbitrary cast shadows, brought high light against deep dark with startling effect, made of his lights and shades a new and independent pattern, overlying and dominating the pattern of line and mass. With him light and shade becomes the great vehicle of expression, dramatic, intense, almost savage in its energy, making us forget the essential triviality of his conception.

For there is nothing for which he has been more overpraised than for the truth

and power of his imagination. His treatment of subject is rarely more than vigorously picturesque, is often coarse, and at times sinks to the level of claptrap and sensationalism, as in the "Last Supper" of San Giorgio Maggiore, where the troop of angels formed from the smoke of the lamp is an invention worthy of Gustave Doré. And yet he is a great master. When the subject suits his turbulence, as in the "Miracle of Saint Mark," he is wonderfully exhilarating. His force and his abundance are equal to Rubens, his color is more fiery and superb, and his virtuosity of hand incomparable. And, once or twice, in quieter subjects, when there is a moment of appeasement and he gives himself time to express his genius fully, he has produced masterpieces of perfect art. There are few things in the world more noble than the "Saint Jerome and Saint Andrew," few things more masterly than the "Saint George," and there is nothing lovelier than the "Ariadne" or the "Pallas Driving Away Mars."

Tintoretto was an exception in the Venetian school as he would have been in any

other, a kind of thunder-storm in the heat of the day. Veronese was a calm and serene afternoon. Though he came to Venice from without, and much in his art was not strictly Venetian, yet he had the Venetian qualities in their utmost perfection, united with those which he brought with him or created for himself. Painters, from his own day to ours, have always known him for what he was, one of the mightiest of masters; but, misled by the apparent simplicity of his art, criticism has hardly yet done him justice.

Veronese was by nature and by training what most of the Venetians were not, a decorator, and with him, though he painted it admirably, the isolated easel-picture was the exception rather than the rule. Therefore, the purely Venetian qualities of painting were modified in his work. The exquisiteness of surface and texture of the earlier work of Titian would be quite ineffectual on a vast scale, placed upon a ceiling or at the end of a long hall, and Veronese invented, or adopted, a simpler method and used it even in small pictures. His painting, as such, is always beautiful, but it is straightforward and

direct, appearing to deal in few subtleties, yet much more subtle and refined than is at first apparent. He had all the Venetian love for color and for light, but his color is cooler and his light broader than those of the other Venetians. The richness and fiery depth of Giorgione, the deep gloom or the violent contrasts of Tintoretto are equally unsuited to pure decoration. Veronese was an admirable fresco-painter and he brought to oil-painting something of the paleness and unity of tone of fresco. But as his knowledge of color, of chiaroscuro, and of the resources of oil-painting was complete, the result was a greater truth to the full-colored appearance of nature in open daylight than had ever been attained or than has since been attained on anything approaching his scale. It is only in small pictures that his degree of naturalism in the treatment of light has been surpassed, and it has never been combined with his decorative splendor.

He had to the full, also, the Venetian naturalism of temper—the love of life as it is, and especially of all that is sumptuous and luxurious in life. He had little of Giorgione's romanticism — his temper is

more like Titian's, but like Titian at his best—a frank and manly spirit, with a spice of humor which Titian had not, but with an unfailing simple dignity also, perfectly free from pompousness and affectation. He is never violent or theatrical, as Tintoretto often is, never coarse or unfeeling, never sentimental or morbid. His is a great, kindly, smiling, giant-like nature, loving all that is beautiful and rejoicing in it, but not squeamish, and quite willing that even a dog should have its day or that a cat should look at his kings.

In his broad tolerance of temper, in his love of light and color, in his perfect mastery of the technic of painting, Veronese was typically a Venetian, the equal of any of his fellows, and he had even added new conquests to the Venetian domain. But with the purely Venetian elements of his art he combined in a singular degree those qualities which were not specially Venetian but had marked the other great schools of Italy. He drew far better than any other Venetian and better than any but a few of the Florentines, and he composed better than any one except Raphael. Not

that he was in the least an Eclectic. His
drawing and his composition are his own
and fit him perfectly. His drawing is es-
sentially Venetian drawing, simplified and
enlarged to carry light and color, but he
had a stronger sense of form and structure
than other Venetians, and a purer taste, and
no one in the whole range of painting has
created an ideal of the female form that
approaches so nearly to that of the finest
Greek sculpture—sculpture which he never
saw and from which he can have borrowed
nothing. And his design is even more his
own, the development of his greatest native
gift—the gift that makes him the incompar-
able decorator he was. It is incredibly spon-
taneous, resourceful, and varied, ranging
from great formality to the extreme of pic-
turesque irregularity, but it is always sover-
eign and dominating, and not the smallest
detail of his most crowded and sumptuous
canvases escapes from its sway. In other
things he may fail now and then. Occasion-
ally a bit of false drawing will show itself;
occasionally a note of color is wrongly felt
or is so altered by time as to escape from
the general harmony; in composition he is
never wrong, and the best proof that a

work is not his, but an imitation, is that it anywhere fails in design.

In the work of no other master whatever—not even in that of Titian—are so many of the great elements of painting combined in so high a degree of perfection. If he is not the greatest of all masters, he is assuredly the most complete painter that ever lived. With him the art of painting reached its highest point —its greatest balance of all possible virtues. If it has gained something in the changes it has undergone since his day, it has lost more than it has gained.

Veronese died in 1588, Tintoretto not until 1594. After a hundred years of continuous and magnificent productiveness even the Venetian school was losing something of its splendid vitality. Yet all through the seventeenth century it continued to produce artists who, if not of the first rank, were yet painters and Venetians. The splendid tradition of the school had still some life in it, and would not give way to the eclecticism of the Bolognese or even to the naturalism of Caravaggio and his followers, though their art had

some points of contact with the later Venetian style. And in the eighteenth century the dying energy of Venice renewed itself and again produced a group of able painters and one man of surpassing talent who in a better time might have done almost anything.

The old Venetian love of landscape and architecture and the charm of their own wonderful city inspired Canaletto and Guardi. Canaletto painted Venice with a degree of architectural accuracy, a feeling for atmosphere, and a manly sobriety of tone that excuse his lack of color and make him a painter of real importance and one of the ancestors of modern landscape-painting. Guardi is slighter, gayer, more amusing, but much less serious. The last form of the Venetian conversation piece is found in Longhi's little interiors in which the degenerate Venetians of his own day carry on their little flirtations and their trivial affairs. But it is in the work of the greatest decorator of the eighteenth century that the old splendor of Venetian art is most nearly revived.

Tiepolo almost renewed Titian's international successes of two centuries earlier.

His art was in demand in Germany as well as in Italy, and he died in Spain, where his work influenced Goya and, through him, the art of modern France. He was thoroughly of his time and pushed the extravagances of the baroque and the rococo further than any one else. Nowhere else will you find such audacities of perspective, such violence of foreshortening, such reckless disregard of all measure and all restraint. He erects pyramids and obelisks on the clouds, paints galloping horses seen from directly beneath, fills the air with frolicking girl-angels whose long white legs hang out of immense masses of rumpled and tormented draperies. He allows his picture to tumble out of its frame on all sides, plastering clouds and cherubs straight across the cornice mouldings and doing to the actual architecture what Correggio did to an architecture that was merely simulated. At Nervasa, in the lake district, he has even painted a ceiling in two stories, the lower one cut out as with gigantic scissors and allowing the upper to be seen through its interstices like a piece of stage scenery or a child's valentine. All this he does with an amazing virtuosity

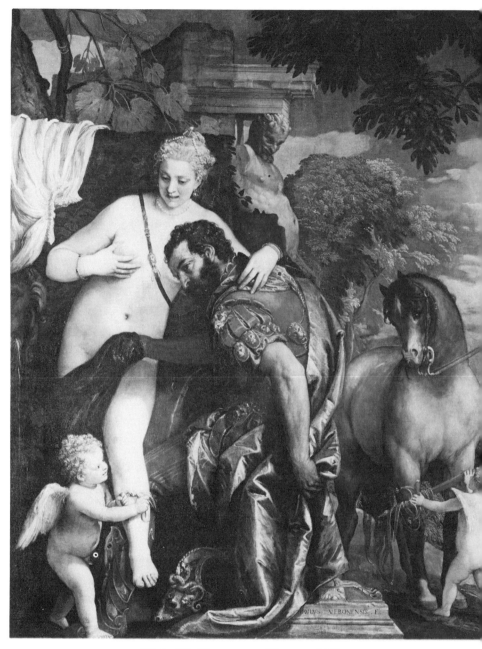

Plate 12. Veronese, *Mars and Venus.*

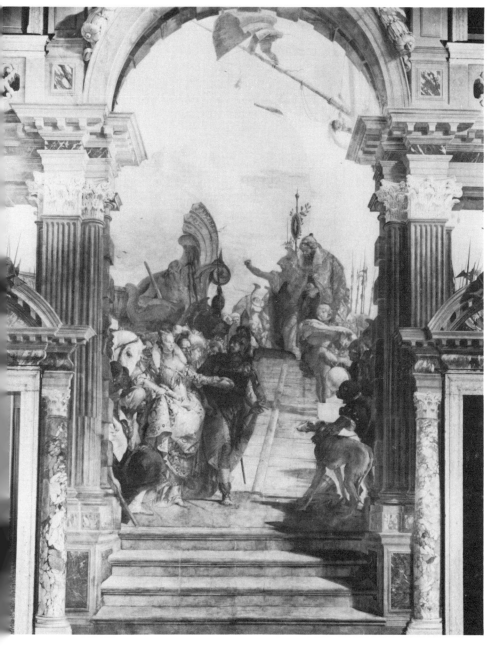

Plate 13. Giovanni Battista Tiepolo, *Landing of Cleopatra.*
Venice, Palazzo Labia.

and in a captivating scheme of light but warm color interspersed with vivacious darks. Nothing is difficult to him, and nothing seems to require any preliminary study. His power of improvisation is unprecedented, and his slightest sketches, like his completed works, show an absolute foreknowledge of what he intends to do. There is not a wasted touch in them, or the slightest indication of afterthought. If he does not carry out a work exactly as planned, he replans it in his head and does it differently—he makes no alterations in the sketch.

All this shows a prodigious and almost superhuman cleverness, but the frescos of the Palazzo Labia in Venice show how much more than mere cleverness there was in Tiepolo. On four bare walls he has painted a simulated architecture, a quite possible and even dignified architecture of the late Renaissance, such as Veronese delighted in, and between the columns he has painted, in frank imitation of Veronese, scenes from the story of Antony and Cleopatra. The costumes are Veronese's with a slight change that gives an eighteenth-century touch to them. The coloring is

Veronese's, only a little cooler and a little more vivacious. The compositions have almost the richness and the authority of those of the earlier painter. Imitative as they are, and therefore less characteristic of their time and of their author than some other of his works, they show a real kinship with the master they imitate. They lack the gravity and the simplicity of Veronese, but they have almost his brilliancy and more of his spirit than any one else has ever attained, and they incline us to believe that in a more serious age Tiepolo might almost have equalled his great prototype.

So, down almost to the end of her independent existence, Venice maintained a living school of painting—a school that is still living in its offshoots in other lands. It is, in the literal sense, a school—*the* school—of painting as a separate and distinct art—a school which Rubens and Velasquez attended and whose lessons they passed on to others. The masters of that school are the teachers of all the world, and all who have fruitfully studied the art of painting have found in Venice their Alma Mater.

# III

## DUTCH AND FLEMISH PAINTING OF THE SEVENTEENTH CENTURY

By the end of the sixteenth century Italian art was rapidly declining, even in Venice; but the influence of Italy was spreading into other countries, and in the seventeenth century the vital art of the world was produced in Flanders, in Holland, and in Spain. It was a century of painting. These countries had produced the best of which they were capable in architecture and in sculpture long before this time; now, while they were creating great and important schools of painting, their architecture was mediocre and their sculpture almost non-existent.

In Flanders there had been an admirable native school of painting in the fifteenth century—a school not unlike the Venetian in some things and one that, by its invention of oil-painting, provided the Venetians with their necessary means of ex-

pression. The Flemings, like the Venetians, lived in a moist climate and, like the Venetians, they were a nation of traders with the East. They were fond of color, of material luxury, of rich brocades and splendid materials of all sorts. Even more than the Venetians they were Naturalists, accepting life as they saw it and reproducing it as accurately as they were able. What they had not was the Italian love of beauty, the Italian genius for form, and the Italian mastery of ordered arrangement. When intercourse with Italy taught them to perceive this lack they set themselves to studying Italian art, and when Rubens came upon the scene they had been "Italianizing" for near a hundred years with deplorable results. Their imitation of Raphael and Michelangelo had succeeded only in eradicating the native qualities of the school and in substituting for them a ridiculous misunderstanding of the Italian genius. It is doubtful if any painting more worthless and sterile than that of the Italianized Flemings of the latter part of the sixteenth century has ever been produced.

Rubens, too, was an "Italianizer" and

spent many years in Italy, but he had a great genius for painting, and his instinct led him to find in the Venetians a school sufficiently akin to that which had once flourished in his native land to be capable of a fertile union with it. The result was an art of immense vitality and fecundity —an art prepotent among all others— which filled the seventeenth century with its glory and became, in its turn, the ancestor of the best art, English or French, of the succeeding century.

Peter Paul Rubens is almost, in his proper person, the Flemish school of the seventeenth century. He was surrounded by able men, many of them of his own age or older than he, but his dominant personality reduces them to the rôle of mere satellites, revolving about him and adding to, while they reflect, his splendor. Born almost exactly a hundred years after Titian, he held in his day much such a position as Titian had held a century earlier. His fame was world-wide and his art everywhere in request. Whenever the best man was wanted he was called upon, and he served the little courts of Italy

and the great ones of England, France, and Spain as well as that of his native country at Antwerp. He is a splendid figure in history, a cultivated gentleman speaking seven languages, a knight, an ambassador, and a friend of princes, a man occupied with many things besides his art, yet withal a painter of such prodigious industry that he produced more than twenty-two hundred pictures, many of them of huge size. Such an enormous production was made possible only by the systematic use of a corps of pupils and assistants; but while Rubens was the head of a vast manufactory of works of art, he put so much of himself into everything that left his workshop as to maintain its output at an extraordinarily high level, and there are enough works of his own hand extant to provide masterpieces for half a dozen painters of our modern stature.

In temper his art is more like that of Veronese than any other; he had much of Veronese's power, his love for the sumptuous, his pride and joy of life. But he is without the Venetian seriousness, without the grave and dignified elegance of

Veronese. He is, by comparison, a trifle barbaric, more exuberant, more emphatic, coarser-fibred. Veronese is often at his best in depicting a banquet; Rubens is never more himself than when painting a kermess. His sensuality is franker than that of any Venetian, and where Veronese's female figures are amply classic, Rubens's are pulpy and even baggy. Yet he has an easy, florid, high-worded eloquence that can rise to almost any theme. No one was ever more flowing, more abundant, more vigorous—perhaps no one was ever so skilful. For him difficulties exist only to be conquered with a triumphant facility, yet his virtuosity is never indulged in for its own sake but is kept in subjection to a cool intelligence and a profound learning. For this jovial, ruddy, full-blooded, Flemish giant is in his way a Classicist and an Eclectic. Everything in his work is calculated and everything is based upon a deep study of the art of the past. He has pondered the works of Leonardo and Michelangelo no less than those of Veronese and Titian; has found time in the midst of his vast productivity to make many copies; has chosen from everything that

has been done before him those elements which he can usefully incorporate into his own style and bend to the expression of his own ideals and the ideals of his own time. How thoroughly he did express those ideals is shown by his almost universal popularity.

At the close of the wars with Spain, Flanders had remained Catholic and monarchical while Holland had become Protestant and republican. Rubens is the painter of the Catholic and monarchical reaction and his art was of the same kind as that of the Jesuit churches—splendid, a little pompous, without great purity of taste, an art intended to impress and to dazzle rather than to win. His business was to paint great altar-pieces for the churches or great allegorical decorations for royal palaces; and to carry out such tasks one of the most essential qualifications is rapidity of execution. So he became one of the speediest of executants, but his speed is very different from the hasty improvisation of a Tintoretto. His rapidity is simply efficiency. It is perfectly deliberate, and both his style and his technical methods have been profoundly

modified to attain it. His drawing is full of flowing and redundant curves, partly because they are in the taste of the day, partly because such forms are most rapidly and easily executed with the brush; but these curves are not the result of rapid and careless brush-work. They are intelligent modifications, consciously adopted, of the forms of Michelangelo, and they are carefully provided for in his preliminary studies. When one of his patrons—a Frenchman who was, perhaps, influenced by the severer classicism of Poussin—found fault with the bandy legs of some of his figures he gravely defended them as properly drawn according to the best tradition. His composition, his color, his technical method have all received a similar modification. His composition is full of the same emphatic, cursive, S-shaped lines as his drawing. It is restless and full of turbulent movement, but it is rigidly controlled, perfectly lucid, never for a moment out of hand. His color is now rich and sonorous, now coolly brilliant, but it is never carried beyond a certain point of subtlety, and there is always an element of recipe in it. It is neither passionate nor

exquisite, but the best color attainable in the time given to the work by a man who knows all that is to be known about color, as about other things, and who has learned just how his effects may be obtained with the least labor. His method of painting is based upon the Venetian, modified by the old Flemish love for thinness of material and smoothness of surface—modified above all by the necessity of speed. Nothing so light, so rapid, so flexible was ever invented, and as he grows older and his mastery of it increases he comes to paint almost with vapor, and there seems to be no solid matter at all on his canvas.

The consciously eclectic and almost academic nature of Rubens's art is most clearly seen in the "Descent from the Cross," the first important picture which he painted after his return from Italy. Here the attempt at a synthesis of great qualities is almost as patent as in any of the Bolognese. The composition is largely borrowed from Daniele da Volterra, and the determination to combine Florentine draftsmanship, Venetian color, and the realistic force and sombre light and shade of the Naturalists

is self-evident. But the fusion of elements is more conspicuous in this instance only because it is as yet incomplete. The picture is his "masterpiece" only in the original sense of the word—the piece intended to announce and to assure acceptance of his mastery. It is in later works that this style, compounded of many simples, is fully matured and becomes fully his own, so that he speaks through it with perfect ease. How entirely his manner is suited to the matter, and how admirably his painting accords with its natural setting of sumptuous and somewhat overornamented architecture may be seen in the "Marie de' Medici" series in the Louvre, now that these pictures are seen together in a room designed to hold them. They are not of Rubens's very best and they contain only here and there his own handiwork, but it is all the more evident how magnificently they are planned. Years ago, when they hung among other pictures in the Long Gallery, they seemed rather pompous and summary, empty and lacking in quality. Now they are seen to be superb decorations which, in the great halls of the Luxembourg Palace for which

they were designed, can have lacked nothing of perfect appropriateness.

Such was what one may call the official art of Rubens. Others have created an art that is nobler and purer, more passionate or more delicate and lovely; there is no art that is more intelligent or, in its own way, more admirable, and hardly any from which so much may be learned. But, after all, Rubens was a man and not a formula, and so he escapes on all sides from our definition. He had his likes and his loves, which were those of an eminently sane and manly nature, and as he could paint as easily as he could talk, these likes and these loves expressed themselves pictorially. He liked hunting and was fond of animals, and he painted beasts as almost no one else has done. He was fond of country life and he became a great landscape-painter, painting a landscape more homely and less stately than that of the Venetians and making distinct advances in truth of light and natural effect. He could even be tenderly poetic now and then, painting one of the most delicate and beautiful representations of moonlight known to art; or romantic, as in that

little picture of fighting knights that might
have been painted by a Frenchman of
1830. Most of these things are the work of
his later years when he had retired from
statesmanship and from the execution of
great commissions and painted to please
himself. At fifty-three he married his
second wife, Helena Fourment, a girl of
sixteen, and his love for her inspired a
series of portraits and of pictures in which
she is ever the central figure, which are
among the most delicious things in the
world. He painted her in the most splen-
did costumes his well-furnished purse could
buy; he painted her, with singular frank-
ness, in next to nothing at all. Plump and
white and blond, a true Fleming, but
radiant with youth and beauty, we know
her as a bride, we know her as a young
mother, we know her as this or that per-
sonage of mythology or of sacred legend.
In "The Garden of Love," at Madrid,
there seem to be half a dozen Helenas,
each lovelier than the other.

In such pictures as this last, Rubens
descends straight from Giorgione. They
are like the "Partie Champêtre," but a
little gayer, a little more florid, a little

less nobly poetical. A hundred years later Watteau was to take up the theme, to treat it at once more frivolously and more sentimentally, to etherealize its frank and solid humanity, and to find the type of the French eighteenth century.

Among the brilliant courtiers of this king of painting, one needs special mention not only for his own merit but for his decisive influence on the English school. Anton Van Dyck is not a painter of the very highest rank—not one of the world's dozen supreme masters—but, as Fromentin said of him, if not on the throne he was near it. No other painter not of this supreme rank is quite his equal, and he needs but a little more sturdy strength, a little more originality, to step from the highest place in the second line into a place in the first. He is like a Rubens of less rugged fibre, more polished, more elegant, with a languid and melancholy distinction that predestines him for the favorite painter of Charles I, but without the sap and vigor, the hearty, natural humanity of the greater man. He is more impressionable and therefore more vari-

[ 237 ]

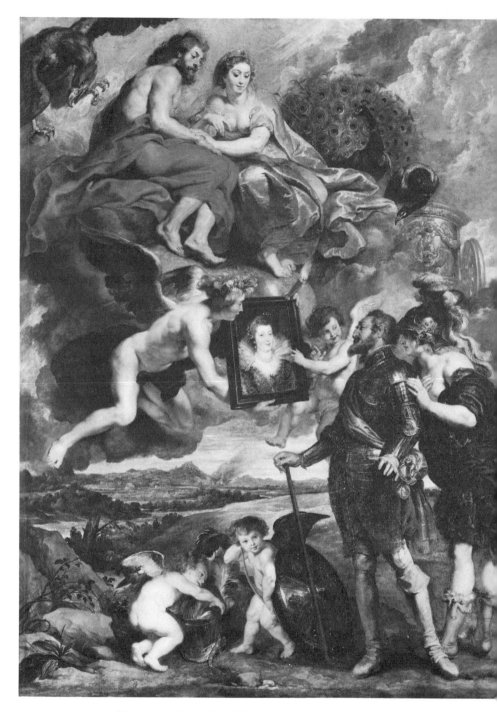

Plate 14. Peter Paul Rubens, *Henry IV Receiving
a Portrait of Marie de' Medici*. Paris, Louvre.
(Photo: Giraudon Art Resource.)

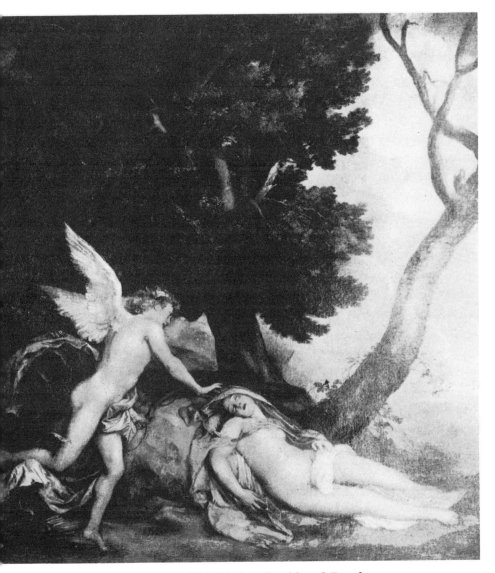

Plate 15. Anton Van Dyke, *Cupid and Psyche.*
London, Hampton Court Palace.
(Photo: Marburg Art Resource.)

able than Rubens. His early work is thoroughly Flemish and scarce to be distinguished from that of his master. In his Italian days he comes under the influence of Titian and achieves, in both portraits and subject pictures, a dignity and a beauty of color beyond Rubens's range and almost worthy of the great Venetian. Back in his native land, at a time when Rubens is absent, he almost usurps the leadership, and his art has the full-ripe Flemish savor. Finally, in England, he ceases to paint altar-pieces or mythologies and becomes definitely the court portrait-painter. Gentility and prettiness gain upon him. Having no rivals, he gives himself less trouble and relies upon assistants for nearly everything but the heads. His art had already fallen far below its best estate before he died at the early age of forty-two.

But he was a *peintre de race*, if, perhaps, a little too high-bred for stamina. In his "Charles I" of the Louvre he has given us the finest example of the state portrait —the portrait which is also a decoration and in which dignity and decorative splendor are as important as likeness. He has

[ 240 ]

given more seductiveness to the beauty of women than almost any other. And in such an accomplished and straightforward piece of work as that portrait, in our own Metropolitan Museum, of the Duke of Lenox and his wonderful dog, he reaches very nearly to the highest level. Lastly, and this itself is a kind of glory, if we cannot imagine a Van Dyck without a pre-existing Rubens, neither can we imagine Reynolds or Gainsborough without the pre-existence of Van Dyck.

Nothing could well be more unlike the royalist and Catholic art of Rubens or the eminently aristocratic art of Van Dyck than the bourgeois, almost plebeian, art that was developing during these same years in the northern provinces. In the Protestant Netherlands there were no great church pictures to be painted; in republican Holland there was no demand for splendid allegorical glorifications of the royal house. These comfortable Dutch traders wanted only two things of art: they wanted their own portraits, and they wanted little pictures to hang upon the walls of their comfortable little rooms. The guilds and

shooting companies wanted group portraits for their halls, and some of these are very large, but they were the only large canvases in demand. And every burgher wanted the portrait of himself and his wife to hand down to his children. Of these portraits, whether large or small, they did not ask splendor or distinction, they asked only that they should be indubitably and recognizably like. They were not to represent a caste but an individual. And of the little pictures also they demanded that they should be likenesses of the things they knew and could recognize—portraits of their own houses with the people that lived in them, of their peaceful Dutch landscape with its canals and polders and cattle, of their towns or their ships and harbors. If you tried to give them anything more or anything else, it was at your own peril.

One more thing they asked, and that was perfect workmanship. Like the tradesmen and manufacturers they were, they wanted their money's worth of sound painting, as of sound carpentry or solid weaving, and you must know your trade if you were to please them. You might be

a brilliant executant, you might be merely a painstaking mechanic, but from the bravura of a Hals to the painful finish of a Gerard Dou some form of competent workmanship was imperiously necessary. And a thorough craftsman could look for the reward of a craftsman, no more. Each town had its painters as it had its blacksmiths, and the best painter in the town could make a fair income; but he might no more look for fame, international or even national, than the best blacksmith. He might, indeed, travel from one town to another in search of work, as the blacksmith might, but if he prospered where he was he stayed there, and his reputation might not, in his lifetime, travel so far as from one town to the next one in a country where distances are absurdly small.

Such a local tradesman, the best painter of Haarlem, was Frans Hals. Not an exemplary tradesman; rather too fond of drinking and notoriously quarrelsome with his wife; having to be fetched from the tavern now and then when his services were wanted; unthrifty, and dying at last

in the poorhouse. What was worse, a little careless and slovenly at times, but, even in the poorhouse, so much the best workman to be had and so sure of his likeness that one had to employ him. He had even been called as far as Amsterdam once, thirteen miles away, but came back before he had finished the great guild picture he began there. He is inimitable at these great guild pictures; half a dozen of them are to be seen in the town gallery. They have not much composition, but are put together anyhow; they have not even, at least the early ones, any general harmony of tone, being full of bright colors rather than of color. But they are miracles of rendering, unimaginably dexterous, marvellous in freedom and precision. Nobody can paint a sash or a halberd, a glass goblet or a cut-velvet jerkin, as he can. His handling is like sword-play, as free, as dazzling, above all as accurate. It is made up of separate, sharp, slashing touches, each falling into its exact place, each of the right shape and size to a hair's breadth, each more wonderful for its precision than for its rapidity. And there can be no doubt about his likenesses. You

would know one of these men anywhere; you do know some of them at once, when they turn up again after an interval of years. They are not psychological masterpieces, these heads; there is no great depth of feeling or subtlety of expression about them. Hals is content with externals; but for exact portraiture, sheer physical resemblance, it would be hard to better them.

Later, and in other things, single portraits of burghers and their wives, Hals can be graver and more solid. Nobody but Rembrandt could improve on the portrait of Vrouw Bodolphe in the Morgan Collection, and even Rembrandt could not much improve on it as mere painting, its free handling based upon impeccable draftsmanship, its quiet color perfect in its relations of tone. And Rembrandt alone could better its rendering of character. It is Hals at his best, which is as much as to say that it is as good as the best of any one in all that it attempts.

As he grew older still Hals simplified his palette still more, until he painted with three or four colors only, of which black and white are the chief. His handling grows

ever looser and less explicit. In the last stage of all, his wonderful eye has lost its sharpness, his wonderful hand its cunning. He is an old, old man. But the profound knowledge gained by a lifetime of work is still there, and a kind of pathos that is his own rather than his sitter's, and in the wreck of his physical organization he is still a master—perhaps a more affecting one than ever before.

No theory of demand and supply, no philosophy of "the race, the *milieu*, and the moment," will account for Rembrandt. Negatively, indeed, the fact that he was a Dutchman of the seventeenth century may help to explain some of the things he was not, but it will go a very little way toward explaining what he was. He was that entirely inexplicable thing, a great original genius. He had enough of what was common to his countrymen to make an early and marked success, and to be for a time the fashion. He had so much of what they could never understand that he early ceased to be popular and sank further and further into poverty and neglect as his genius developed. He is the

first notable instance in the history of art of the romantic and misunderstood artist—the artist out of harmony with his public.

He had to the full, when he chose to exercise it, the admirable Dutch lucidity of observation, the capacity to see and to reproduce the external world. He had, though it is not quite clear where he got it, the sound Dutch training. At any time of his life he could, if he chose, paint a portrait as like as those of Hals and as well painted, perhaps even more like and better painted, but you could never tell if he would choose. He would begin to dream of expressing the inmost soul of his sitter and forget the shape of his nose. He would see the possibility of some picturesque effect and violate all probability of costume. He would lose himself in the poetry of light and shade, and indulge in all sorts of expedients and experiments to the destruction of accepted methods. He would accept a commission to paint the shooting company of Captain Frans Banning Cocq, and instead of the kind of thing that Van der Helst could do so well and Hals so brilliantly, he would turn you

out a fantastic *Cour des Miracles* or a troop of bandits. What were you to do with a man who might thus, at any time, substitute a grotesque fancy or an imaginative vision for the plain statement of facts that you wanted? Really, he was not to be trusted.

And the thing this strange genius substituted for the truth was as likely to be trivially picturesque as profoundly imaginative. He had inherited a sham Orientalism from his master Lastman, and he made it more absurd than his master's. He got together all sorts of strange frippery and odds and ends of costume, had a magpie love for chains and gorgets and old morions or anything that shone and glittered, liked beggars' rags or Jewish gaberdines; and of all these things he would concoct elaborate nonsense pictures. The next moment he is seized and dominated by a true vision and becomes amazing in his clairvoyance, gives you blind Tobit feeling for the door or Doctor Faustus silent before the miraculous vision, or makes you feel that his Christ, breaking bread with the disciples at Emmaus, has as surely been dead as he is now risen and living.

And the same man who does these things is capable of the most hideous vulgarity and even of the grossest indecency.

He has no dignity, no sense of propriety, no sense of beauty, does not conceive the meaning of good taste. But he has a breadth of humanity and a depth of sympathetic insight that are unequalled. It is these qualities that enable him to enthrall us with those story-telling pictures which no other painter—least of all any other Dutch painter—could have produced; that make us accept the stories of the Gospel or of the Old Testament as actual happenings that we have seen, and believe in Tobias and his angel as we believe in our next-door neighbors. It is this humanity and this sympathy that give a strange intensity of life to his portraits, even when their accuracy of physical likeness is most dubious; that make them, when he is able to combine the powers of the observer and the man of imagination, the most wonderful portraits ever painted.

Some of these wonderful portraits we have in this country. There is nothing more characteristic of Rembrandt than "The Man with the Black Hat," in the Metro-

Plate 16. Frans Hals, *Vrouw Bodolphe* (detail).
New Haven, Yale University Art Gallery.
(Photo: Joseph Szaszfai.)

Plate 17. Rembrandt, *The Orphan.*
Chicago, The Art Institute of Chicago.

politan Museum; nothing in the world finer than "The Orphan," in the Chicago Art Institute. Perhaps his greatest masterpiece is a group of such portraits on one canvas, the famous "Syndics," of the Rijks Museum at Amsterdam. Here he has allowed nothing strange or fantastic—the conception is as simple and as straightforward as it can well be—but the power of his imagination and the magic of his light and shade have endowed these plain citizens, busy over the accounts of the Cloth Hall, with an essential humanity that is eternally interesting to mankind.

It is always with light and shade that Rembrandt performs his miracles, that he expresses the inexpressible and realizes the supernatural. Of light and shade he is the supreme master, understanding its possibilities of mystery and of sentiment as no one else has done, doing with it what can be done by no other means and what no one else has done at all. Neither Tintoretto nor Correggio himself understood Correggio's invention as Rembrandt understood it—neither of them makes it the warp and woof of his art as Rembrandt does. For Rembrandt the world exists only as

light breaking through shadow, as light illuminating shadow. He composes by light and shade, he draws by light and shade, he colors in light and shade, he executes for light and shade. With him composition is not a matter of lines and spaces, it is a matter of lighting. The importance of any part of his picture is strictly measurable by the amount of light it receives; the eye is led by gradations and directions of light; the things which are to be subordinated are lost in swimming shadow. Without some suggestion of his light and shade no composition of Rembrandt's would be intelligible, and he thinks so habitually in light and shade that his merest scratch of outline always gives this suggestion. His drawing is so essentially a matter of light and shade that he never draws a true contour, but follows an edge here or an interior marking there as the light reveals it to him. For him the color of an object is only important as it is luminous or shadowy in its nature. He never hesitates to falsify the color if it will help him to get the light he wants, and in his mature work the color tends to disappear entirely and we have a brown world in which the illusion of color is maintained only by degrees of

light and dark. The degree of luminosity of a given color has been extracted and is made to do duty for the color itself. Even his handling is modified and broken up by his search for light. In his earlier days he can still paint objects as well as any one, with all Hals's explicitness if not with his brilliancy. Later he no longer paints a hand or a sword-hilt, he paints only the light upon it. As a registry of form his touch is enigmatical, is clumsy and fumbling, is even, sometimes, physically unpleasant, as is his hot brown tone. But as a rendering of light it is infallible.

The very qualities which have made Rembrandt one of our gods of art and have caused him to be reckoned, by many, the very greatest of masters, rendered him incomprehensible to his own countrymen and contemporaries, and the painters understood him little better than the public. Ruysdael had, perhaps, a little of his romantic temper and this, with a love for such exotic things as rocks and waterfalls, insured his failure of popularity and his death in poverty and neglect. The typical Dutch painters are those who, with as little of Rembrandt's intensity of feel-

ing as of the Italian love for decorative
splendor, carried out the truly Dutch task
of embodying in an exemplary technic
a prosaic and exact portraiture of the
familiar world about them. There are a
host of them, almost all admirable after
their degree, and they painted everything
in Holland and in the narrow seas, indoors
and out. They were a race of specialists
and created a number of new *genres*. One
man painted only drunken boors, another
the lower middle classes, a third ladies and
gentlemen. They were the first pure land-
scape-painters, the first marine-painters,
the first painters of cattle, the first still-
life painters. They subdivided these *genres*
almost indefinitely, and one man would
devote himself wholly to winter scenes,
another to architecture, or even to church
interiors. By this piecemeal attack they
accomplished their aim of an almost com-
plete picture of the visible world as they
knew it. Little as they had in common
with Rembrandt, he had yet furnished
them with their necessary tool. If they could
not make light and shade express the super-
natural, they found in it the only possible
and complete expression of the natural, and
the whole Dutch school became a school of

chiaroscurists who devoted their best efforts to rendering the gradations and reverberations of light. Indeed, it is often their interest in light that alone makes their choice of subject comprehensible. It is only the play of light and shade that makes their church interiors interesting or their butcher's meat and dead game tolerable.

And if the Dutchmen were all naturalists and chiaroscurists, they were all admirable and impeccable craftsmen. Such sound, enduring, beautiful workmanship, such thoroughness of education, such precision and delightfulness of handling, had seldom been seen in the world and are hardly likely to be seen again. We have lost their methods and forgotten their training, and the best modern work, whatever its merit in other respects, is in technical matters but bunglingly amateurish in comparison with theirs.

In the study of landscape the attempt at a minute and complete investigation of natural appearances was not carried to so full and satisfactory a conclusion as in the painting of interiors. Dutch landscape is of great historical importance because it opened the way to further exploration in many new directions, and when landscape

began to be seriously studied again, in the nineteenth century, Dutch influence was, for a time, not only stimulating but dominant. But there were but a few effects of light in the open air that the Dutch painters really mastered, and in that field they left a great deal for their successors to accomplish. In the painting of interiors, on the contrary, they achieved a complete and final success, and the best works of three or four of their best painters have remained unequalled and inimitable.

These pictures have no subjects, there is no conceivable story connected with them. There is no emotion in them, no passion or imagination, and assuredly no idealism. They are well-arranged, or they would not be works of art, but there is little of what the great Italians would have recognized as composition. There is an impeccable draftsmanship as far as the accurate notation of the shapes of things is draftsmanship, but of drawing as a great expressional art there is no trace. Even color does not exist for its own sake or for the decorative and emotional effects that may be obtained from it. It is merged in tone and becomes an element in securing truth of

Plate 18. Gerard Ter Borch, *The Concert*. Paris, Louvre.

representation. But such absolute truth of representation, combined with material and technical perfection, exists nowhere else in art, and is in itself capable of giving a high and enduring pleasure. In such pictures as that by Ter Borch, in Berlin, of two well-bred women playing together on the harpsichord and the violoncello, or in Mr. Morgan's wonderful Metsu, "A Visit to the Nursery," now in the Metropolitan Museum, the simplest incidents, seen under the simplest effects, are sufficient for the creation of endlessly delightful masterpieces. De Hooch, who draws less well than the others, attempts more complicated effects of lighting, opens his rooms onto vistas of sunny streets and courtyards, or lets the sun into the rooms themselves. But the greatest of all these masters of light, of these extractors of beauty from the commonplace, is Ver Meer of Delft, an artist of rare subtlety, of infinite delicacy, of exquisite refinement—a master as absolute, within his own narrow domain, as any that ever lived.

Before the end of the seventeenth century this admirable school had died out.

In two hundred years the art of painting had passed through many stages. From an art of form it had become first an art of color and then an art of what we moderns know as "values"—of the exact notation of degrees of light. To an art abstract and expressive it had added more and more of truth to the appearance of nature, till it reached, with Titian and Veronese, the noblest balance of the ideal and the real; then it had slowly lost its more abstract and formal elements until it had become an art of almost pure representation. At each of these stages it had brought forth masterpieces of a perfection since unknown. The eighteenth century could still create an amiable art of its own, but it is an art of weaker fibre. The nineteenth century could find here or there an unexplored corner in the domain of realism, or produce artists of an essential greatness though mutilated and incomplete from the struggle with uncongenial surroundings. But the golden age of painting was past.

*PART III*

SOME PHASES OF NINETEENTH-
CENTURY PAINTING

# I

# NATURALISM IN THE NINE-
# TEENTH CENTURY

Except for the work of a few great
masters who stand apart from the general
stream of tendency, what the art of
the nineteenth century accomplished was
mainly a broadening of the subject-matter
of painting, and a new and detailed in-
vestigation of the appearance of nature.
The nineteenth century painted many
subjects that had not been painted before,
and it made discoveries of certain aspects
of nature which had not been previously
observed or, if observed, had not been re-
corded in art. It studied landscape for
itself and painted it as it had never been
painted; it placed the human figure in
the open air and tried to register the exact
effect upon it of the sun and the sky. Its
activities were so essentially naturalistic
that even the schoolmen admitted more
and more the direct imitation of nature,
and it was late in the century before the

realization that an exact imitation of nature
is not sufficient to art led certain artists
to abandon nearly everything savoring of
representation and to concentrate them-
selves upon the effort at self-expression.

One of the later phases of nineteenth-
century realism was that attempt at a
scientific analysis of light and that sacrifice
of everything else to the rendering of light
which we know as impressionism. One of
the earliest was the English Pre-Raphaelite
movement.

In the late forties the art of England
was at low ebb. If it had escaped the
pseudo-classicism of David and his school
it had also missed the exhilaration of the
romantic revival of painting, and its tradi-
tionalism, though not very old, was already
moribund. If the art was not to sputter out
like a burned candle, some new source of
inspiration must be found. A revolution
was necessary, and when it came its form
was largely determined by two things: the
teaching of John Ruskin and the invention
of photography.

In the first volume of "Modern Painters,"
Ruskin, who at that time knew more of
nature than of art and who always loved

nature better than art, had based his de-
fense of Turner entirely upon an exam-
ination of the facts of nature and a demon-
stration that Turner was a more accurate
recorder of such facts than was Claude;
and had, in a celebrated and eloquent
passage, advised young artists to attempt
nothing but simple imitation—to "go to
nature in all singleness of heart . . . re-
jecting nothing, selecting nothing, and
scorning nothing."

At about the same time the new art of
photography began to show the world how
surprisingly different was the actual ap-
pearance of nature from the conventions
that had passed muster as representations
of it. To a few enthusiastic young students
these two influences were decisive. They
were to imitate nature exactly, and as
nature was entirely unlike what they had
seen in pictures, they were to throw all
traditions to the winds and begin art all
over again. And as they constantly heard
Raphael quoted as the great authority
for the academic rule and knew very little
of the intensely traditional art of the
earlier Renaissance, they called themselves
the Pre-Raphaelite Brotherhood.

Ford Madox Brown, a somewhat older man who was never formally a member of the brotherhood, though intimate with all its membership, had made some more or less tentative efforts at the representation of the figure in true, open-air lighting as early as 1840-42, and had attempted absolute and unconventional realism in the portrait of Mr. Bamford, painted in 1846. Of the seven actual members of the brotherhood, only three achieved any notable reputation in painting. Millais was the precocious and brilliant executant, destined to an early success, for whom Pre-Raphaelitism was but a phase of youthful militancy, soon to be outlived. Rossetti, whose enthusiasm and persuasive power made him the apparent leader in a movement to which he never really belonged, made one or two efforts at strenuous realism but soon gave it up as too difficult for him and became a poetic dreamer. Holman Hunt was the true originator of the movement, as he was its last adherent, and it is from his works, and from some of those of Madox Brown, that the truest idea of its nature may be formed. In such pictures as Hunt's "Hireling Shepherd" and "Awakened Conscience" or

Brown's "Work" and "Last of England," the overthrow of all established conventions is well-nigh complete. For composition is substituted the effort to depict the incident as it might really have happened without regard to the agreeability or disagreeability of the resultant arrangement. All accepted attitudes and gestures are discarded in the attempt to find the gesture most likely to have been employed, with the result that awkwardness seems deliberately preferred to grace and constraint to amplitude. In the same way all typical drawing is abandoned in favor of precise portraiture of individuals, all chiaroscuro in favor of the exhaustive study of the actual lighting, all breadth of effect or of handling to the most laborious and minute research into detail. Add to all this that these men had an exasperated sensitiveness to colors and little sense of color and one begins to understand their extraordinary productions. There is an immense amount of fact in these pictures, an immense amount of thought, a prodigious laboriousness; the thing that has been left out of them is art. They are meritorious, eminently respectable, and hideous.

The technical methods of the Pre-Raphael-
ites were as revolutionary as everything
else. On a pure white canvas or panel, on
which the design was lightly traced, they
began with the background and finished
minutely a bit at a time. When the back-
ground was entirely completed, and not
until then, they began painting the figures
in the same piecemeal way, each little
bit being pushed to the utmost degree of
detail possible to eyes and hands "fit for
the portraiture of insects." Sometimes they
began upon the background without even
an outline of the figures which were to form
the principal subject. Madox Brown re-
cords in his diary how, having settled on
a subject the night before, he "began by
three and worked till eight" and "painted
eight bricks and some leaves." It was not
until a month later that he began to draw
his figures.

Any unity of effect is impossible of attain-
ment by such a method, except as the old
fresco-painters attained it, by the rigid
adherence to a conventional scale of color-
ing, consciously adopted and perfectly mas-
tered through long practice. In the hands
of men who would have no conventions

and would accept nothing on trust it could
lead only to a confusion of separate, un-
related, and irreconcilable observations. It
was in this way that Millais worked until
he found that "one could not live doing
that." It was in this way that Rossetti
struggled for weeks over the calf in the
never-finished picture "Found" until he
gave it up in despair, and began paint-
ing little water-colors out of his head with-
out reference to nature.

If there has been endless dispute as to
who was the real leader of the Pre-Raphael-
ites and as to what their doctrines really
were, it is because Pre-Raphaelitism was,
from the beginning, a mixed movement.
To Rossetti it meant a kind of sentimental
mediævalism. It was he who recruited the
weaker brothers; his quaintness and pic-
ture-bookiness were easier of imitation than
the strenuosity of Hunt or Brown. Later
his forces were joined by William Morris
and Burne-Jones and Brown came over to
them, and what had begun as a revolt
against tradition and an exaltation of exact
imitation became a purely æsthetic move-
ment. Yet in popular parlance it retained
the old name, and the secondary followers

of Burne-Jones are still spoken of as Pre-Raphaelites.

The effort to found a great school of art upon the purely analytical study of nature was bound to fail in the long run, but it had, for a time, a very great influence and that influence was, upon the whole, beneficial. It shook the English school out of an indolent and empty traditionalism, forced it to reconsider the relation of art to nature, and made it try for a larger amount of truthful representation in its art. It is safe to say that everything good in modern English art owes something to this courageous if short-lived revolt against the nature of art itself.

In the same years in which the Pre-Raphaelite battle against traditionalism was at its hottest Gustave Courbet, on the other side of the Channel, was proclaiming in his own way the doctrine of realism and the return to nature. But as no two men could be more unlike than Hunt and Courbet, so there was a vast difference between Hunt's Pre-Raphaelitism and Courbet's realism. Hunt was a man of high moral purpose and of deep religious conviction

who thought that art should deal only with the noblest themes and wished to revivify religious art by exact literalism of treatment. Courbet was a robust, full-blooded animal with little intellectual power, a free-thinker and a radical, who scoffed at all attempts at elevation of subject or of manner. As a man he was every way Hunt's inferior, but he had the great advantage of being a born painter, and the revolution in art which he inaugurated, while much less fundamental than that attempted by the Pre-Raphaelites, was much more fertile in results.

With Courbet realism is a matter of temper rather than of technic. Being a born painter, his one desire is to paint—to paint as well and as much as possible—and he could not conceive of sacrificing technical beauty and freedom to painstaking analysis, or of spending years on one picture when one might produce twenty in the same time. But if he wanted good painting, he wanted nothing else of art. He hated taste and denied the existence of style. Anything like classic elegance and reticence savored of aristocracy to this democrat, and all restraints were intolerable to his exuberance.

[ 273 ]

As for romanticism, with its exoticism and its research for emotion, all that sort of thing struck him as purely "literary." He cared no more for mediæval knights or Oriental sultanas than for Greek nymphs or Roman Emperors. His business was to see and to paint, and to paint only what he saw. The one important thing about a subject was that it should furnish good paintable material, and that was to be found all about him. Thus it was in the attitude of the artist to his subject, where the Pre-Raphaelites remained idealistic or sentimental, that Courbet was most revolutionary. Where they were most revolutionary he was least so and was content to paint in a manner founded mainly on that of Ribera and the seventeenth-century realists—a manner of vigorous brush-work and powerful light and shade, not unlike, though less sombre than, that which Ribot made the vehicle for his graver naturalism. Later, in his search for vigor, he used the palette-knife in place of the brush, and some of his most original and effective paintings are rather unpleasant in handling.

As Courbet was a politician as well as a painter, and a most active beater on the

great drum of *réclame*, it often happens
that his most "important" canvases are
theses rather than pictures. The "Funeral
at Ornans" can hardly be taken seriously as
a representation of anything that ever hap-
pened, and "My Studio after Seven Years
of Artistic Life" seems rather a preposter-
ous allegory than a record of fact. Moreover,
his mere vigor of representation was not
enough to carry him across such vast spaces,
which need tying together and unifying
by atmospheric subtleties of which he had
no perception. It is in smaller things that
he is at his best. Some of his portraits are
admirable, and his early portrait of himself,
known as "The Man with the Belt," is
superb. His nudes, inelegant and even in-
correct in form, are yet masterly in the
rendering of the pulpy firmness and soft-
ness of white flesh under a studio-light.
It is only when he puts a landscape behind
them that the" very literalness of his ob-
servation of them entails a falsity of rela-
tion. Perhaps he is at his best in his animal
pictures and hunting-scenes, where his
somewhat brutal power has full play, and
in his landscapes which, if they inevitably
lack grace and sentiment, are as inevitably

full of sap and life and of a certain fresh-
ness and joyousness which is invigorating.
Forcible, unfastidious, a bit rude, now and
then not a little vulgar, Courbet, at this
distance of time and in comparison with
many of his successors, assumes rather
giant-like proportions. Certainly he was
a great power. His work is the starting-
point for that of Manet and he influenced
men as unlike as Whistler and Monet.
Not only impressionism but all that less
specialized and less scientific naturalism
which in many forms pervades the later
nineteenth century is the child of his loins.

Among the group of young men of the
early sixties who were to make so much
noise in the world, an intimate of both
Manet and Whistler, was a quiet, gentle-
manly painter who, because he indulged
neither in controversy nor in self-advertis-
ing, has been relatively neglected—yet who
seems to many of his admirers to have
had a rarer talent than either of his more
loudly acclaimed friends. By his charming
pastels illustrative of music, of which he
was a true lover, Fantin-Latour is a Roman-
tic, but in his portraits and flower-pieces he

is a pure Naturalist, content to see and to paint, but to see with a fine and sensitive penetration, to paint with a breadth, a precision, a refinement, and a restrained power almost beyond praise. His canvases are very gray, almost colorless, yet full of those delicate discriminations of hue which mark the accomplished colorist. His drawing is correct, unnoticeable—almost photographic, one might think, were it not always beautiful and always expressive. His light and shade is simple but his perception of subtle gradations of value is almost infinitely tender. He never speaks loud—he is as reserved as Ver Meer of Delft—but what he says is well worth listening to, and it is always perfectly said. The same eminently aristocratic reserve marks his presentation of character. To have been painted by him is almost a certificate of good breeding, and if one were ever inclined to heretical doubts of the genuineness of Manet's talent and character, a look at Fantin's wonderful portrait of him is enough to reassure one that the sitter must have been worthy of the noble fidelity of the treatment. It is one of the greatest of modern portraits, and no other painter

Plate 20. Élie Delaunay, *Portrait of the Artist's Mother.*
Paris, Louvre.

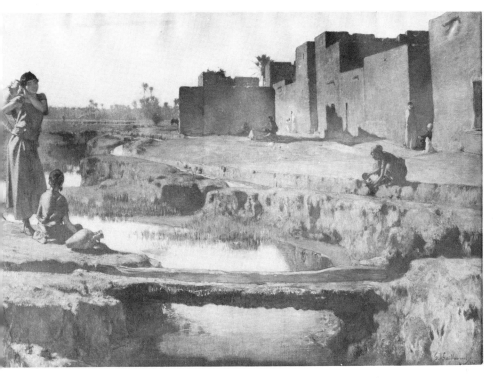

Plate 21. Gustave Guillaumet, *The Leguia near Biskra.*
Paris, Musée d'Orsay.

of the time was capable of emulating its admirable faithfulness restrained by perfect taste, unless it were another of those artists whose popular reputation has never equalled his merit, Élie Delaunay.

A talent not unlike that of Fantin, but exercised upon a very different subject-matter, is that of Gustave Guillaumet. Guillaumet may be reckoned among the Orientalists in so much as he went to Algiers for his subjects, but he has little else in common with the Romantic painters. There is nothing of "the gorgeous East" in his work, no glitter of costumes or prancing of horses. What he saw there was sun-baked, dust-colored villages under an ardent sky, the inhabitants as sun-baked and dust-colored as their houses; and these he painted with wonderful truth, gaining an extraordinary illusion of brilliant sunshine and clear, dry atmosphere by the perfect modulation of his simple tones. His work is a capital example of what has been the chief task of modern art: the discovery of new opportunities for beauty in the intelligent study of hitherto neglected aspects of nature.

The Dutch and the Flemings have always

retained something of the spirit of their
older art, and even Israels was a sound
naturalistic painter, if not a very great one,
before, in his addiction to sentimentality,
he almost ceased to be a painter at all.
But it is the Belgian Alfred Stevens who
gave to the nineteenth century its nearest
equivalent for the sober and admirable
art of Ter Borch and Metsu. It was in this
same wonderful time of the sixties when
the Barbizon men were still living and paint-
ing, when Courbet was at the height of his
power, when Manet and Whistler, though
young, were doing their best work; it was
in this silvern age—the brazen was yet to
come—that he produced a series of little
pictures of the *Parisienne* in her habit,
and her habitat, as she lived. They are
marked by a mingling of delicate sentiment
and yet more delicate humor which gives
them a slight literary flavor—a flavor ad-
vantageous to them, though Ter Borch
would not have appreciated it—but they
are seen almost as the old Dutchman saw
things, with the same breadth of effect and
the same sharpness of realization, and
they are painted with almost the old Dutch
feeling for beauty of surface and grace

of handling, making the very paint a precious and delectable thing. But the love of painting for its own sake, which in these early works is balanced by a thorough observation of nature, leads Stevens in the end to a mere display of virtuosity. The more human and the more truly artistic side of his talent tends to disappear and, from a little master who might almost be called a master without the little, he became an astonishingly clever painter of clothes and bric-à-brac.

It is virtuosity that distinguishes a whole section of modern realists—realists in so much as they care for little in art beyond representation, having nothing more to say than that "things look so to me," but differing from the refined realists we have been considering in that they care less for the things represented, or even for the truth of their own observations, than for the brilliancy of the language in which their observations are set down. If there were no painters who care more for painting than for what is painted, there would be no pictures of still-life; but not all still-life painters are virtuosi.

Chardin was a pure painter who could find enough occasion in a jug, a bunch of grapes, and a home-made loaf for the expenditure of his best powers, but there is nothing of the virtuoso in him. His observation is close, attentive, almost humble; his painting exquisite but with no display—rather with a careful hiding—of his dexterity. With Vollon or our own Chase you feel that the immense brio, the evident delight of the painter in the wielding of his tools and in the exercise of his skill, is the principal source of your own enjoyment, and that the truthfulness and acuteness of observation, acute and truthful as it is, is a secondary matter. Of course neither Vollon nor Chase is a mere still-life painter, and indeed there is almost nothing that Chase has not painted and painted extremely well. But whatever they paint you feel that a masterly and vigorous handling of their material is the thing that has most interested them, and is therefore what most interests you.

But it is with certain Spaniards and Italians that virtuosity most completely usurps the place of everything else, and the display of it becomes apparently the sole

aim of art. In the marvellous little pictures of Fortuny and the almost more marvellous little pictures that Boldini used to paint in his younger days everything becomes still-life and is treated quite impartially as the occasion for a dazzling and capricious brilliancy of handling. In looking at such a picture as Fortuny's "Choice of a Model" you cannot feel that the nude back of the woman interested him any more than the rococo table on which she stands, or that he cared for the heads of his Academicians as much as for their clothes. He does not say "things look so to me," but rather: "See how well and how easily I can paint things! See what witty touches I can invent! Would you ever have thought painting could be so entertaining?" And Boldini, on his six-inch panels, can be even more fantastically and audaciously amusing. There is a less artificial side to Fortuny. He had at bottom something of the old Spanish temper and he could feel inclined to paint a "Moorish Slaughter-house." There is rugged character study in some of his figures of Arabs and Kabyles, and he was one of the serious students of sunlight. But, after all, his prodigious virtuosity

remains his chief characteristic, and even for sunlight he cared primarily, one imagines, because of the glitter and the touch-and-go of his manner of rendering it. In Robert Blum, America had a technician of the same school, and of almost equal brilliancy, who died before he had completed that evolution toward a larger style which is shown in his decorations for Mendelssohn Hall.

A naturalism of a very different order is that of the Germans Lenbach and Leibl. Theirs is a realism by true descent from that of Dürer, a realism of which the exact expression of character is the primal aim. In Lenbach's thinly smeared, bituminous portraits nothing but the character exists —the character almost unembodied—but the research of character is carried to a point of extraordinary vividness. Leibl's studies of peasants are more in the old tradition. They are hard and gray and flat, exhaustively studied in detail, showing no more care for general effect than for beauty or for suavity of manner. Character is attained in them by the remorseless pursuit of the individual and the accidental—

Plate 22. Alfred Stevens, *Tous les bonheurs.*
Brussels, Brussels Museum.

Plate 23. Jules Bastien-Lepage, *Joan of Arc.*
New York, The Metropolitan Museum of Art.
(Gift of Erwin Davis, 1889.)

by the portraiture of every wart and the mapping of every wrinkle. In Paris that admirable engraver Gaillard did much the same thing in his few paintings, handling the brush like a burin and pushing analysis to the rendition of the separate hairs of the eyebrow, the striations of the iris, and the minutest corrugations of the skin of the lips. His results are as dry and as effectless as Leibl's, but far more agreeable because more sympathetic. You feel that Gaillard likes the people he is depicting and pushes his investigations so far only because he wishes to depict them completely. Leibl seems moved by a cold curiosity which has no feeling of any sort toward its subject.

In a brief sketch of the multifarious activities of nineteenth-century naturalism during thirty years it has been possible only to touch here and there and to mention none but the most prominent or the most interesting among the swarms of artists who were working at one or another part of the great task of a detailed reexamination of nature. By the end of the seventies the time had come when, if ever, the audacious attempt of the Pre-Raphael-

ites at an art entirely devoid of convention and corresponding at all points with the actual appearance of the real world might be renewed with some prospect of success. The renewed attempt was made by Bastien-Lepage.

At the first glance the resemblance between such a picture as Bastien's "Hay Harvest" and the works of Holman Hunt and Madox Brown is apparent. Here is the same contempt for conventional composition, the same awkwardness of attitudes imitated from nature and not invented, the same replacement of artificial light and shade by a thorough analysis of out-of-door lighting, almost the same insistence on accumulated detail. But the differences are very great also, and they are almost all in Bastien's favor. The efforts of a generation of painters have taught him both what can and what cannot be done, and his realism is less uncompromising than it seems and is wisely limited in what it attempts. Also he is a Frenchman, with French training and French taste, and therefore incapable of the crudities of technic which marred the work of his English predecessors.

Bastien realizes that the task of imitation is difficult enough without unnecessary complication, and he limits himself to the painting of one or two figures at a time, composing them with a certain care, in spite of his air of unconventionality, and avoiding, except in its simpler forms, the problem of placing figures one behind the other at varying distances. He knows that sunlight cannot be imitated and that it can be suggested only by such methods as are incompatible with prolonged and careful study in the open air, and he paints only on cloudy days. He knows that even in cloudy weather the sky is bright beyond the range of his palette, and he reduces the sky in his pictures to the smallest limit or excludes it entirely. Finally, though he gives great fulness of detail, he is too intelligent to attempt the microscopic, or to give more detail than can be readily seen and appreciated.

By such careful limitation of his effort to the imitation of what is most nearly imitable in nature, and by the exercise of very great talents, Bastien succeeded better than any one else has done in actually holding the mirror up to nature—in producing the nearest possible resemblance

to the image on the back of the camera. And his very success in this is decisive of the uselessness of the effort. His pictures leave us entirely cold. They approach so closely to the exact reproduction of a natural scene that they produce no other effect upon us than that which the scene itself would produce, and they are therefore quite evidently superfluous. There was great good sense in the question of the peasant to the painter: "Why take so much pains to imitate an oak-tree when you can always look at the tree?" You scarcely get from such pictures even that lowest and most fundamental of the pleasures afforded by the imitative arts, the pleasure of recognition, just as you do not get it from the image in a mirror. The imitation is so much like the thing imitated that there is not the least excitement in the perception of the likeness. The experiment has proved too successful, and it is doubtful if it will ever be repeated. Even with l'Hermitte, who most resembles Bastien, there is more composition, a more academic drawing, and much less insistence on detail.

After 1880 there is a sort of relaxation of fibre in modern naturalism. Its strenuous

days are over. The great investigations have
been made and their results are at every
one's command. Every one has learned to
paint in the key of light which shocked the
conservatives when Manet first employed
it. Every one has learned to see blue
shadows instead of brown ones, and to
dissect light more or less after the manner
of Monet. Every one draws in the natural-
istic way and composes unconventionally if
he takes the pains to compose at all. What
had been innovation has become current
practice, and what it had once taken cour-
age and originality to do, it now takes
courage and originality not to do. Hence-
forth the revolutionary spirits will be found
fighting against rather than for naturalism.
But as naturalism has become the art of
all the world, it must somewhat mitigate
its rigor. If all the world is to take to re-
cording observations, the observations can-
not be very profound and they must be
recorded in some current language, not too
difficult to learn and admitting of rapid
and facile expression. This language was
furnished by that brilliant portrait-painter
Carolus Duran and by his yet more bril-
liant pupil John Sargent. Duran somewhat

rapidly degenerated from the sound and vigorous realism of his earlier work into a facile painter of fashionable ladies in splendid toilettes, but he had a great command of his brush and invented a manner of painting, founded on a simplification of the later method of Velasquez, which, after Sargent had supplied and enriched it, became the basic manner of recent naturalism, on which each practitioner founds his own, following it as closely as he is able or varying from it as much as he chooses. It is a manner of painting more or less directly in opaque color, without preparation or underpainting and without subsequent modification by transparent rubbings or glazes, the colors being mixed on the palette and applied in great sweeps of a large brush. Such a method has been used by artists of many schools for rapid sketching because it lends itself readily to the notation of effects and the expression of masses, but it cannot easily express beauty of line or readily attain to any great fulness or subtlety of color. In the hands of any but the greatest painters it tends to become a kind of enlarged sketching which gives up at the first glance all that it contains.

It is impossible to notice one out of a hundred in the multitude of clever practitioners who, in something like this style, have registered for us their impressions of man and of nature in every quarter of the globe. We must let a very few stand for all the others. In the work of Alfred Roll, sturdy, solid, with a certain homeliness, there is much of that sound sense for the paintable which has always marked French naturalism. His "Woman with a Bull" is like a Courbet painted with a more modern palette. Brighter, sharper, more wide awake and up to date, superficially more brilliant but fundamentally more rudimental, Anders Zorn may represent a host of modern Scandinavians. The Spanish aptitude for virtuosity made of Sorolla the somewhat startling phenomenon that he seemed to us a few years ago, until we discovered that his observation is as facile and as much on the surface as his very able handling. His countryman Zuloaga is less superficial and less pleasing. He has more of the old, savage, Spanish spirit which had always a rather cruel delight in ugliness and deformity and his handling of his material is increasingly brutal. But the

ablest of all these more modern realists is John Sargent, and if I were to choose one picture as an example of the best that the school can do, it should be one of those that this many-sided man has produced for his own amusement in the intervals of painting portraits for a living and mural decorations for glory. He has produced them at all periods of his life, with ever-increasing power; and for acuteness of unexpected observation and easy, direct, almost instantaneous execution I know nothing more astonishing than, for instance, his "Hermit" in the Metropolitan Museum. It is a particularly typical if extreme example of the school, in the way in which the effect of light has become the centre of interest, the figure of the hermit himself almost disappearing into his surroundings and receiving attention only as another object on which the spots of sunlight fall. This is the final state to which a too exclusive occupation with the visual aspects of nature was bound to lead.

Our own school of painting has, almost all of it, inclined more or less toward naturalism, and in Winslow Homer this country produced one of the most powerful and

original realists of the nineteenth century
—a painter so entirely independent and
self-sufficing, so surprisingly free from any
trace of the influence of others, that it is
impossible to consider him except by and
for himself. He belongs to no school, he is
just Winslow Homer—a separate and dis-
tinct personality, almost as detached from
groups and movements as if no one else
had been painting during his lifetime.
He was one of the most acute observers
that ever lived, almost every picture he
ever painted being the result of a fresh
observation of nature differing from all
previous observations, and he covered an
extraordinarily wide range of subjects, in-
cluding figures, animals, landscape, and,
above all, the sea. He had little academic
training and never mastered the structure
of.the human figure, but his native sense
of weight and mass gave his figures bulk
and even a certain majesty, and he almost
infallibly finds the one right and inevitable
attitude to express the action and the state
of mind of his personages; while the same
sense of weight and bulk and movement
which confers expression and dignity upon
his figures gives an unequalled power and

veracity to his pictures of surf and rock. No great painter had ever less amenity or less care for the purely decorative and æsthetic elements of art. His coloring is sometimes powerful, sometimes almost nonexistent, but is never subtle and seldom beautiful. His handling is vigorous but rude and even harsh and repellent. In everything his work is calculated to give the utmost sense of unmitigated truthfulness and he is quite ready to forego charm —if he is even conscious of the existence of such a thing.

All this is realism, but it is a very different realism from that which deals primarily with the visual aspects of things. If it had occurred to Homer to paint a hermit, which, since he saw no hermits in the world he knew, is a quite unlikely supposition, there could have been no doubt as to what was the principal subject of the picture. The hermit himself and his human significance would have been everything to us and to the artist. That the picture should have become a sort of puzzle of light and air, or challenge us to find the hermit, is quite inconceivable. It is first this power of dealing with essentials, whatever the

[ 297 ]

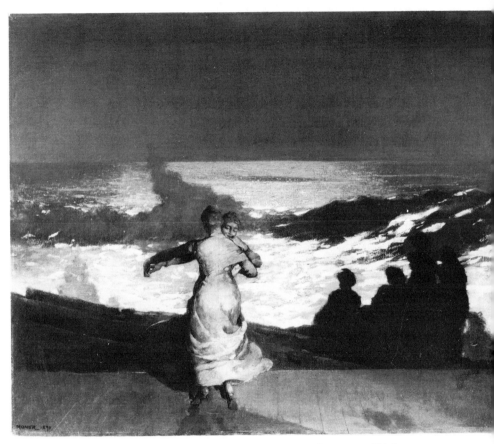

Plate 24. Winslow Homer, *A Summer Night*.
Paris, Musée d'Orsay.

Plate 25. Pierre Paul Prudhon, *La Source*.
Williamstown, Mass., The Sterling and
Francine Clark Institute.

subject on which he is engaged—a power in which he is akin to such a true Classicist as Millet—that raises Homer out of the ranks of the mere Naturalists and marks him as a great interpretative artist; and with it— perhaps a part of it—an extraordinary capacity for vital and original design. He is certainly one of the most remarkable painters of his time, and his peculiarly native quality gives us an especial right to be proud of him.

How much our contemporary painters of the sea owe to the example of Homer it is difficult to judge, but we have a whole school of marine-painters such as, I think, exists nowhere else. Waugh is the most exact realist of the school, Dougherty perhaps the most brilliant painter, while Emil Carlsen adds to his profound knowledge of nature an unfailingly decorative sense of color and line. The most conspicuous of our present-day landscape-painters are direct and rapid sketchers of nature's aspects, such as Schofield, Redfield, Gardner Symons, and a host of others. A more delicate and penetrating observation marks the work, whether in landscape or figure, of Julian Alden Weir and is combined with a

charming personal caprice in the pictures of
T. W. Dewing; while a quiet and thought-
ful naturalism is the principal character-
istic of Sergeant Kendall. Finally, in the
work of what is known as the Boston school,
with Edmund C. Tarbell at its head, we
have a naturalism akin to that of Stevens,
less witty and less technically admirable,
but pushing the study of interior lighting
to a higher refinement.

If, in all this naturalistic effort of the last
seventy-five years, there has been some
neglect of the higher aims and qualities of
art, yet the naturalistic movement has
been in the main a wholesome one. At
least the Naturalists have never forgotten
that it is the business of a painter to paint,
that painting is essentially and necessarily
an imitative art, and that, if an exhaustive
analysis of the aspects of nature is not
artistic creation, yet all acquired knowledge
of such aspects is an invaluable tool in the
hands of the artistic creator. They have
been equally free from the pedantries of
a hidebound pseudo-classicism on the one
hand and from the excesses of a lawless
individualism on the other. In an age not

very propitious to the creation of art, because the natural relations of the artist to his public have been dislocated, they have at least kept the tools of art bright and furbished, and the best of them have produced works of real merit which are likely always to retain some interest for mankind.

# II

## THE LOVERS OF TRADITION

THROUGHOUT the nineteenth century a few powerful and original artists maintained a reverence for the great traditions of the past and produced, each in his own way, an art that was truly classical. However they may appear to be mingled in the quarrels of the schools and the movements, they really stand apart from and superior to them. They are neither Pseudo-classics nor Romantics nor Naturalists. They are, first of all, great individual masters, and their connections are less with those around them or even with each other than with the great masters of all time. The first of them was born in 1758, the last of them died in 1904, and their lifetimes so overlap that their activities cover the whole century from the rigid tyranny of David at its beginning to the capricious lawlessness of its end. As against the absolutism of authority

they are apostles of freedom; as against latter-day anarchy they are the upholders of eternal law.

Prudhon belongs, by the years of his production and by the character of his art, to both the eighteenth and the nineteenth centuries. Ten years younger than David, he was twenty-six—an unknown student but an artist whose convictions were already formed, whose personal point of view was already established—when David made the first proclamation of his doctrines by the exhibition in 1785 of his "Oath of the Horatii"; and he never submitted himself to the influence of the great dictator. When he died in 1823, Géricault's "Raft of the Medusa" and Delacroix's "Bark of Dante" had both been painted and the romantic revolt had begun. His art is so much akin to that of the eighteenth century that David slightingly called him "the Boucher of his time"; so much akin to that of the earlier Romantics that they were the first to hail him as the great master he was.

In his grace, his exquisite fancy, his delicate elegance; in his flights of baby

Loves and his swinging Zephyrs, in his dainty sentiment and gentle moralizings, Prudhon is thoroughly of the eighteenth century, of the epoch of Louis XVI, when the exuberance of the rococo is giving place to a kind of staid simplicity which prepared the way for that Empire style of decoration of which he was so eminent a practitioner. He belongs to the Romantics by a deep personal feeling which underlies his graciousness—a passionate and unsatisfied yearning for the noble and the beautiful —and by the fact that he is a painter in love with light and air and the pearly gleam of flesh emerging from ambient shadow. He went to Rome a poor and ill-educated youth to study Raphael, for the time had not yet come when Raphael himself, the founder of the academic tradition, was thought insufficiently austere for profitable study. He remained to become a fanatic admirer of Leonardo and to make a deep study of Correggio, whose use of light and shade he better understood and more nearly equalled than has any other painter. Like every one else of his time he studied the antique also, and studied it profoundly, but with what different re-

sults! Where David could find only hel-
mets and sword-hilts or set patterns for
the drawing of pectoral muscles and knee-
caps, Prudhon, by a sympathetic intuition,
found nature and life, infinite charm, ex-
quisite refinement. Out of fragments here
and there, for much of the ancient art that
we know to-day was inaccessible to him,
he formed a truer conception of the spirit
of the Greeks as it showed itself in the lighter
and more delicate side of their work than
any other modern has possessed. Of eight-
eenth-century gayety, of romantic feeling,
of Greek sense of form and arrangement, of
Correggiesque light and shade—out of these
various elements by the strange alchemy
of personality is combined that perfectly
unified and homogeneous thing, the art of
Prudhon.

He is so steeped in chiaroscuro that he sees
everything in masses of light and shadow,
and draws by such masses and by the soft
modelling of surfaces more consistently
than almost any one. He was fond of draw-
ing upon blue or gray paper and of building
up his figure by the gradations of light,
laid on with white chalk, almost more than
by the shadows. And even in his slighter

drawings you never feel that the contour exists for itself or is more than the limit of the mass of light. If he has drawn it with a line, it is because he had not time, at the moment, to realize everything in tone. But the forms he draws with light are more classic than those which others draw with lines. He seems to have worked very little from nature. He had learned the human figure early and knew all he needed of its construction; he had formulated an ideal of human beauty which was at his finger-tips, and on it he played endless modulations and variations. It is not massive or majestic, this ideal, but youthful, supple, suave, yet with a certain plenitude of form. He draws children, youths and maidens, seldom a man. His women approach now and then to a riper splendor, but they never pass it; like the women of Leonardo, they are eternally and desirably young. On the other hand, his maidens, with all their youthful slenderness, are rounded into an adorable maturity. There is ever something of Venus in his vision of Psyche. Only Correggio, and Correggio only once, has come so near to the exquisite perfection of some little Greek torso, and if the "Danaë" is as beautiful

as Prudhon's "Psyche" and more humanly fascinating, she is less impeccable in the draftsmanship of the attachments. And these beautiful forms of Prudhon's are never cold and immobile, but palpitating, breathing, living flesh, cool and silvery in tone but radiant and glowing, bathed in a strange purple twilight of their own.

For Prudhon's coloring is entirely personal. He had a dislike and distrust of yellow and banished it almost entirely from his palette, so that all his tones, subtly and delicately varied, are based upon violet, and this coloring, together with the chastity of the forms themselves, gives a cold and moonlit purity to the most passionate of his dreams.

Another thing that Prudhon must have learned from the Greeks is the supreme elegance of his draperies. Not that his draperies are copied from statues, or that they are particularly correct from an archæological point of view; but no one knew better how to make the crisp folds draw the contour beneath and continually reveal what they as continually cross and contradict. His thin stuffs never cling too tightly, as if they were wet through; his

ampler draperies never swathe and conceal what they cover. In a style so modified as to be pictorial rather than sculptural, they have the perfect rightness of the draperies of the Attic stelæ.

Such was the art that Prudhon, during his long struggle for existence, put into count-less drawings for all sorts of purposes, official letter-heads, business-cards, even bonbon-boxes. Such was the art he put into the pictures of his few happier and more prosperous years. Once or twice he struck a graver note, as in his first really successful work, painted in 1808 at the age of fifty for the criminal court, but now placed in the Louvre: "Justice and Divine Ven-geance Pursuing the Criminal." In this noble work there is a true tragic intensity restrained and controlled by a classic dig-nity, and the beauty of the pursuers as they sweep upon their victim is the lofty and severe beauty of Pallas Athene. And in this, as in the still more tragic "Crucifixion" of his last days, after the death of his be-loved pupil Constance Mayer, his chiaros-curo and his purplish coloring take on a sombre and almost a terrible aspect. But these are exceptions in his work, and in

[ 309 ]

general he remains the painter of love and of the dreams of youth.

Unfortunate experiments with a medium of his own invention and the abuse of bitumen have played havoc with some of Prudhon's paintings; but the best of them are of immortal beauty and there is no material degeneration to mar the exquisiteness of his perfect drawings.

Jean-Auguste Doménique Ingres—Monsieur Ingres, as the Romanticists of 1830 used to call him with an ironic respect—was a pupil of David, but not a very docile one. Compared with the Gérards, the Guérins, and the Girodets, he is almost a Romanticist and a realist. In Rome he had the audacity to fall in love with Raphael, which was become almost a crime for a Pseudoclassicist, who should study nothing but David and the antique; and his "Œdipus and the Sphinx," which seems too coldly classical to us nowadays, created a sort of scandal by its exact representation of the forms of a particular model. To the straiter members of the sect he was almost as antipathetic as the revolutionaries themselves, but he was the only man with enough

talent to be opposed to the terrible Delacroix—Delacroix who was himself, if they could have seen it, a Classicist and a worshipper of tradition after his fashion—and he cared nothing for color, disliked all looseness of handling, and detested Rubens. Against their will they were obliged to make him their standard-bearer, and for thirty years he was the head of the École, though he never heartily believed in its ideals or its methods.

In theory, strangely enough, he was an absolute realist, a literalist, though his realism was of rather an unusual kind. He had a horror of ugliness and could not look at a cripple without physical pain, or listen to a singer whose eyes were too close together. He resolutely refused to see anything that was not beautiful; but he violently disclaimed idealizing anything or doing more than copy exactly the beauty that he found in nature. He would not study anatomy or allow a skeleton in the student's workroom, partly because anatomy was an ugly thing, partly because he held it useless or worse. You should not know anything or ever allow yourself to draw more than you can see. Your business is to follow

the model submissively, naïvely, even stupidly. His saying that "drawing is the probity of art" shows exactly what he thought drawing ought to be—a perfectly honest and literally truthful statement of form. And that this statement shall be accurate enough, nothing must be allowed to interfere with it. To him color was a negligible accident of nature; atmosphere and mystery were merely annoying obstacles to clear vision. Of light and shade he wanted no more than was strictly necessary to model objects, and even that much was a concession to the public. For himself he was perfectly indifferent whether things looked round or flat, but people preferred them round. As to handling, there was no such thing in nature. He wanted to abolish all painting-classes in the schools, maintaining that any one who could draw could color well enough, and that painting could be taught to any one in a week.

This belief of Ingres in the literal accuracy of his drawing was largely an illusion, but it has imposed upon others as well as on himself, and he is constantly referred to as the "impeccable draftsman" and the "high priest of form." It is most nearly

true of some of his portraits and of those
wonderful little portrait-drawings in pencil
by which he earned his living when he was,
as yet, an almost unknown young man.
But even in these there are frequently to
be found what we must believe to be devia-
tions from fact for the sake of style or of
beauty. In the drawing of the nude he is
very capricious, and he was not only igno-
rant of anatomy but, what is more serious,
he had very little native feeling for struc-
ture. In the sense in which Michelangelo
was the greatest of draftsmen, Ingres was
hardly a draftsman at all. The nudes of
his "Turkish Bath" are as boneless as so
many white grubs, and the foreshortened
figure in the lower right-hand corner could
hardly be more ill-drawn. It would be
difficult to account for the position of the
head and neck of the "Angelica" or for
that of the right arm of "Ruggiero" in the
little picture in the Louvre, and even in
that masterpiece "La Grande Odalisque"
the height of the bust and the extreme
length of the hip are, to say the least of
them, highly improbable. Of course these
examples are exceptional, and there are
plenty of figures in his works, from the

"Œdipus" of his youth to the "Source" of his old age, which are perfectly well-proportioned and perfectly just in their attitudes. But even in these the characters of structure and movement which are the material of the true draftsman are not conspicuous. When he tried in his "St. Symphorien" to prove that he could, if he chose, depict the human figure in violent action, he succeeded only in demonstrating the contrary.

What Ingres truly was is something much rarer and more important than a correct draftsman—something quite as rare and as important as a great structural and significant draftsman. He was one of the world's great masters of the line. It is the line by and for itself, the line studied for its own beauty, its own subtlety, its own elegance that is his means of expression. It is the character of the line that he is searching for in his exhaustive and repeated study of the model, and he really cares very little for what is inside it. It is the line that he pursues, as he said it must be pursued, *avec nerf et rage*, with the concentrated fire of a domineering and violent nature. This "cold Classicist" draws with

a white-hot excitement, and not Mantegna nor Botticelli ever made the line more subtle and sinuous, more suave or more austere, more passionately pure or more icily voluptuous. Beside Ingres's line that of his adored Raphael is undistinguished and cursory.

And if Ingres far surpassed Raphael in the quality of the individual line, he almost equalled him in that arrangement of lines and of the spaces they bound which we know as composition. One is obliged to say "almost" because in his large compositions of many figures he has not Raphael's inimitable felicity, but in smaller things, in the "Grande Odalisque" or the "Mme. Rivière," his design is beautiful beyond anything, save that of the most perfect of antique gems. To study the long, almost unbroken, curves of back and arm in the "Odalisque" with their marvellously delicate flattenings and accents which mark the bony planes and the joints, is a revelation of what beauty of line can be. To see the way in which these curves are taken up and carried on by those of the silken curtain, how these last are carried down across the figure, at exactly the right point by the

Plate 26. Jean Auguste Dominique Ingres,
*Ruggiero and Angelica*. Paris, Louvre.
(Photo: Alinari Art Resource.)

Plate 27. Jean François Millet, *Shepherdess and Flock*.
Paris, Louvre.

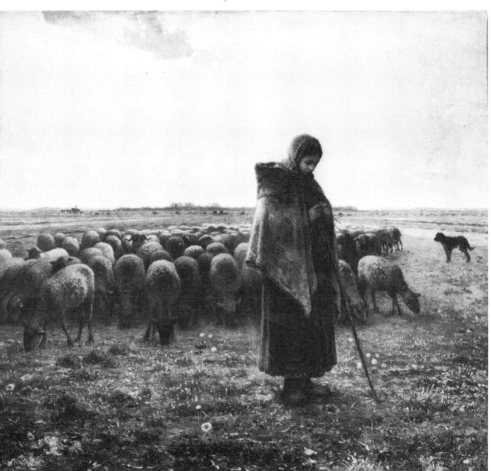

feather fan, and to note the perfect rightness of relation between all these lines and those of the enclosing rectangle, is to have an unforgetable lesson in the meaning of linear design. In the placing of "Mme. Rivière" within the oval boundary, in the wonderful lines of her veil and shawl, in the unalterable perfection of each detail to the swirl of the arm of her couch, the art is almost more consummate.

Even in color and in technic the true lover of Ingres would not have his work other than it is. His dictum that "it is without example that a great draftsman should not have found the color that went exactly with the character of his drawing" was certainly justified in his own case. His gray and ivory tones are the natural and inevitable accompaniment of his line, pleasantly sustaining but never drowning it with too full a harmony, and the enamelled hardness of his surfaces is the proper technical expression for his gem-like perfection of composition. The slightest loosening of his touch, the most momentary relaxing of his tension, would have been fatal to that air of permanence, of a fixed and eternal repose, which renders his art unique

in the history of painting—an art *sui generis*, unequalled, and in its own way inimitable.

What is known as the Romantic movement was, as far as painting is concerned, an effort to get back of the pseudo-classic régime to the older traditions and to recover the lost art of painting. Even Delacroix with all his exotism and his mediævalism in the choice of subject was as true a worshipper of tradition as Ingres himself (only it was to the tradition of Rubens and the Venetians that he looked instead of to the tradition of Raphael), and Corot was far more truly a Classicist than David. But the most classically minded of all these so-called revolutionists was that one whose long residence in the little village of Barbizon has led us to give the name of the Barbizon school to this whole group of painters, many of whom, likely enough, never saw the place.

Jean François Millet was a Romanticist only by his love of landscape and by the accident of association. He was a Naturalist inasmuch as he chose to paint peasants and so aided in the expansion of the subject-matter of art. Essentially he was a

Classicist of the Classicists, the one modern
master of the grand style, the lineal de-
scendant of that most austere of painters,
Nicolas Poussin, a Norman like himself,
and like that sturdiest of literary Classicists,
Pierre Corneille.

Born a peasant and accustomed from child-
hood to work in the fields, Millet had re-
ceived an unusual education at the hands of
his great-uncle, who was a priest. He read
Virgil in the original, and Homer, Shake-
speare, and Goethe in translations, and was
steeped in the Bible. He came up to Paris
in 1837, a young man of twenty-three, with
a pension of six hundred francs, and en-
tered the studio of Delaroche, where he
studied for little more than a year. Then he
broke away from the school and worked
by himself, doing anything that came to
his hand from portraits to sign-boards, de-
signing covers for sheet-music, and painting
many little pictures of nude figures for the
market in which is to be discerned a con-
stantly increasing power. But he had al-
ways wanted to paint men at work in the
fields with their fine attitudes, and he
began to experiment in that direction be-
fore 1847 and exhibited "The Winnower"

in 1848. In 1849 he went to Barbizon for a summer's holiday and to remove his family from the danger of cholera which had broken out in Paris, and there he lived in decent poverty the rest of his life, devoting himself to the production of his great epic of the soil.

Even in the choice of subject the art of Millet is essentially classic. Though he paints the lives of peasants, he is far from being a painter of *genre*, and though he had ever a story to tell, it is never a trivial anecdote or an insignificant action that he depicts. What he deals with are the sowing of the seed and the gathering of the harvest, the hewing of wood and the drawing of water, the guarding of sheep and cattle, the shearing and the spinning of the wool— the most important and significant labors of man from the days of the patriarchs to our own. And these actions he deals with in the classic way, eliminating all nonessentials, purging away everything temporary or accidental, telling his story with the utmost force and clarity. He returns to a subject again and again, enlarging it, broadening it, simplifying it, until he has found its typical expression. He does not

paint a peasant sowing corn, he paints forever "The Sower." A subject on which he expended his full power has found its final and definite form and need never— one might say *can* never—be painted again. This constant effort at simplification, at the discovery of the permanent and the essential in all things, this attempt to establish the type, is the constant characteristic of Millet in every part of his art. The costume of the peasant of his day was simpler and more rustic than it has since become, but he simplified it still further, eliminated all folds and details that could be spared, moulding it to the figure beneath it, until it has almost the value of classical drapery, "expressing," as he said, "even more than the nude, the larger and simpler forms of nature." And these forms he treated in the same manner, drawing heads almost without features and hands almost without fingers, but finding always the essentials of structure and movement.

He was the most profound master of structural drawing since Michelangelo, who deeply influenced him and who "haunted him through his whole life"; but his drawing is much less explicitly anatomical, much more abstract and generalized than

that of the great Florentine. It is only the
"larger and simpler" forms that he ex-
presses—the forms strictly necessary to
convey the sense of bulk and weight and
movement which are the essentials of great
figure-drawing. It is especially in the ren-
dering of the adjustment of the human body
to a weight which it has to sustain or to
move that he is incomparable. It is the
strain of the weight upon her arms that
gives such monumental gravity to the figure
of his "Woman with Buckets." It is this
same strain upon the arms combined with
the pushing movement of the whole figure
that makes his little etching of a "Man
with a Wheelbarrow" as grand as one of
the Prophets of the Sistine vault. It was
his creed that "one must be able to make
use of the trivial for the expression of the
sublime," and this seemingly impossible
task he nobly performed.

There is the same power of simplification,
the same reduction to the essentials in
Millet's composition as in his drawing. It
is a single vertical and a single horizontal
that give the enduring serenity to his
"Shepherdess," two or three curves that
make us feel the day-long, back-breaking
toil of his "Gleaners." There is never a line

or a touch that is not necessary, never a
failure in complete expressiveness. His pic-
tures are inevitably "all of a piece" and
"things are where they are for a purpose."
Nothing could be added to them and noth-
ing taken away.

But if, in all these things, we see in Millet
a Classicist more intellectual and more
austere than Poussin himself, he was also
what Poussin was not: a great painter and
a great colorist. In his earlier days before
he went to Barbizon he had acquired an
admirable method, and Diaz used to speak
of his "immortal flesh-painting." When he
began his long series of rustic pictures
this earlier technic seemed too luscious to
him, and for a time his workmanship be-
came harsh and his handling heavy. Gradu-
ally he learned to subdue his material to
his uses, to soften and enrich his manner,
until he painted well-nigh perfectly. His
coloring is not modern, in the sense that
he had not learned to see blue shadows;
but it is grave, simple, powerful, with great
fulness and subtlety in its sobriety, and few
men have been able to attain greater beauty
of individual hue or a nearer approach to
splendor within a restricted gamut.

Finally, Millet was as great a master of landscape as of the figure. He treated it as he treated the figure, reducing its multifold details to what was strictly necessary for his purpose and expressing its essential character by the simplest means, with a profound knowledge of natural forms and an assured mastery of atmospheric effect. No one has so made a flat plain recede gradually into almost infinite distance; no one has so overarched it with the dome of sky; no one has so modelled the back of a hill or expressed the ruggedness of a bit of waste ground. Above all, no one has so made us feel the rejoicing of all nature after the passing of the storm, the wet brightness of the apple blossoms and the glory of the shining rainbow, as he has done in that marvellous little landscape in the Louvre called "Spring."

For if a certain solemnity and almost biblical grandeur give the prevailing color to Millet's mind, he is capable of infinite tenderness and even of lyrical fervor, and this little masterpiece is his "Ode to Joy."

These three—Prudhon, Ingres, and Millet —differing from each other at almost every

point, are the only painters of the nine-
teenth century to whom we may give quite
unreservedly and unequivocally the title
of master, placing them upon the same
level with the great ones of the past; yet
there is another who, in spite of such grave
shortcomings as must make his claim to
the title doubtful, produced work of a
high order which inclines us to rate him as
almost a fourth with them.

George Frederick Watts lived so long and
died so recently that it is almost impossible
to remember that he was born in 1817
and was only three years younger than
Millet, whom he survived nearly thirty
years. He was a man of noble character
and of lofty ideals. He aspired to "paint
ideas, not things," and "to suggest great
thoughts which shall speak to the imagina-
tion and to the heart and arouse all that
is best and noblest in humanity." This
high and legitimate ambition he attained
in his best works, by the exercise of great
powers of drawing, of coloring, and of de-
sign, and his masterpieces have an ele-
vation of style which would have been rare
in almost any epoch and was particularly
so in the nineteenth century.

He was almost entirely self-taught, leaving the schools of the Royal Academy after a very brief experience, and he formed his style first by a prolonged study of the Elgin marbles and later by a study of those great Venetians who, as he always maintained, were nearest akin of all painters to the spirit of Phidias. These two influences are visible in his work and in the faults of that work almost as much as in its merits. His admiration for the marbles, for instance, led him to an insistence on draperies crumpled into a multiplicity of small folds, which, as they do not cling to and draw the figure as the Greek draperies did, often become distracting in his pictures and conflict with the serenity of the greater lines. And his admiration for the later work of Titian led him to a dry and crumbling technic which becomes more and more habitual with him, and which, in conjunction with his habit of constant retouching, results at the end in an almost total formlessness. But the study of Phidias led also to such grandeur of abstract form as in that mighty and sombre figure of Death in the "Love and Death," and the study of Titian led to much beautiful painting in

his earlier work and to a sober richness of color in almost everything he did.

Like Prudhon and Millet, Watts hardly ever worked directly from nature, using the model only for studies of parts of the figure when he felt his knowledge insufficient. Though he never reached Millet's solidity of structure or Prudhon's perfection of form, he yet succeeded in evolving a type of the figure of great decorative value and in becoming so far master of it that he could employ it freely in the expression of his feeling and the construction of the sweeping lines of his design. In his compositions of many figures, such as the "Death of Abel" and the tall and narrow "Birth of Eve"—he painted some subjects so many times that it is necessary to specify —he is liker to Tintoret than to any other master and has more of Tintoret's swing and force than can be readily found elsewhere. The rush of the avenging angels in the first of these pictures and the repelling vigor of their outstretched arms are particularly fine, while there is something majestic in the slow upheaval of Eve from the side of the sleeping Adam, and a splendid energy of joy in the soaring spirits above her.

But the most unequivocally successful of his pictures are the two great allegories of "Love and Death" and "Love and Life," simple compositions of two figures each, in which the thought has found its appropriate and inevitable expression: in the one case Life, trembling, unclad, feeble, painfully mounting the steep and rocky way, encouraged and guided by the gentle spirit of Love: in the other, irresistible Death advancing, slowly but inevitably, heedless of the agony of Love—who, with wings crushed against the door-jambs, struggles in vain to resist her approach.

Unhappily, the same noble purpose that led to these successes led also to many failures; and when Watts fails, he fails almost altogether. The thought in these two pictures was capable of presentation in clear and beautiful pictorial form, but not all his thoughts were so, and when they were not, his desire to paint ideas rather than things led him to forget painting altogether. The result of a determination to be moral and didactic, whatever happened to his art, is the existence of such unspeakable nightmares as "Mammon" and "Cruel Vengeance"—things it

is almost a crime to have committed—or such mushy sentimentalities as his "Conscience." From such total failures and from a great range of half-failures or of grievously marred successes it is a relief to turn to such early works as "The Childhood of Jupiter," in which beauty was his only and sufficient preoccupation.

Besides his imaginative figure-compositions Watts has left behind him a few landscapes treated in something like the old classical manner—composed landscapes, not merely transcripts from nature—and a large number of portraits, including a gallery of the greatest men of his time, as well as a few pieces of sculpture. In portraiture he tried, as in everything else, for something more than the delineation of externals. He was not content to paint men's foreheads and noses, he tried deliberately, and not merely unconsciously, as most painters do, to depict their characters rather than their features. His portraits, in a word, no less than his allegories, are works of the imagination, and as such they share the strength and the weakness, the success and the failure of his other works. When he succeeds, as in the noble portrait of Joachim, in

which the very spirit of music reigns, he is as superior to other portrait-painters as he is inferior to them when his inspiration fails him, and we have neither the clear conception of a personality nor the truthful record of a physical appearance.

Few artists of any time have so uniformly aimed at the highest, and if his failures were many, his successes were so frequent and of an order so nearly unique in the art of the recent past that he has fairly earned the respect and honor in which his name is ever likely to be held. After a disinterested and laborious life, he died at the age of eighty-seven, leaving the greater part of his work, which he would never sell, to the British nation.

No other country in the nineteenth century produced an art comparable to that of the three great Frenchmen we have discussed, or even to that of the less completely great Englishman. Certainly America did not. Yet if we have had no such masters as these, we have had and have artists with something of their temper, men who shared their reverence for the great traditions of the past, and have tried

with some success to carry on these traditions in their own art. Such an artist was John La Farge and such artists are Abbott Thayer and George de Forest Brush.

It is more difficult to form at present a final estimate of the work of John La Farge than of that of almost any other artist. The man himself was so extraordinary, his personality is so vivid to us, the impression of his culture, his wit, his subtlety of intellect is so strong, that it is almost impossible for us to separate our feeling of what he was from our feeling for what he did, and to imagine with any clearness what his art will mean to those who never knew the man. Certainly nothing he did contains the whole of him, and it is hardly possible that he should seem as important to posterity as he does to us. His formal education as an artist was brief and almost accidental, undertaken in the spirit of an intelligent amateur rather than in that of an intending professional, and something of that spirit he always retained. His production is rather desultory and fragmentary, as if he were interested in too many things to be quite contentedly a painter. He had an intense and highly trained

feeling for color and an oddly personal
and rather untrained feeling for form, and
these, combined with a mechanic's delight
in craftsmanship and a love for all niceties
of manipulation and tricks of the trade,
made him an incomparable designer of
stained glass. He had not only a great love
for and a great knowledge of the art of
the past and of all countries, but a curious
unscrupulousness in the way in which he
would utilize it in his own productions,
just as he would utilize the photograph or
the talents of his assistants. But if he took
anything he wanted anywhere he found it,
with the unconcern of the chief of a fif-
teenth-century *bottega*, he gave to every-
thing he took, as to everything he invented,
his unmistakable personal stamp. With his
great mural paintings, which are perhaps
the more important part of his work, I
shall have to deal later; but in his smaller
figure-pictures, his landscapes, his water-
color studies, there is always a beauty of
arrangement and of color, and beyond
and above these an indefinable, enigmatic
charm which is the artist himself.

In Thayer we have a striking instance of
an artist in whose art the personal point of

view—the personal conception of beauty—
seems to find expression independently of
and almost in spite of his technical methods.
There is such a conception of beauty;
but one almost doubts if the artist knows
clearly what it is, and one is certain that
he does not know how he expresses it.
His pictures are the result of a long series
of tentative gropings, and when the ex-
pression sought for is found at last, it is
likely enough to be encumbered with the
detritus of a hundred preliminary attempts.
Still, the expression is found, the beauty
attempted has been attained, and the lack
of technical amenity becomes of secon-
dary consequence. In his best things there
is a delicate modulation of color almost
without colors, a noble breadth of form and
of arrangement, above all a spiritual rather
than physical beauty in the faces, which
cause one to forgive and even to forget
the asperities and negligences of the execu-
tion.

Brush is a much more conscious workman,
a lover of and a striver after material per-
fection. In his earlier work he followed
pretty closely the academic and rather
photographic realism of his master, Gérôme,

though he had always a more romantic and personal feeling. He has retained a love for precision and definiteness, but has shown more and more the influence of the great Italians, both in composition and in coloring. He is one of the foremost representatives, to-day, of that combination of a respect for tradition with personal feeling and a thorough study of nature, of that reticence and dignity and sense of measure, which constitute the true classicism as opposed to the false.

# III

# MURAL PAINTING IN FRANCE AND IN AMERICA

THE French people have never lost the sense that painting and sculpture are the natural allies of architecture, and that no great building can be properly completed until the painter has been called upon to make it splendid within and the sculptor to make it magnificent without. Every public building has been the occasion of commissions for decorative and monumental paintings, and every painter has been desirous of such commissions and has put forth his best efforts to obtain and to execute them. But just because mural painting was taken for granted as the highest ambition of every painter, and because every painter was a mural painter upon occasion, there has seldom been any clear distinction in the mind of the artist or of the public between mural painting and any other kind of painting. Each artist has produced his own kind of art whether he was

working upon a wall or within the bound-
aries of a gold frame, and when a com-
mission for a great decoration has fallen
into the hands of a painter especially fitted
for decorative work, it has been as often
a matter of good luck as of intelligent
choice. Much such a state of things worked
well in the Italian Renaissance, when all
art was primarily decorative. It has not
worked so well in a time when art has
become dominantly naturalistic. In Italy
men gradually took to putting into easel-
pictures what they had learned in the prac-
tice of fresco-painting. In modern France
they have too frequently placed upon the
walls of buildings what they had learned
in painting small and isolated canvases.

But with the provision of abundant op-
portunity painters of true decorative in-
stincts were bound to find their proper
bent, and even those without any great
decorative aptitude might feel the necessity
for a greater gravity of style in monumental
art, as did Paul Delaroche when he devised
the balanced and formal composition of
his "Hemicycle" in the École des Beaux
Arts, though he painted it in his usual
heavily naturalistic manner. Thus a dec-

orative tradition gradually arose in France which reached its highest point in the work of Baudry and Puvis de Chavannes, between 1870 and 1880. Since that time it has somewhat disintegrated under the battering of modern realism and impressionism while a similar tradition has been growing up in this country, so that at the present time mural painting is perhaps in a healthier state here than there.

The beginning of this nineteenth-century decorative tradition may be traced back to the two great protagonists in the battle of the Classicists and the Romanticists, Ingres and Delacroix, each of whom put much of his best effort into work destined for a decorative purpose and each of whom had an almost incalculable influence. There is, however, very little decorative work by Ingres actually in place. His "Apotheosis of Homer" was painted for a ceiling but has been replaced by a copy, the original hanging among his other pictures in the Louvre, and the great wall-paintings begun for the Duc de Luynes at Dampierre were never finished. But from the "Homer" and the replica of "The Golden Age" we

can see how little he altered his habitual
style in applying it to mural painting.
Like Delaroche, he formalizes his composi-
tion, but he makes no other change. No
other change was, indeed, necessary. His
art was founded on that of Raphael and,
to some extent, on that of the primitives.
It was an art of the line, in which there was
no mystery and little light and shade,
essentially a mural art like that of the
Italian *frescanti*. The only thing wanting
to make it well-nigh perfect as decoration
is greater fulness and beauty of color, and
that he could not have given by any effort.
His color is at its best when there is the least
attempt to use definite colors, and in this
respect his easel-paintings are more deco-
rative than his "Apotheosis of Homer."
His pupil Flandrin, applying his master's
methods without his genius, produced a
series of paintings in the Church of Saint-
Germain-des-Prés which are grave, digni-
fied, appropriate, and, withal, a little
commonplace and uninteresting.

There is a decorative strain of another
sort in the art of Delacroix, a strain derived
from Veronese and Rubens, and with him
the responsibility of monumental art acted

as a calmant, so that in his "Heliodorus" and "Jacob and the Angel" in Saint Sulpice one is less impressed by his fiery energy and exuberance than by the almost classic restraint which holds them in check. His powerful coloring is here subdued to harmony with its gray surroundings, while it loses little of its fulness and quality; his restlessness of composition is kept within bounds, and the result is a decorative style almost as noble as it is vigorous. In the superb background of the "Jacob and the Angel," Delacroix is one of the first of the moderns to feel the decorative possibilities of a broad and generalized treatment of landscape forms.

If the qualities of these two decorative manners could be united in the same work —if one could have something of the stability, the clearness, and the linear beauty of Ingres conjoined with the emotional power, the full coloring, and the love of nature of Delacroix—one would have, in such a combination, an almost ideal decorative style. Such a synthesis was attempted by Théodore Chassériau, and he seems, from the little we know of his work, to have very nearly succeeded in it. He was a pupil

of Ingres, and he always retained something
of Ingres's linear beauty and classic repose
mingled with a more passionate feeling
and a love for color which were the result,
or the cause, of his admiration for Dela-
croix, and with a love of light and air in
which he was more modern than either of
his masters. He died at the age of thirty-
seven, in 1856, and his principal work,
the decoration of the stairway of the Cour
des Comptes, was destroyed during the
Commune. From the fragments of it which
remain one divines a genius that might
have anticipated the art of Puvis de Cha-
vannes, which it profoundly influenced,
and that may well have had a real, if less
decisive, influence upon the art of Baudry.

The late Augustus Saint-Gaudens, de-
signer and lover of decorative design if
ever artist was, had three great solar prints
made from photographs of monumental
paintings which he used as the principal
decoration, apart from his own works, of
his Cornish studios. One of them was
after Michelangelo's "Creation of Adam";
another after Raphael's "Jurisprudence"
from the Camera della Segnatura; the third

was Paul Baudry's "Pastoral Music" from the Foyer of the Paris Opera-House. The mere collocation of names is significant of the estimation in which he, with others, held an artist whom it is now somewhat the fashion to decry.

Baudry was one of the most brilliant pupils of the schools and had taken the Prix de Rome at the early age of twenty-two. In Italy he fell under the spell of the great masters of the Renaissance and studied deeply the art of Leonardo, Titian, Correggio, and, above all, of his chosen master, Raphael. He had already produced some of the finest portraits and some of the most beautiful paintings of the nude to be found in modern art, and had made some essays in monumental decoration, when his great opportunity came to him in the award of the commission for the work in the Opéra. One would have said that a painter of such accomplishments, a painter whose style was already so classic and so charming, had nothing to do but to paint upon the ceiling of the great Foyer what he habitually painted elsewhere. Baudry himself did not feel so confident. He wished that his work should

be truly monumental and truly decorative, and he was willing to give any amount of work and study to the perfection of a decorative style. In 1864 he went to Rome to prepare himself for his great task by making a series of full-sized copies from Michelangelo's frescos of the Sistine, in 1868 he went to London to copy Raphael's Cartoons, and in 1870 to Italy again, still bent on his investigation of the grand style of the Renaissance masters. His great work was finally completed in 1874 and was received with astonishment and delight.

In size alone the series of paintings in the Opéra forms perhaps the most colossal scheme of decoration carried out by one man since the great days of Italian art, but it is the high intellectual and artistic character of the work that most concerns us. Baudry's color is always pleasing, if not very profound; his light and shade, while strong enough to bear juxtaposition with Garnier's rather overloaded architecture, is subordinate; his main reliance is on linear composition and on significant drawing. Of decorative design on a monumental scale he is more nearly the master than Ingres or than any of the moderns.

[ 343 ]

In the nice balance of his filled and empty spaces, the elegance of his silhouettes, the binding and weaving of lovely lines, he is unfailingly felicitous. His pattern is always perfect, and it is always perfectly related to its surroundings and perfectly expressive of the sentiment of the subject in hand. No one has composed better since Raphael and Veronese, and one can think of no other modern who would deserve the fellowship or could survive the comparison which Saint-Gaudens instituted. As to Baudry's drawing, if he had not Ingres's passionately purified line or Millet's massive solidity and structure, he was yet a master draftsman, every line being full of knowledge and intelligence, of elegance, and of that clarified expressiveness which we call style. In the great single figures of the Muses there is a much softened reminiscence of his studies of Michelangelo, but in general his types are more like Raphael's though with a crisper and more nervous accentuation of the bony structure and a certain air which is not only French but Parisian.

Baudry's later work grows ever lighter and gayer in color, more brilliant and

delightful in handling, but there is a certain loss in monumental gravity of composition. His "Glorification of the Law" seems almost too joyous a work for a law-court, but the "Rape of Psyche" at Chantilly is delicious in its rococo gayety and is admirable in its rendering of light and air. One is curious to know what he would have made of the commission for the Life of Jeanne d'Arc in the Panthéon, where he would have met Puvis de Chavannes on Puvis's own ground. He never did more than make some preliminary studies for this work, but he seems, from all accounts, to have been contemplating something in the style of mediæval illumination—perhaps not unlike what Boutet de Monvel afterwards made of the same subject.

His fame must ultimately rest on his paintings in the Opéra, which constitute one of the greatest and most successful schemes of architectural decoration in existence, perfectly suited to their surroundings and entirely in harmony with the uses of the building. Because his art is eclectic and intellectual rather than spontaneous and emotional, because it is idealistic rather than naturalistic, and classic and imper-

sonal rather than individual, it is not highly prized to-day. Whenever the pendulum of public taste swings back from modern naturalism and modern individualism to a recognition of classic standards— as it must inevitably do sooner or later and as I believe it will do sooner rather than later—he will again be recognized for what he is, a great artist and one of the legitimate glories of the French school.

Puvis de Chavannes was thirty-two years old when Chassériau died, and the two young men had been intimate, though they quarrelled before the death of the elder of them. We are informed, also, by La Farge that Puvis kept to the end of his life certain of Chassériau's drawings and studies. Certainly the influence of Chassériau is unmistakable in the earliest of Puvis's important decorations, those in the Museum at Amiens. The first of these, "War" and "Peace," were not painted for their places but were rather experiments in the formation of a decorative style. They were exhibited in the Salon of 1861, when the artist was thirty-seven years old, and no one seems to have any clear idea of what his

work before this time had been like. When
they were acquired for the decoration of the
great staircase hall of the Amiens Museum
the artist was so delighted that he painted
two other great canvases, "Work" and
"Rest," and presented them to the Mu-
seum. These were painted in 1863, and he
was afterward commissioned to complete
the series by the "Ave Picardia Nutrix"
of 1865, and the "Ludus Pro Patria,"
which was not finished until 1880 and is
in his later and fully matured style. It is
in these early works, from 1861 to 1865,
that one must study the origins of Puvis's
art. He had been in Italy and had been
deeply impressed by Piero della Francesca
and others of the more masculine among
the primitives, but a comparison of photo-
graphs is all that is necessary to show how
deeply he bears the impress of Chassériau.
This is to be seen in the "War" and
"Peace" and even more distinctly in the
"Work" and "Rest" and in the "Ave
Picardia Nutrix," works planned for the
places they occupy and painted in a lighter
key than the "War" and "Peace," which
were rather decorative Salon pictures than
true decorations. It is to be seen in the

[ 347 ]

sentiment and the manner of composing, in the classical landscape settings, above all in the clear and beautiful drawing of the figures, a drawing descended through Chassériau and Ingres from that of Raphael. There are certain female figures in these paintings as beautiful as any that have been done by any one. In these works Puvis is already in possession of a noble and admirable decorative style, and though he was to do more personally characteristic work, it is doubtful if he ever did anything in all respects better.

The modifications of this earlier style which led to the gradual formation of Puvis's later manner are the result of two tendencies which might seem contradictory, but which work together in a strangely harmonious way—a growing primitivism and a growing modernity. The primitivism shows itself in a constant simplification of both composition and drawing. The composition is thinned out, the figures more widely spaced, the lines more and more reduced to verticals and horizontals, the lines of stability and repose. At the same time all detail is eliminated from the drawing of the figures, the contours be-

come almost without accent, and within the contours everything is flattened, light and shade and modelling being reduced to the minimum necessary for the expression of the chosen attitude. The modern tendency is marked by the growing importance of the landscape and the more intense study of light and air. In some of his later work the landscape becomes the predominant element, and the "Summer" and "Winter" of the Paris Hôtel de Ville are landscapes with figures, and very admirable landscapes rather than true figure compositions.

Of Puvis in his great central manner, Puvis in his best and most characteristic style, the "Sacred Wood" at Lyons is perhaps the finest example. It is a long landscape, the horizontals of pool and shore broken by the verticals of a fragment of Greek architecture and of a multitude of slender tree-trunks, the evening sky, with its tender crescent moon, visible only by reflection in the quiet water. On the flower-sprinkled sward stand or recline some dozen figures, women and children, some in a loose group, others more scattered, while above, in level line of flight, two others are returning to this chosen spot

"dear to the Arts and the Muses." The figures are beautiful with the beauty of archaic Greek sculpture, entirely simple in their forms yet with all necessary points of structure felt rather than seen, and the scant draperies have as few folds as those of Giotto. There is little binding together of the design, almost every figure being so far isolated as to seem at full length, and these figures are almost as vertical as the tree-trunks or as horizontal as the pool. It is an art profoundly calculated in its abstinence and nothing could more consummately express an endless stability, an eternal peace.

In still later work the tendency to simplification of form and to naturalism of landscape treatment carries Puvis farther and farther from his earlier methods. From figures austerely simplified in drawing he comes to create figures that are not drawn at all—figures not only angular and awkward but, at times, quite impossible, wrongly put together and out of joint, or mere approximate silhouettes without substance. On the other hand, his landscape gets better and better—a landscape simplified and clarified to fit it for decorative ends, but increasingly modern and natural-

istic in its forms and increasingly beautiful
and truthful in its light and color. But at
any stage of his evolution Puvis is always
a decorator and always fits his work per-
fectly to its surroundings and keeps it
mural in its character. His paintings seem
to grow out of the wall rather than to be
arbitrarily placed upon it. The one ex-
ception is in the case of his decorations in
the Boston Public Library. He never saw
the building, and failed to understand the
architect's drawings or to realize from
small samples what would be the effect of
the splendid masses of yellow marble that
there surround his work. It has taken our
own painters a long time to learn that
there is such a thing as a sumptuous style
of decoration, fitted for the ornamentation
of magnificent architecture. Puvis, in his
old age, could hardly be expected to change
his manner entirely, and to create a style
which should harmonize with its new en-
vironment as perfectly as that which he
had formed in a lifetime of effort harmo-
nized with the cold gray walls of the Pan-
théon.

From Puvis de Chavannes is descended
what one may almost call a school of nat-

uralistic decoration—a school which hav-
ing learned from him the decorative value
of pale tones comes to rely entirely upon
this paleness of tonality for its decorative
character and to abandon almost entirely
that gravity of design and balanced com-
position and that generalization and ideal-
ization of form which have always been
essential elements in monumental art. Cazin
is even more the landscape-painter than
Puvis himself, and indeed most of us know
him mainly as a landscape-painter pure
and simple, but he produced some charm-
ing decorations in which his delicate color-
ing and idyllic feeling make up for the lack
of monumental design. Degas's character-
ization of him as "The Puvis of the dwell-
ing-house" marks with perfect precision
his relation to the greater master. One
could live long with his pictures and always
find them pleasing and refreshing, but one
would not wish to place them in a temple or
a court of justice. Besnard took a still longer
step toward naturalism, and in his paint-
ings in the École de Pharmacie gave a cer-
tain decorative value, by the fresco-like
paleness of his colors, to a series of frankly
and even painfully realistic subjects. To-

day Henri Martin is painting for the walls
of public buildings great compositions of
realistic subjects in which the whole ap-
paratus of impressionistic division of tones
and pointillist technic is employed to
achieve the only unity which is any longer
thought necessary to decorative art, the
unity of light.

During all this time of the rise and decline
of a decorative style in France the old
French idea that any painter may become
a mural painter by the simple process of
mounting his pictures on a wall has, un-
happily, persisted. In the Panthéon, be-
side the works of Puvis, are placed the
academic insipidity of Cabanal and the
powerful and almost brutal realism of
Bonnat, and one of the most important
positions has been assigned to a painter
as hopelessly undecorative in every fibre
as Detaille. Of all the artists there engaged
in a sort of frantic competition the only
one who can at all sustain the forced com-
parison with Puvis is Jean Paul Laurens,
whose heavy color and realistic form are
saved by a certain nobility and gravity
of composition. The only thing that ties
together the work of so many men of con-

tradictory ideals is the repetition of a
border which was supplied by the profes-
sional decorator Galland, not one of them
—not even Puvis himself—being sufficiently
an ornamentalist to design a border of his
own.

In spite of the very great talent of many
of the artists employed upon it—in spite
of the fact that it contains, in the work of
Puvis, some of the noblest of modern
decorations—one would be inclined to con-
sider the Panthéon as one of the worst
decorated buildings in the world, did not
one remember that final triumph of hig-
gledy-piggledy, the Paris Hôtel de Ville. It
would seem that all the painters in France
have been given their lodging in that un-
happy building, three or four of them,
wretched bedfellows, quarrelling for each
room, and not the most modern of com-
posers could emulate the cacophony of the
sounds they emit in their conflict. So
limited was the space and so great the
competition for commissions that, in one
great hall, the very piers that support the
roof have been, as it were, *painted out*, each
pier being covered on its four sides by four
realistic landscapes, and nothing but a nar-

row gilt moulding being left to mark its function. We have made some blunders in decoration in this country, but we never have done, and I trust we never shall do, anything so bad as that.

Before 1892 there had been sporadic attempts at the mural decoration of public buildings in this country. The first of these was the decoration of Trinity Church in Boston by John La Farge, done in 1876; the second was the painting by William Morris Hunt in 1878 of his two lunettes in the State Capitol at Albany, "The Flight of Night" and "The Discoverer." Hunt painted his decorations directly upon the stone walls, and they are now hidden from sight by changes in the building. Trinity Church has been so darkened that La Farge's paintings are nearly invisible. It is thus very difficult to form any clear idea of these pioneer works, but though La Farge's pictures in Saint Thomas's Church in New York have been destroyed by fire other things remain, including his greatest work, "The Ascension of Christ," in the Church of the Ascension in the same city. La Farge had received his artistic educa-

Plate 28. John La Farge, *The Ascension.*
New York, Church of the Ascension.

Plate 29. Henry O. Walker, *Lyric Poetry*.
Washington, D.C., Library of Congress.

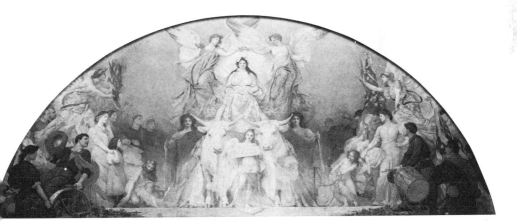

Plate 30. Edwin H. Blashfield, *Minnesota as
the Granary of the World*. St. Paul, Minnesota State Capitol.
(Photo: Al Ominsky for the Minnesota Historical Society.)

tion in Paris at a time when the influence of Delacroix was paramount with the younger men, and his work is of the Delacroix tradition. He had known Chassériau but had little sympathy with the strain of classicism which Chassériau had inherited from Ingres. If he had ever seen the work of Puvis he showed no trace of its influence. The "Ascension" is the most formal and monumental of all his compositions, which are generally rather irregular and picturesque, and in spite of its lack of severity in form and even of certain distinct errors in drawing it is a noble and impressive work. Its main reliance, as ever with its author, is on his powerful and harmonious coloring, in which he has no modern rivals, and on an original and beautiful use of landscape. He is not only the earliest of our mural painters, and the trainer of several of those who have since attained distinction, but he is likely to remain one of the greatest.

But the beginning of the general movement toward mural painting in this country—a movement which has since attained considerable proportions—is due, more than to any other man, to Francis D. Millet.

As Director of Color at the Chicago Exposition in 1892 he called in a number of painters to add their contributions to the creation of that "great white city" which proved such an educational stimulus to the appreciation of architectural beauty and dignity. Hardly one of these men had ever had the opportunity to attempt mural painting, and several of them have since found that their bent is in other directions. But though some were not decorators by nature and none were decorators by training, they all fell to work with energy and enthusiasm, and their achievement was sufficient to convince architects and public that, henceforth, no monumental scheme of architecture could be complete without the aid of the mural painter. The decoration of the Library of Congress, the Boston Public Library, the Appellate Court in New York followed in rapid succession, and to-day the decoration with paintings not only of State capitols and court-houses but of banks, hotels, and even private houses of any luxury has become a fixed habit.

Such an amount of work carried out in a few years by painters without experience

in decoration for architects equally inexperienced, in a country without traditions and without great examples handed down from the past, must inevitably contain faults of judgment and of execution. The astonishing thing is that the faults have not been graver and more frequent, and that they have been so rapidly corrected. In the decoration of the Appellate Court of New York, the same mistake was made as in the decoration of the Hôtel de Ville of Paris, but with much less distressing results. The decoration of the main court-room was intrusted to no less than six painters, and as a result the room is certainly over-decorated, each painter having felt bound to plan an important figure composition in the space assigned him even though, had he had control of the whole work, he would have placed there nothing more important than ornament. But the six artists made a serious effort to harmonize their work, each making some sacrifice of his personal ideas for the benefit of the total effect, and the effort met with a surprising degree of success. If the room is not what it should be, it is far from the hodge-podge of some of the rooms in the Hôtel

de Ville, and the lesson of its partial failure has been learned. To-day no American architect of standing would ask two painters to co-operate in the decoration of one room, all the paintings in any one room being intrusted as a matter of course to one artist, and even a general supervision of the plain and ornamental painting being accorded to him.

A similar facility has been shown in the correction of their individual errors by particular men. When Edwin A. Abbey and John Sargent were given commissions for mural paintings in the Boston Public Library, the one was the first of American illustrators, the other, as he still is, the first of living portrait-painters. In Mr. Abbey's paintings in that building there is a lack of relation in scale and in tone between the pictures and their surroundings, and even between one picture and another, which renders even their fine drawing and painting nugatory as decoration; while Mr. Sargent betrayed a curious hesitation as to the appropriate manner of working out such a task and combined modern naturalism in the frieze of the "Prophets" with an extreme archaism in

the painting of the lunette and the vaulting. That both men saw their error is shown in their subsequent work. At the other end of the same hall that contains his "Prophets" Mr. Sargent has since placed an entirely harmonious and sumptuous piece of decoration in a style which may be called modernized Byzantine. In the capitol at Harrisburg Mr. Abbey has produced a series of paintings which are no longer splendid illustrations but mural paintings, properly planned for their relations to architecture.

Each new decoration is a new problem, and it may be that it is because of the different nature of the problems set them by our architects that our mural painters have from the first relied more upon formal design than has been common in France. They have seldom had such free wall spaces at their command as determined the style of Chassériau and Puvis; rather they have had to paint lunettes, pendentives, friezes, or wall-panels so situated and surrounded as to impose a formal treatment. They have not been called in to decorate walls left bare by the architect, as happened so

often in the Renaissance and as has frequently happened in France, but rather to fill certain gaps left for them in a carefully planned scheme of architectural adornment. It may be also that the lack of that habit of painting on a large scale so common in France has helped them to think of mural painting as something different from the making of pictures, and to feel that it requires a different kind of composition. For whatever reason, it is certain that they have produced relatively few enlarged easel-pictures, and few, even, of the freer sort of decorative compositions, and have tried to relate their work to its setting by an architectural symmetry of arrangement. This tendency has been pronounced from the beginning. It is clearly marked in three out of the four lunettes in the Walker Art Building at Bowdoin College, painted in 1894, and in most of the decorations of the Library of Congress, painted in 1896. It dominates the work of men as different from each other as Edward Simmons, Henry O. Walker, and Elihu Vedder. Mr. Walker, indeed, has confined the symmetrical arrangement to the charming and delicate painting en-

titled "Lyric Poetry," at the end of his corridor and marking its axis, and has judiciously varied the composition of the small lunettes on either side wall, but all of Mr. Simmons's lunettes of "The Muses" are formally balanced, and Mr. Vedder, in his powerful representations of good and bad government, has secured a remarkable variety without a single departure from a fixed symmetry. That this formality of design is not adopted by our mural painters because of a special love of formality for its own sake, but from a sense of architectural propriety, is shown by the way in which they have escaped from it whenever it seemed allowable to do so. Not one of them but has welcomed the opportunity for a free composition when the architectural arrangement permitted of it, but in their freer as in their more formal work they have shown a power of designing in a truly monumental manner which is rather uncommon, to-day, in France and which hardly exists elsewhere.

In its reliance upon formality of design the art of our mural painters is more nearly allied to that of Baudry than to that of Puvis, but in the earlier work of most of

them the influence of Puvis is to be felt in an extreme paleness of tone and a tendency to the use of blue and violet shadows. Gradually they have learned that such tones, admirable in their proper place, are rarely in harmony with the rich woods or marbles of many of our public buildings. Gradually they have learned that insufficient lighting or thirty feet of intervening air will tone down the strongest color, and that if the design be truly decorative the fullest coloring, and even a considerable degree of chiaroscuro, will not interfere with a sufficient degree of mural flatness. They have consulted Raphael and Veronese and our own La Farge, they have filled and enriched their compositions, painted silks and brocades and armor—above all, they have increased the fulness and power of their color until they have produced work of sufficient depth and vigor to hold its own against the most magnificent surroundings. A decoration by Puvis used to look thin and poor when shown in the Salon and to reveal its tranquil beauty only when it was placed upon the wall for which it was intended. A modern American decoration is more likely to look overcolored and

violent when strayed among other pictures, and to need the subduing influence of shadow and distance to transform its vividness into a chastened splendor.

Having been led to base their decorative style upon a study of the great Italians, our mural painters have learned from them something of their noble generalization of form, and a few have made at least an approach to a grand and monumental style of drawing. Many have learned to appreciate the importance of ornament, and show in this or that work a knowledge of architectural and ornamental forms, while an increasing number would be quite capable of planning the entire decoration of a building. Perhaps no one else has shown the capacity of H. Siddons Mowbray for placing figure-painting of a high order in a setting of appropriate ornamentation, after the manner of Pinturicchio, but one could name others who only need the opportunity to demonstrate a similar ability.

If America has produced no mural painter of such lofty talents as Puvis de Chavannes or Paul Baudry, she has yet, within twenty-five years, developed a whole school of mural painters such as exists nowhere else

—painters who are extremely capable and efficient; who have formed a distinctively decorative manner in design, in drawing and coloring, and in the use of ornament; who have, in fine, made mural painting their profession and have learned their trade. In the course of my attempt to describe the evolution of this school I have had to mention the names of half a dozen of them; I could easily name as many more of equal standing, but as I could do no more than name them, I shall confine myself to some mention of the chief of them all, the man who, since the death of La Farge, is the recognized head of the profession.

Edwin H. Blashfield was one of the painters called in by Millet to decorate the domes of the Liberal Arts Building at Chicago, and he demonstrated his ability for such work by finding far the best solution of the difficult problem which was there set for so many raw hands. Since then he has been in constant demand by architects and building committees, and he has probably produced as much important work as any two of his fellows. He has seen the whole of the evolution we have been tracing and he has been, in his own

person, a large part of it. By his ability
and intelligence, by the elegance of his
style, by his constantly increasing mastery
of color, by the inevitable fitness of his
work for its place, he has earned the con-
fidence of his employers. By all these things
and by a beauty and sentiment which ap-
peal to the great public no less than to the
small, he has earned the right to be the
last artist named in this review of mural
painting in France and in America.

In many fields America has been develop-
ing a native art, independent of that of
other countries—an art inherited, indeed,
from the past but modified by American
temperament and suited to American needs
—an art, whether or not the public and the
critics have become aware of it, not inferior
to any other now extant. In no field have
American artists more decisively taken
their own way than in this of mural paint-
ing, in none have they produced an art
more their own. And perhaps that which is
most characteristically American in this
art is its conservatism, its discipline and
moderation, its consonance with all great
and hallowed traditions—in one word, its
classicism.